MASTERS
OF
DRONE
PHOTOGRAPHY

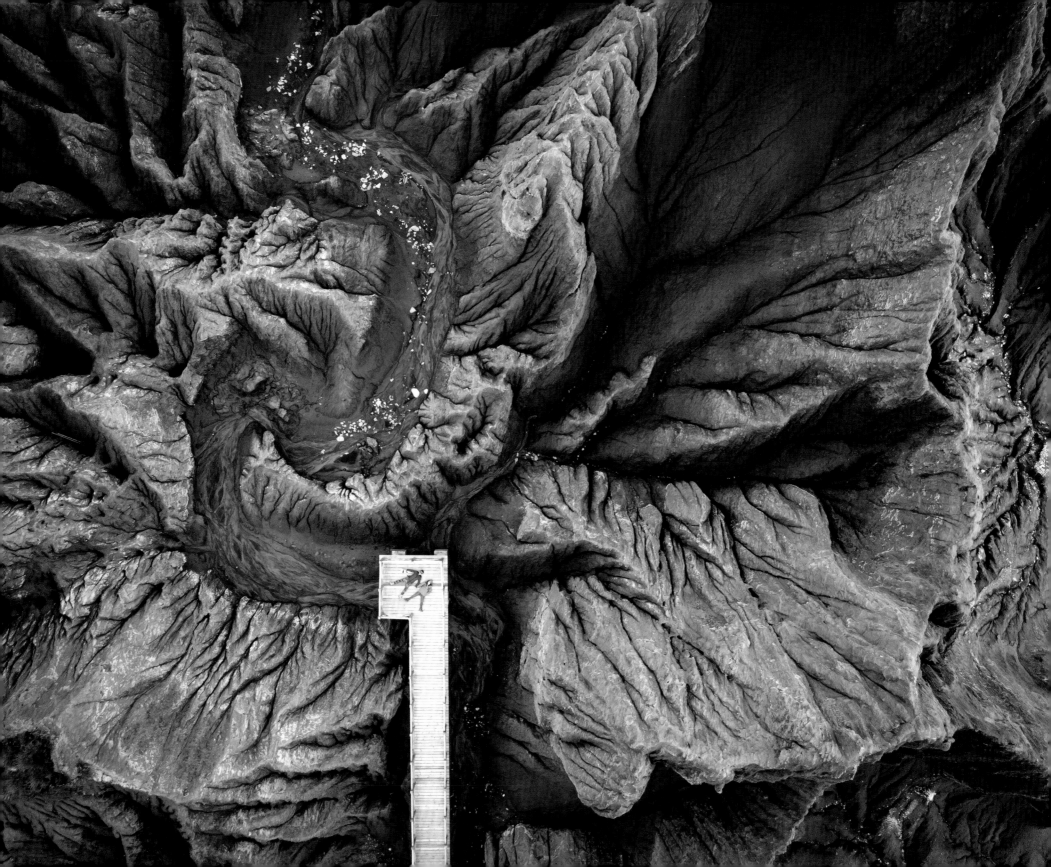

MASTERS
OF
DRONE
PHOTOGRAPHY

CONSULTANT EDITOR: FERGUS KENNEDY
FOREWORD: TRISTAN GOOLEY
EDITOR: ROB YARHAM

AMMONITE
PRESS

First published 2018 by
Ammonite Press
an imprint of Guild of Master Craftsman Publications Ltd
Castle Place, 166 High Street, Lewes, East Sussex, BN7 1XU,
United Kingdom
www.ammonitepress.com

ISBN 978 1 78145 331 5

A catalog record for this book is available from the British Library.

Publisher: Jason Hook
Design Manager: Robin Shields
Designer: Luke Herriott
Editor: Rob Yarham

Color reproduction by GMC Reprographics
Printed and bound in China

Front cover image: copyright © Jerome Courtial
Title page image: copyright © Tugo Cheng

CONTENTS

FOREWORD

On a walk across part of central Borneo with the Dayak in 2013, my aim was to understand how they navigate. Scratching lines in the mud by my feet, Titus, the senior and most experienced of the Dayak, explained how they have a relief map of the area in their head. The Dayak know the rivers, valleys, ridges, and summits and from this mental map can always find their way between villages and hunting grounds. When talking about direction they have no interest in north, south, east, or west—they always talk in terms of uphill-downhill, or upriver-downriver.

"What do you do if you get lost?" I asked Titus.
"We walk uphill until we can get a view of the surrounding terrain," he explained via the interpreter.
"OK. But what if you climb and still can't see anything?"
"We go higher, higher…" Titus threw his hands at the slope behind me, "all the way to the top if we need to."
Where we stood was not far from a local summit and I looked at the dense jungle foliage that surrounded us. There was no clearing and no view.
"But what if you are at the top and still can't see very far?"
"Then we climb to the top of the tallest tree."
I smiled. The Dayak are serious about gaining a view and some perspective. As they know from experience, the more we can see the more we can understand.
A good view gives the land meaning.

While today's drones afford us the most far-reaching of views, tensions are growing around our relationship with technology. Drones straddle the two sides of the debate, enticing us to spend more time engaging with microchips, but then giving us a richer, better understanding of the nature and landscapes around us. Like many others who work in nature, I regularly get asked whether I think technology is damaging our connection with the natural world. My answer: no, I believe we can

have the best of both worlds, providing we understand the opportunity cost of how we choose to spend our time. Having a smartphone in your pocket is the not the same as staring at one for hours without a break.

Personally, I enjoy getting carried away by nature and then rescued by technology. After spending hours crossing an ancient wood using wildflowers, trees, and moon as my map and compass… I jump into the Land Rover only to realize on looking at my phone that I'm running late for something in town. Tapping the satnav, I assess the best route, factor in live data about traffic, and arrive almost on time with goosegrass still stuck to my trousers.

A book of stunning images that capitalizes on the drone's fresh perspective is a great example of this best-of-both-worlds approach bearing fruit. We use a new technological tool to gain a better understanding of the world we live in, including the challenges we face—the 'Man Vs Wild' photograph by JP and Mike Andrews on page 14, showing military trucks lined up against the trees, is one of many that are both powerful and thought-provoking.

From the loftier perch of the drone's-eye view—"higher, higher"—we are also invited to reassess our role on the planet. The first astronauts' photos of Earth are credited with giving wings to the environmental movement, and drone photography joins this noble tradition. It is ironic that building extraordinary small flying machines can humble us and remind us that we are a small part of a beautiful world.

Tristan Gooley

INTRODUCTION

Drone photography is an incredibly new discipline. Although enthusiasts have been using a variety of remote-controlled aircraft equipped with specialist cameras for quite a few years, small multi-rotor drones with cameras have only become commercially available to the general public since about 2012. This makes it all the more astonishing that the standard of drone-based aerial photography has made such great leaps in such a short time.

The big breakthroughs came when the camera could be effectively stabilized, and the picture easily controlled and monitored from the ground. Once these technical advances were in place, drone photographers could really unleash their creativity, and they have done this on every continent and in a huge variety of environments, from pristine wilderness to the urban jungle. Further fuel has been poured on the creative fire by the ease and speed of sharing great images online. This has led to a huge cross-fertilization of ideas and inspiration, making this a very exciting time to be involved in drone photography.

I can remember being particularly pleased with my first drone aerial photograph—what now seems a very bland image of some fields. I had the feeling that this was the beginning of something big, but I scarcely imagined that it would blossom so quickly into such a diverse and beautiful photographic discipline. Scarcely a week goes by when I'm not blown away by an original and creative aerial shot, shared on the now ubiquitous social media. In many ways, it's this sense of rapid progress that makes it all so exciting.

The very fact that technically sound images can now be shot from a folding drone, which takes up a similar amount of space to a camera lens in your bag, means that the aerial perspective is now a viable option for a great many photographers in a number of photographic disciplines. Drones are used regularly by landscape photographers, photojournalists, wildlife photographers, sports photographers, and wedding photographers, to name but a few.

Successful drone photographers must master all the usual photographic techniques, and then apply these to an aerial platform. If anything, drone photography demands an extra leap of the imagination. A top-level image is rarely the result of a random flight. As with most other branches of photography, it has usually entailed a high degree of planning and forethought, as well as persistence. It certainly helps to be able to imagine what the world might look like from above, and how different lighting and atmospheric conditions might affect the shot.

The following pages showcase images by some of today's leading drone photographers. Each has been selected for their outstanding body of work, and has chosen a series of their own photographs that represent an area of expertise in which they are particularly skilled. As well as learning about the varied backgrounds of the photographers and the stories behind the photos, we gain valuable insights into their motivations, special techniques, and tips for budding drone photography masters in our exclusive interviews.

Fergus Kennedy

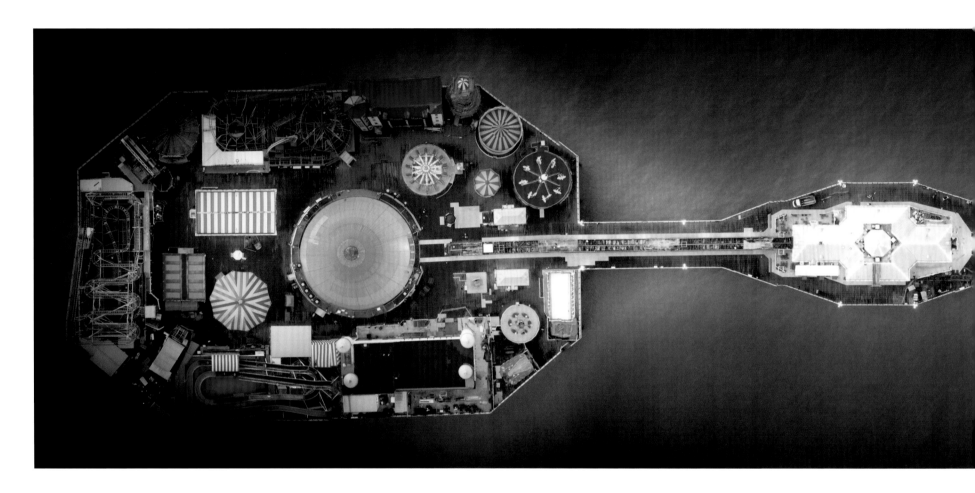

BRIGHTON PIER, TOP-DOWN

I wanted to get a top-down abstract shot of Brighton pier on the south coast of England, as it's not a view you normally get to see. This photograph was taken at dusk on a cold winter's day, but I still had to ensure the pier was quiet so I didn't overfly anyone. The shot was taken from 400ft (120m), which is the maximum altitude permissible in the UK without special permissions, but even at that altitude I couldn't get a wide enough shot. In the end, I took four photographs and stitched them together in Adobe Lightroom. In terms of camera settings, the fading light was the biggest challenge. I was using the small DJI Mavic, which has a relatively small sensor, so it doesn't do so well at high ISO values (of ISO 800 and above). This meant I needed to use a slower shutter speed and hope the drone would hold still enough in the wind. I tried a few different settings before I settled on one I was happy with.

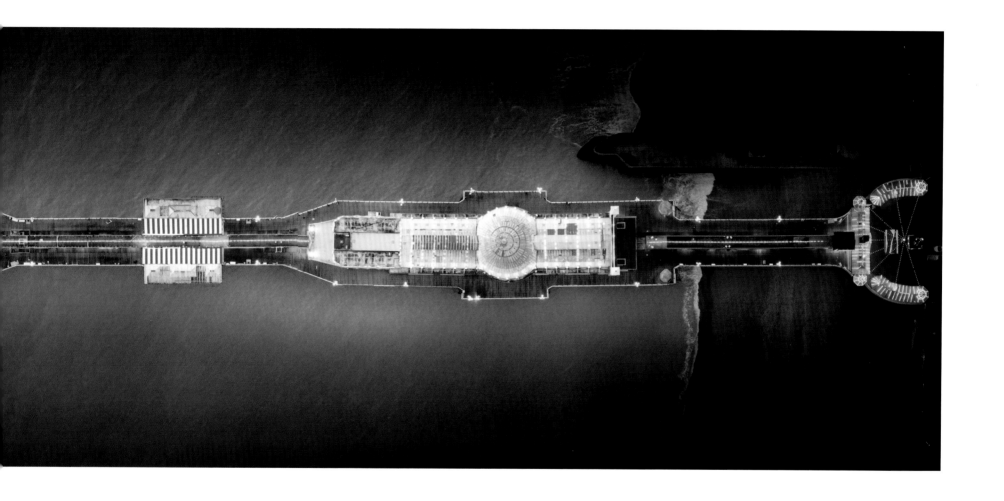

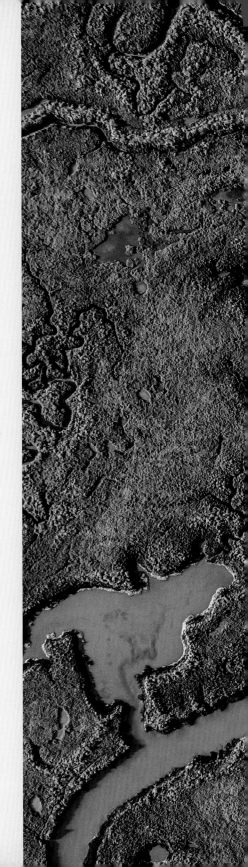

MASTERS OF ABSTRACT
JP & MIKE ANDREWS

Brothers and best friends, JP and Mike Andrews, have a passion for travel and adventure, and specialize in capturing bizarre aerial images. Their aim is to show the world from a perspective not many have the opportunity to witness.

It all began in October 2016 with a discussion in a bar about investing in a drone. Two weeks later, and with no planning whatsoever, JP and Mike bought a one-way ticket to Australia and—armed with their new drone—flew off into the unknown to film and photograph remote Australia. Not long into their trip they realized that they had a number of extremely unusual images that they wanted to share with the world and, as a result, Abstract Aerial Art was born.

As JP and Mike developed their ideas, they began to compose their images as if they were artworks rather than traditional photographs. Since returning from the trip that changed their lives, the brothers continue to search for remarkable aerial images and travel far and wide to shoot them. As they say about their images, "The point is not to work out what it is but to appreciate how weird and wonderful the world can look from above."

HIEROGLYPHICS

Marshlands are one of our favorite things to photograph. More often than not, they are a "go to" subject for us, enabling us to capture an unusual abstract aerial image. From ground level it is almost impossible to appreciate the amazing patterns and textures that these wonders of nature produce. When seen from above, the sight is quite astonishing. Taken as the sun had begun to set, the incredible channels left by the outgoing tide reminded us of a type of ancient scripture or artwork, hence the title.

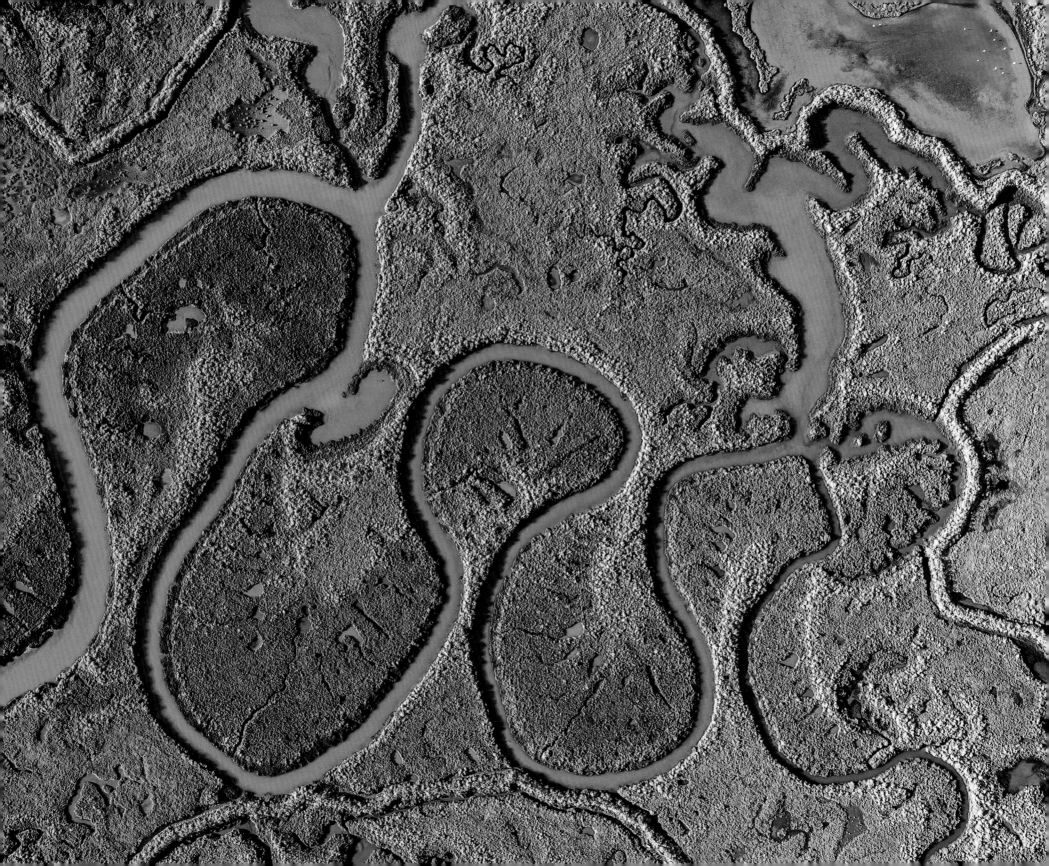

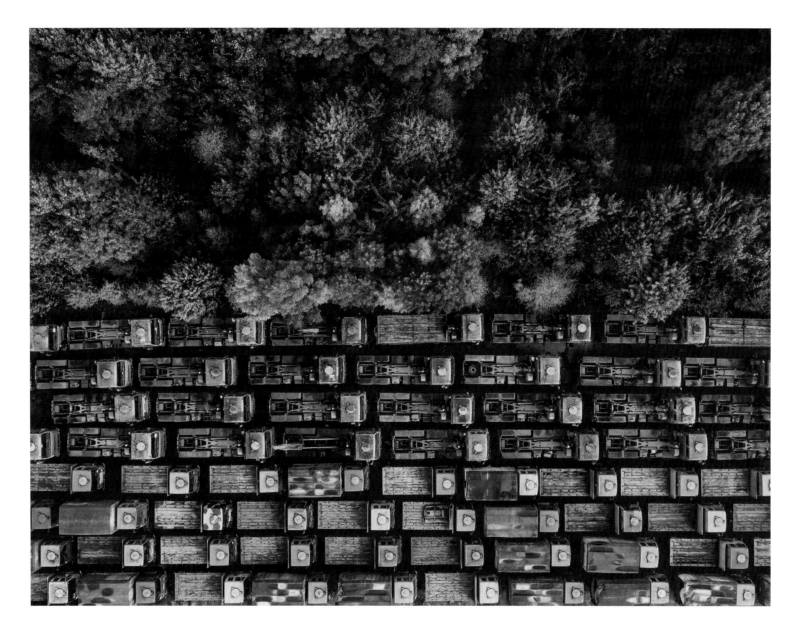

MAN VS WILD

We had been searching for a while for an aerial image that attempted to show the changing world we all live in. This particular shot contains a very powerful message of how modern society and nature are in constant conflict, yet with a little thought and planning they can live side-by-side in perfect harmony. The image shows the edge of a forest as fall takes hold, next to a collection of old military trucks.

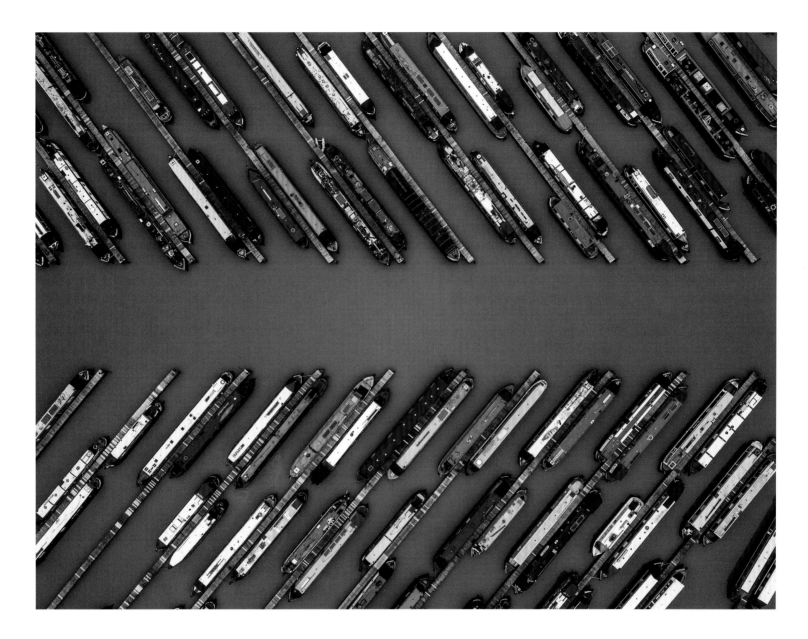

SHUFFLE

We love to find and photograph interesting and unusual shapes that have been created by familiar objects. The canals of the United Kingdom are a major part of the network of inland waterways and the majority of these canals can accommodate boats with a length of up to 80ft (24m), which are now used primarily for leisure. This image shows one of the many marinas that are full of colorful canal boats; wondering how tricky it must be to navigate these boats in such tight spaces gave us the inspiration for the title.

Q + A

How do you set about finding a suitable image in the landscape?

We thrive on traveling to other countries with absolutely no plan whatsoever! However, all of our shots are thoroughly researched, planned, and practically composed before we set off to the location to photograph them. Very occasionally we come across something unexpectedly, but that rarely happens. Using satellite images as a research tool, we often know the exact coordinates of our intended shot before we leave home. Using map and weather apps we then plan a route and work out the most suitable time and conditions to shoot the image. Finally, we head off to the location with all of our equipment in tow. As most of the locations for our images are very difficult to get to, the journey is often an adventure in itself!

What do you think makes a great composition?

Composition is something we spend the most amount of time trying to get right with our images. We have always approached our top-down aerial shots as if they are artworks more than photographs. Although we don't consider ourselves artists, we do feel that this approach works really well for the type of images we try to shoot. Sometimes this involves sacrificing the full perspective of an object in favor of a more composed artwork. Texture, color, or interesting and unusual shapes are what we always look for in the images we want to shoot. It doesn't always have to be complicated. Quite often the simplest photographs look the most impressive.

Do you visualize a shot before you fly?

We already have a good idea of what we are going to shoot before we arrive, so we know roughly what to expect from the location and the image we intend to capture. We just hope that the shot actually looks how we expect it to, although there have been numerous occasions where our satellite research has let us down.

What are your key pre-flight steps for a drone shoot?

The next most important research stage—before we even head to a location—is selecting the best time to shoot, based on the light and weather conditions. It is not always possible to pick a particular moment when the conditions are perfect, especially when traveling with time constraints, but it is essential for a good image to aim for the best conditions available. Believe it or not, the sun causes quite an issue for us. Shooting over water is a great example of this. On a sunny or even a hazy day, pointing the camera directly down toward the ground creates reflective glare on the water, and that really doesn't help an image. We solve this by shooting on a day with thick cloud cover for at least the first 90 minutes after the sun has risen, which gives enough light to create a decent image without any glare. Of course, some may like that effect, but we prefer our top-down drone shots without it.

THE DEVIL'S PLAYGROUND

This is one of the first drone photographs we ever took, and was partly responsible for how Abstract Aerial Art began. The shot was taken in the stunning Kimberley region of northwestern Australia. Standing on top of what is known as Five Rivers Lookout, Wyndham, we spotted this extremely unusual sight and thought it may look bizarre photographed from above—it sure did! We think the photograph shows a mixture of water and iron ore contained in a storage pond.

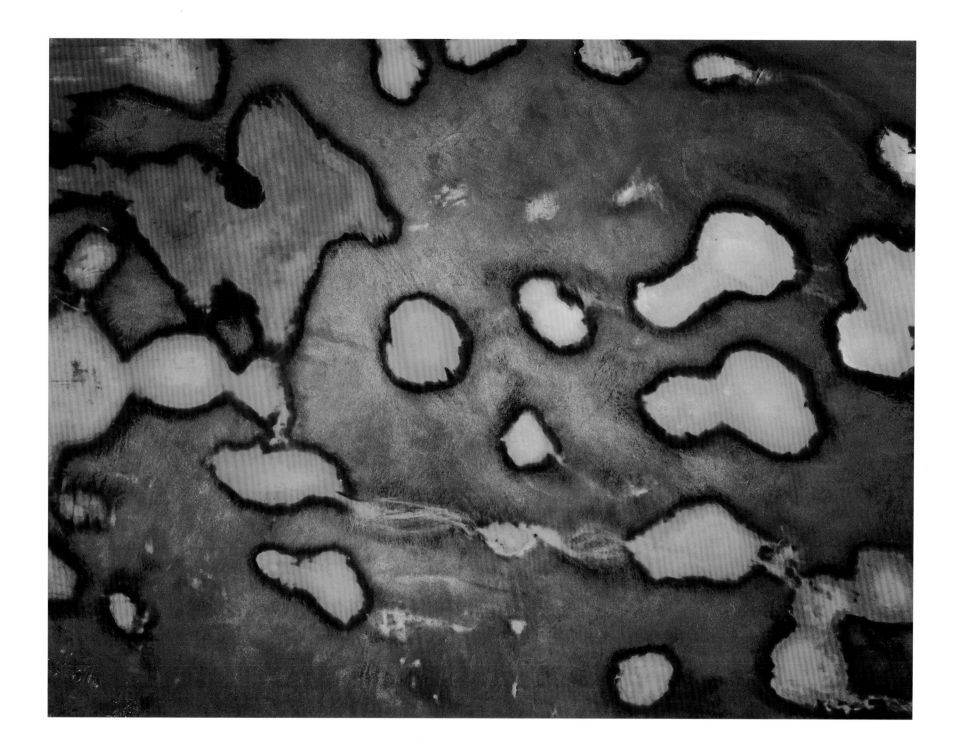

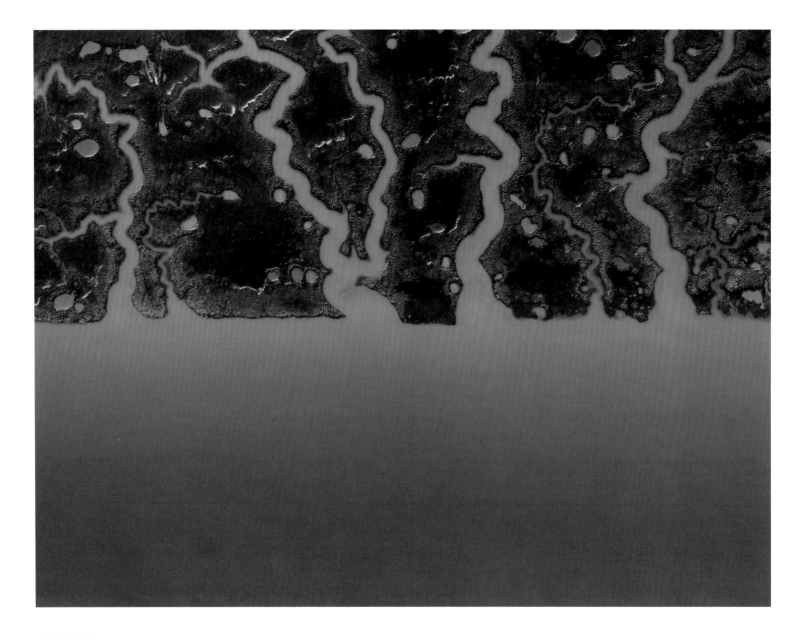

SEGMENT

We took this photograph of channels of water riding through the marshlands on the banks of the Rio San Pedro, near the Spanish town of Cadiz. We think they look like strikes of cartoon lightning. The sharp division in this image is what stands out for us here, and again this is something that the aerial perspective really accentuates.

EARTH'S CANVAS

We have always thought this image sums up our name better than any other. It shows the incredible abstract patterns created by the "dryland farming" in the Aragon region of northern Spain. Finding a section that showed off the variety of shapes and colors took a lot of research and numerous drone flights. However, the final image convinced us that it must have been where Pablo Picasso got his inspiration—maybe he secretly owned a drone! We're certain this won't be the last time we find ourselves in this region of Spain looking for more abstract photographs.

Q + A

What specific techniques do you use most often to create your images, including post-processing?

The most specific technique we use to create our images is the research we do beforehand—we cannot stress enough how important this. You save a lot of time and wasted energy flying your drone aimlessly around looking for photographs if you know what you're going to shoot before you arrive at a location. Once on-site, we like to keep things as simple as possible and let the location do the talking! If all goes to plan, the hard work has been done during our research phase. When it comes to post-processing, again we like to keep things just as simple. We very rarely do anything more than make minor color and contrast adjustments to enhance the image. It all comes down to finding the right location to begin with. Once you've done that, the rest takes care of itself.

You specialize in creating abstract images—what draws you to this style of photography in particular?

We find it fascinating how an aerial view completely changes the way we see something from ground level. All of our Abstract Aerial Art shots are taken with the camera pointing directly down toward Earth. This top-down perspective can make even the most mundane things look very unusual and that has always intrigued us the most since we bought our drone. There's something about bizarre-looking photographs that has always appealed to us, long before we ever thought about flying a drone. We are constantly amazed at the beautiful, often unreal-looking colors, textures, and patterns found on this planet, and we are certain that we've barely scratched the surface. As the idea behind what we are doing has developed, we have become more and more inspired to find the most unusual-looking aerial photographs we can. Our aim is to show how incredibly strange, yet beautiful the world can look from above.

What one tip would you give to budding drone photography masters?

The biggest tip we could give any budding drone photographer would come in three parts. Firstly, understand the equipment you are using and the limitations it has. Secondly, thoroughly research locations before setting off, and choose the best time of day and weather conditions for shooting. Finally, and maybe most importantly, think outside the box and never be afraid to try something different.

What motivates you to continue making photographs?

We pride ourselves on trying to show our audience something completely different. The support we have had in what we are doing from our loyal social media followers will always be the biggest motivation for us. As a result, finding images for them that they may never have seen before will always keep us going.

"We are constantly amazed at the beautiful, often unreal-looking colors, textures, and patterns found on this planet, and we are certain that we've barely scratched the surface."

TECHNICAL INFORMATION

HIEROGLYPHICS
HUELVA, SPAIN

Drone: DJI Phantom 4 Pro
Camera: Integrated
Lens: 24mm (35mm format equivalent)
Aperture: f/4
Shutter Speed: 1/240 sec.
ISO: 100

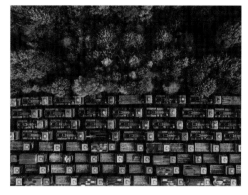

MAN VS WILD
NOTTINGHAM, ENGLAND

Drone: DJI Phantom 4 Pro
Camera: Integrated
Lens: 24mm (35mm format equivalent)
Aperture: f/4.5
Shutter Speed: 1/500 sec.
ISO: 100

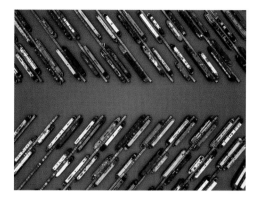

SHUFFLE
WARWICK, ENGLAND

Drone: DJI Phantom 4 Pro
Camera: Integrated
Lens: 24mm (35mm format equivalent)
Aperture: f/4
Shutter Speed: 1/320 sec.
ISO: 100

THE DEVIL'S PLAYGROUND
WYNDHAM, WESTERN AUSTRALIA

Drone: DJI Inspire 1 Pro
Camera: Zenmuse X5
Lens: DJI 30mm (35mm format equivalent) f/1.7
Aperture: f/4
Shutter speed: 1/800 sec.
ISO: 100

SEGMENT
CADIZ, SPAIN

Drone: DJI Phantom 4 Pro
Camera: Integrated
Lens: 24mm (35mm format equivalent)
Aperture: f/4
Shutter Speed: 1/500 sec.
ISO: 200

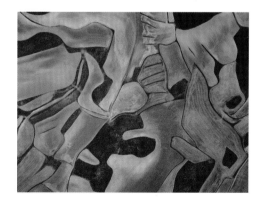

EARTH'S CANVAS
ARAGON REGION, SPAIN

Drone: DJI Phantom 4 Pro
Camera: Integrated
Lens: 24mm (35mm format equivalent)
Aperture: f/5.6
Shutter Speed: 1/1250 sec.
ISO: 100

MASTER OF MOOD
FRANCESCO CATTUTO

Francesco Cattuto was born and raised in a small town called Gualdo Tadino in Umbria, Italy. After obtaining a university degree in Bologna in software engineering, Francesco worked for consulting companies for 10 years. In 2016 he decided to make a change. Resigning from his permanent position, he began working as a freelance project manager with the aim of spending more time doing what he loves the most: photography.

Francesco has always admired the great photographers who work for *National Geographic* and the Magnum agency—especially Steve McCurry—and the work they do finding images and stories in the most remote corners of the planet. He started traveling when he was a child, and he still collects passport stamps to mark the enriching experiences he finds in different countries. He always takes his camera with him, so that he can record his own "little big stories." As a lover of new technologies, Francesco was drawn to drone photography, and it has opened up a new perspective for capturing the world he discovers.

VERTIGO

Ponte delle Torri is a striking 13th-century Roman aqueduct in Spoleto, an ancient city on a foothill of the Apennines, in the Italian province of Perugia in east central Umbria. Since I was a child, I have admired the majesty of this bridge from the terrace of my grandparents' house. Standing more than 260ft (80m) high and 650ft (200m) long, it seems impossible that such a huge construction was built so long ago. I had been asked to shoot a video for a documentary about the city of Spoleto, focusing on details of the buttresses that are practically impossible to reach without a drone. After filming, I took advantage of the situation and shot some photos from unusual perspectives to exaggerate the sense of vertigo that occurs when walking over the bridge. The post-processing was rather difficult, as I had to correct the dominant greens and the highlights while maintaining a visual balance that emphasizes the bridge without separating it from the underlying forest.

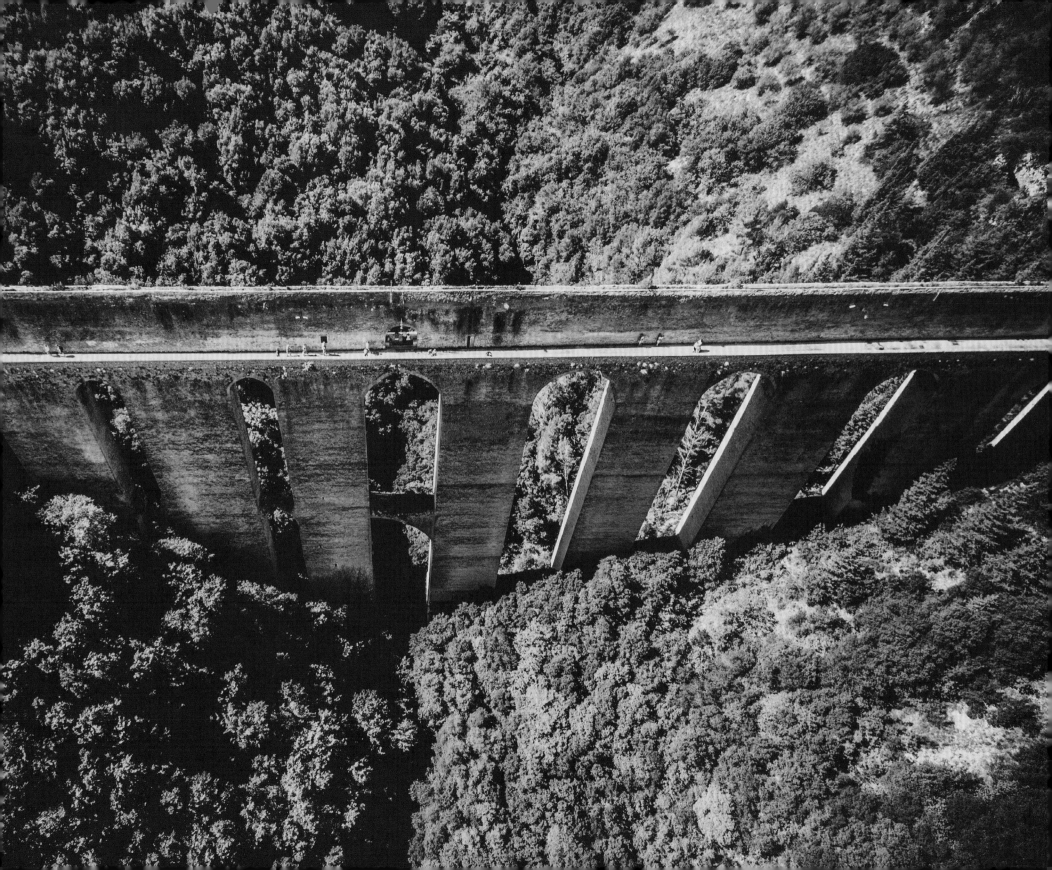

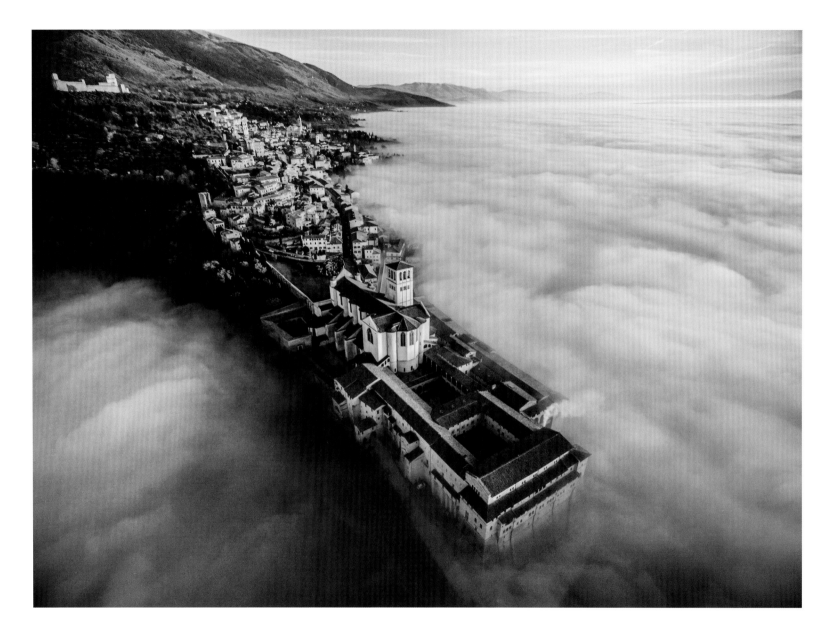

OVER THE CLOUDS I

Assisi is one of the cities that I love most in Umbria and this picture of it—which I took on Christmas Day—went on to win Dronestagram's 2016 International Drone Photography Contest. When I arrived at the base of the city, the fog was thick and wet, but I decided to take a test flight anyway. As the drone rose above the clouds, I could see on my iPad that the scene was absolutely amazing; the clouds surrounded the city perfectly, making it appear celestial and suspended. At sunset, the play of light and shadow was incredible. I did very little post-processing, as it was impossible to add anything to this image.

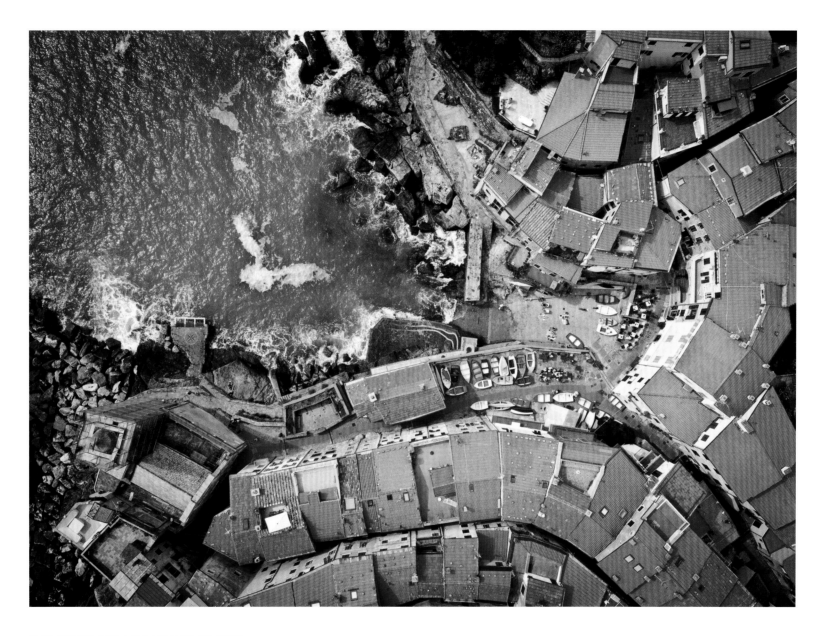

THE AZURE PATH OF HEAVEN'S STEP

Tellaro is a tiny seaside village in the Gulf of the Poets, with colorful houses and steep alleys. Perched on a cliff overlooking the sea, it is often listed as one of the most beautiful villages in Italy and I am always struck by its silence and its union with nature. It was originally built on the rocks to create a natural defense against invaders arriving from the sea and I wanted to underline this strong connection between the sea and the village, where cars are replaced by boats and the streets follow the lines of the cliffs. The excellent stability of my DJI Phantom 4 Pro drone made it relatively easy to take sharp photographs, despite the seaside wind and an exposure that was long enough to soften the crashing waves.

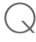

Q +

A

What weather and light conditions best help to create mood in your images?

The most important element, as always in photography, is light—light is everything. Without it, there would be no color, no shadows. The best times to get good results are at sunrise and sunset, when the sun's rays guarantee warm colors and long shadows that enhance the three-dimensionality of subjects. Also, the incidence of the sun's rays does not create annoying reflections as it does in the middle of the day. Weather conditions can add an extra touch of atmosphere, with large cloud clusters, fog, or snow adding magic to a scene.

How do you achieve sharpness in your photographs in these lighting conditions?

The more difficult the conditions become, the more you need to rely on a good drone to get sharp and detailed images. Drone cameras can be quite limited in terms of their performance, because of the small size of the sensor, their electronic (rather than mechanical) shutter, and the lack of a variable aperture. The drop-off in sharpness is especially noticeable when shooting out toward a horizon, as the f/2 or f/2.2 aperture is extremely wide, although sharpness can improve substantially when shooting close subjects or particularly flat scenes. Stability can play a major role in the final quality of the image. In the air, even the tiniest bit of wind can affect the overall sharpness of an image, especially if you are shooting at slower shutter speeds. I usually use Tripod mode, which improves drone stability by applying more torque and power in certain directions. And I always shoot in Raw mode—it's the only way to have full control in post-processing.

What camera settings do you prefer for such shots?

I always prefer to use Manual mode. I often shoot the first photo automatically to quickly get a reference of the best parameters chosen by the camera and then "play" with the settings to get exactly what I want, modifying shutter speed, ISO, and color temperature. I also use "bracketing" to capture three to five images of the same subject, overexposing and underexposing in steps of one or two stops. This way, I ensure I always capture the right exposure. I can easily combine them in post-processing to generate a beautiful high-dynamic range image later on. One of the most important parameters is ISO—I always try to use the lowest ISO possible.

What technical challenges did you face when you photographed the divers at night?

Firstly, I needed to make sure that there weren't any local regulations preventing me from flying at night! Obviously, the lack of available light forces a compromise between long exposure times and a level of ISO that does not create excessive noise in the image. Under certain conditions you know that you will have to sacrifice a small amount of image quality, but this doesn't mean that the final result is compromised—I think the subject is far more important, so a little noise is perfectly acceptable if you are shooting something that is worth recording! You also need to remember to momentarily turn off the lights of the drone before shooting to avoid annoying green or red halos appearing in the image.

A PLUNGE INTO DARKNESS

In September 2016, 133 divers met on the beach of Seccheto, on the Island of Elba, to enter the Guinness Book of World Records as the largest number of divers in a night dive. To achieve this, the divers all descended to 30ft (10m) in Seccheto Bay at the same time. I'm a member of RAID Italia—the organization behind the event—and I was asked to capture this record-breaking moment with my drone. It was really difficult because of the rain, wind, and darkness, but some of the shots are truly memorable! In post-processing I focused on trying to eliminate as much of the high ISO noise as possible, and set the highlights and shadows to capture the cones of light coming from the divers' torches and the ripples of the seabed sand.

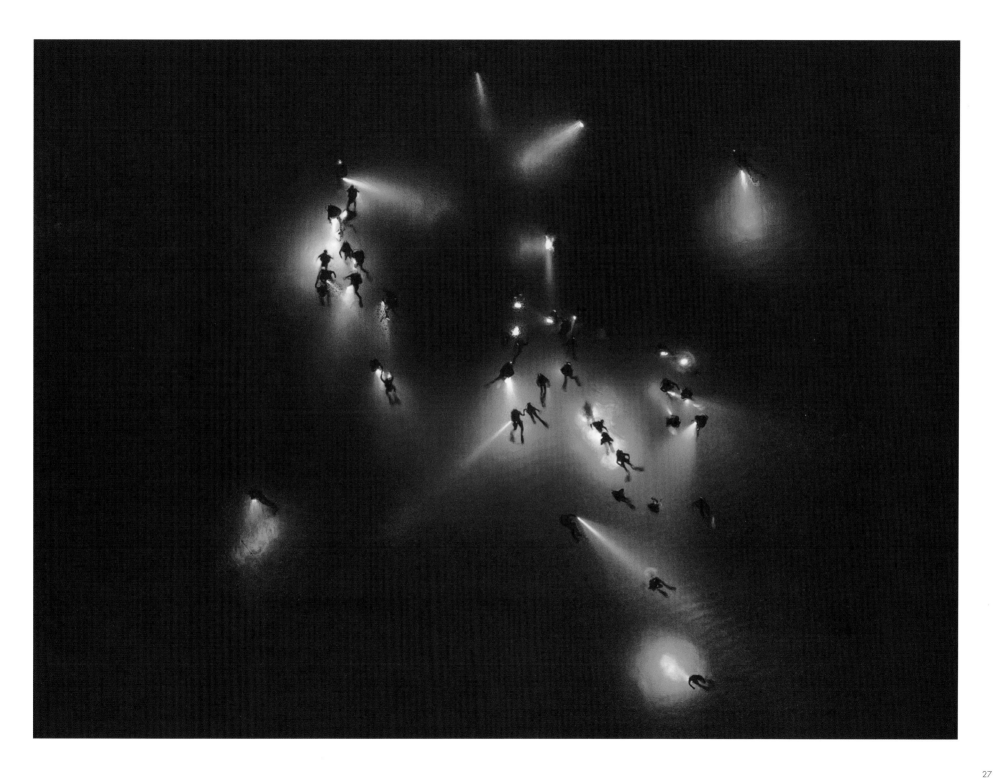

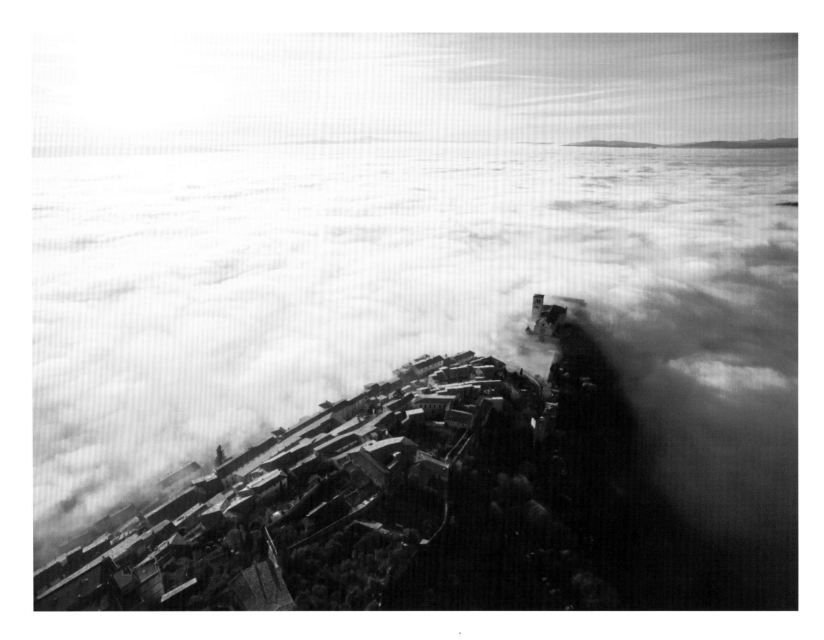

OVER THE CLOUDS II

This is another photograph taken on Christmas Day at Assisi (see page 24). Many people who have seen it say that the majestic Basilica of St. Francis of Assisi looks like the bow of a huge ship sailing an infinite sea made of clouds. This is precisely the effect that I tried to recreate in post-processing by reducing the contrast and lowering the clarity of the clouds beyond the city, and leaving the highlights and shadows to pick out the three-dimensional forms of the roofs.

THE DYING TOWN

Civita was founded by Etruscans more than 2,500 years ago, but at the end of the 17th century all of the remaining inhabitants were forced to move to Bagnoregio after a major earthquake. In the 19th century, Civita turned into an island, and the pace of erosion quickened as it reached the layer of clay below the stone where today's bridge is situated. Bagnoregio continues as a small but prosperous town, while Civita became known in Italian as *il paese che muore* ("the town that is dying"). I arrived at dawn on a summer morning and the conditions were ideal for flying and photography—as the first rays of sun crept over the horizon, they lit up beautifully the mist surrounding the hills. The idea behind the image was to underline the decline of the village, so in post-processing I used cool color tones to emphasize the ancient atmosphere.

Q
+
A

What do you think are the most important techniques to learn when flying a drone for photography?

Flying to shoot still images is easier than flying to shoot video. For photography it is simply about flying to your chosen point of view, perhaps moving slowly in every direction to compose your image, and, when you are satisfied, hover for the time necessary to shoot and then return to home. But this apparent simplicity is offset by the difficulty of choosing the trigger point, as adding vertical freedom greatly complicates things for a photographer. Our brain is not so used to seeing things from above and so it is harder to visualize an image—just moving a few inches up or down can result in a completely different picture. I recommend trying to imagine the view from above before take-off. Remember, though, it is better to learn how to fly well and safely before focusing on photography.

Do you set out to create images for creative or commercial reasons?

Photography has always been a way that I can communicate my feelings and emotions, and show my point of view, so my photographs are never created for commercial purposes—they are always an expression of my being. I am a rather introverted person and very often I keep my creations for myself or for a few close friends, but over the years I've learned to open myself up to the world. We are in the era of social media, and I believe in the positive value of sharing—not so much in the search for easy likes, but in sharing places you've discovered. I am lucky enough to live in Italy, which has many wonderful landscapes, from beautiful seasides to snow-capped mountains, often within a few kilometers, as well as Tuscan hills or the medieval villages of Umbria, to name just a few. Unfortunately, Italian laws for drone-flying are very restrictive, so it is virtually impossible to obtain the necessary permits to fly over cities.

What single piece of kit or software is most useful in your work?

My workflow would not be complete without image development. I do not belong to the school of thought that a photograph must be exactly what the sensor has captured. I firmly believe that post-processing is necessary to fully realize the "sense" of an image. My favorite program is Adobe Lightroom, which allows me to develop any camera Raw file by adjusting tones, highlights, lights, and shadows, for instance, and create a single HDR image or large panorama by merging multiple files. I try to capture an emotion when I edit an image. I start by choosing the subject, then I crop and align the horizon, and then I enhance the contrast, playing with clarity, highlights, and shadows. Finally, I look at the colors and I may choose to saturate warm shades to instil calm and serenity, or choose cooler shades for those images needing action and motion, for example.

What motivates you to continue making photographs?

I can best answer that question with the words of Helmut Newton—a great photographer who I particularly love: "The desire to discover, the desire to move, to capture the flavor, three concepts that describe the art of photography." I am an extremely curious person, and am always looking to research and discover; I never feel satisfied that I know the world around me. We live in a time when we are constantly flooded with images, and often spend only a few moments on a photo before moving on to the next, not thinking about how much work, how much study, or how much time the photographer spent waiting for that precise moment, and how much sacrifice they put into realizing it. So when someone stops for more than a second to look at one of my images, and they feel something, then I think I have achieved something in my own way. Finally, the absolute freedom and happiness that I feel every time I have a camera around my neck or I follow the flight of my drone—when something makes you feel so good, how could you stop?

TECHNICAL INFORMATION

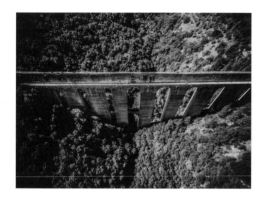

VERTIGO
SPOLETO (PG), UMBRIA, ITALY

Drone: DJI Phantom 3 Pro
Camera: Integrated
Lens: 20mm (35mm format equivalent)
Aperture: f/2.8
Shutter speed: 1/260 sec.
ISO: 100

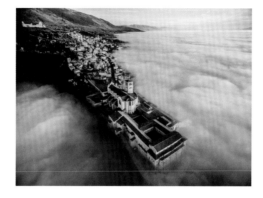

OVER THE CLOUDS I
ASSISI (PG), UMBRIA, ITALY

Drone: DJI Phantom 3 Pro
Camera: Integrated
Lens: 20mm (35mm format equivalent)
Aperture: f/2.8
Shutter speed: 1/250 sec.
ISO: 100

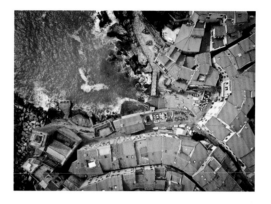

THE AZURE PATH OF HEAVEN'S STEP
TELLARO (SP), LIGURIA, ITALY

Drone: DJI Phantom 4 Pro
Camera: Integrated
Lens: 20mm (35mm format equivalent)
Aperture: f/5.6
Shutter speed: 1/400 sec.
ISO: 100

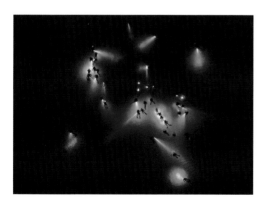

A PLUNGE INTO DARKNESS
SECCHETO BAY, ELBA (LI), TOSCANA, ITALY

Drone: DJI Phantom 3 Pro
Camera: Integrated
Lens: 20mm (35mm format equivalent)
Aperture: f/2.8
Shutter speed: 0.5 sec.
ISO: 1600

OVER THE CLOUDS II
ASSISI (PG), UMBRIA, ITALY

Drone: DJI Phantom 3 Pro
Camera: Integrated
Lens: 20mm (35mm format equivalent)
Aperture: f/2.8
Shutter speed: 1/1800 sec.
ISO: 100

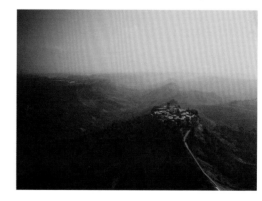

THE DYING TOWN
CIVITA DI BAGNOREGIO (VT), LAZIO, ITALY

Drone: DJI Phantom 3 Pro
Camera: Integrated
Lens: 20mm (35mm format equivalent)
Aperture: f/2.8
Shutter speed: 1/2700 sec.
ISO: 100

AMOS CHAPPLE

Amos Chapple is a travel and news photographer from New Zealand. After spending two years at New Zealand's largest daily newspaper chasing news, in 2003 Amos took a full-time position shooting UNESCO World Heritage sites. In 2012 he went freelance, but kept traveling, and since then his work has been published in most major news titles around the world, and his stories have regularly appeared on the front page of Reddit and other viral online news platforms.

In 2015, the photographs he shot with a modified drone were compiled into a photo gallery on UK Business Insider's website, which received more than six million page views. After near-constant travel through more than 70 countries, Amos says he has experienced almost nothing but decency and goodwill. Although he has the greatest respect for photojournalists working in conflict zones, Amos believes there are many honest stories that need to be told in the news media about all the things we haven't lost or destroyed.

CHURCH IN THE MOUNTAINS

The morning when I shot this had been wild, with storm clouds sweeping over the sun and mist drifting over the land. I had actually committed to shooting another village, and the light was so fickle that I had used up almost all my drone's batteries. When I drove out from the mountains I spotted this church above the highway; I'd seen it before, but it was only with this dramatic weather swirling around it that it really worked. It was painfully difficult to shoot because the sun would hit it then disappear again, and I only had a few minutes of battery life left. I had to decide when was the best time to fly. By the time the sun hit the church, the controller was beeping like crazy and I had to make a very hasty landing.

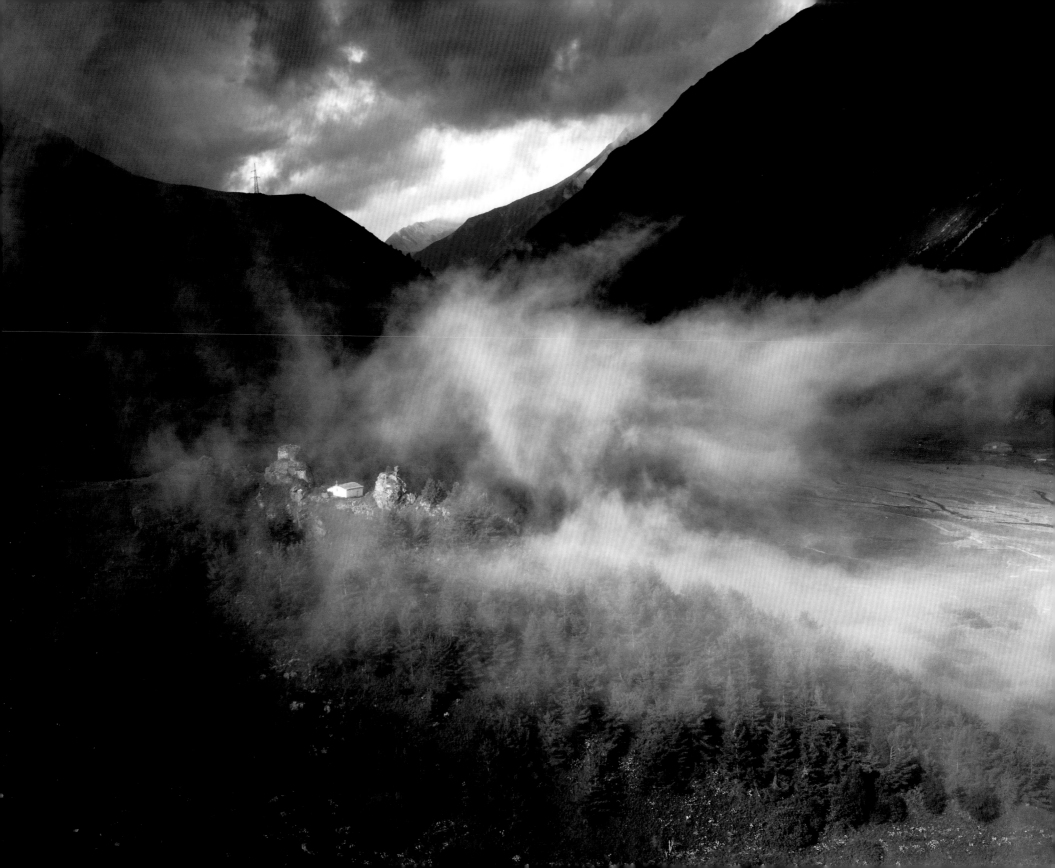

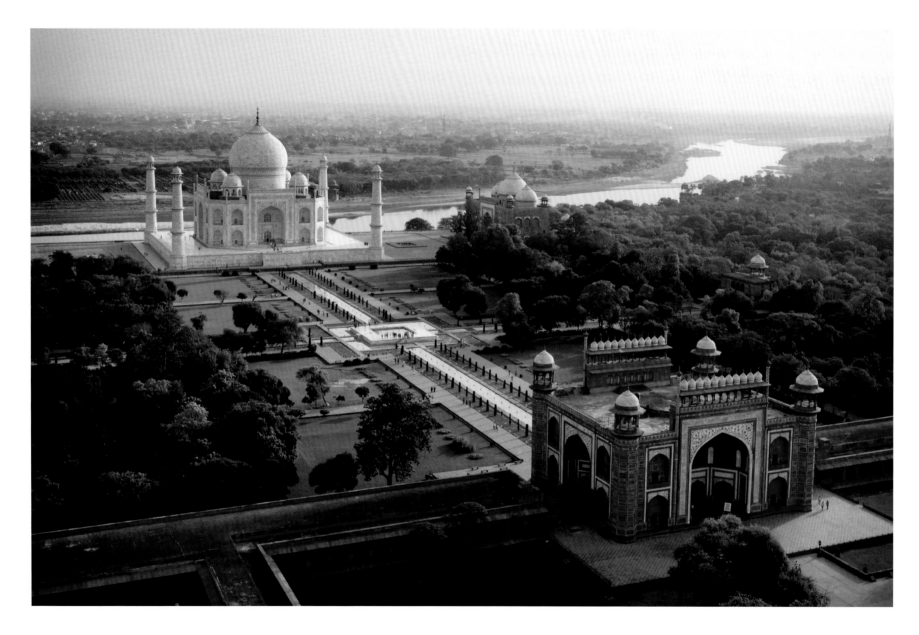

TAJ MAHAL

I shot this image from the roof of an abandoned building, in a weird kind of no-man's land next to the Taj. I was able to see just the tip of the building from where I was standing, but that gave me enough of a sense of location so that I was able to frame the photo nicely. The most stressful part of the shoot was when I was flying the drone back down—a large monkey saw the drone and was freaking out, acting aggressively as it got closer. I had to land the drone a little bit away from me and beat a hasty retreat as a bunch of monkeys started to gather!

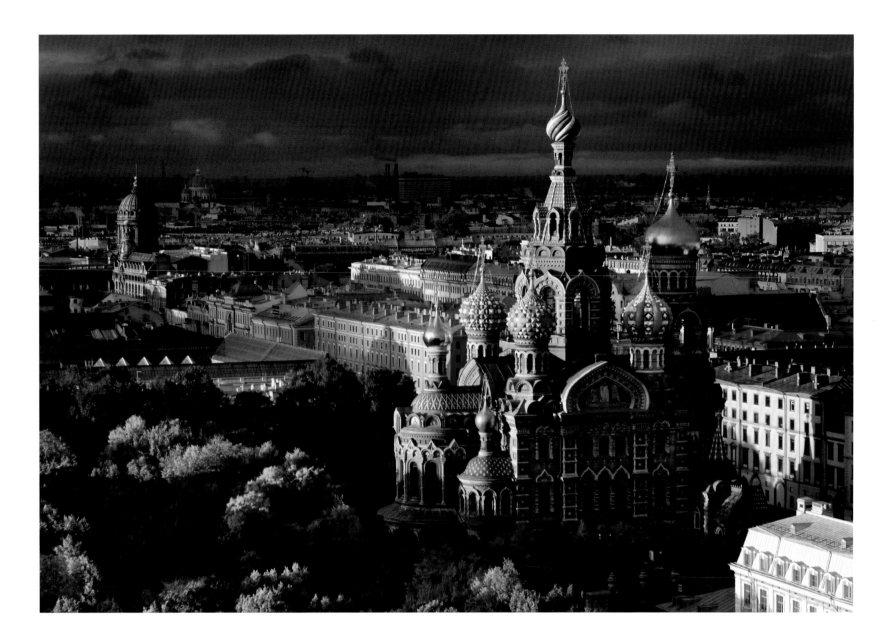

THE CHURCH ON SPILLED BLOOD

This was taken in the very early days of my drone photography, when I was just attaching a small camera to the bottom of a drone and couldn't see what I was shooting. The wind was screaming across St. Petersburg that day, and every now and again a spotlight of sunshine would sweep across the city. The drone was struggling in the wind and I was sitting there stressing out about it, but suddenly the clouds opened up and the sunlight hit the church. It was there for literally two seconds and, at that moment, the 45mm (90mm in 35mm format equivalent) lens was pointed at exactly the right place. I'm still amazed at just how lucky I was to get this shot.

Q + A

You travel to many different places for your photographs—how do you choose a location?

I bought my first drone in 2014, before there were regulations in most places. I realized that drones would start being shut down soon, so choosing places was fairly easy—I just headed to the most iconic places I could get to and moved as quickly as possible before the laws started to kick in. Most of my work in those early days was in Europe, Russia, and India. It was an amazing time. The first DJI Phantom drone didn't have a camera, so I attached a little Panasonic Micro Four Thirds camera underneath using rubber bands, and set it to take a photo every second. I couldn't see what the camera was shooting so it was very hit and miss, but when it worked I had image quality that none of the dedicated drone cameras could get close to.

Have you run into difficulties with local regulations for drone photography?

In those early days there were no rules. I did try to avoid police and people where possible, but it was hardly necessary. I remember once, in 2014, shooting in the middle of Saint Petersburg in Russia, and some police started walking toward me—I was thinking: "OK, I need to just shoot for as long as I can before they tell me to get out of here…" Then they just strolled up watched the drone flying, and were like "Cool, so how much did that cost?" I told them, and they just nodded and walked off!

What light conditions do you look for when creating your images?

Morning is the best time for me, as the low sunlight picks up the textures of the landscape. You might also get lucky with mist, and there are fewer people around on the streets, so it's much safer flying a drone.

How do you predict good light and flying conditions?

Drone photography is like any other photography, you just have to get out there and work hard. If you wake up and look out the window at the fickle weather and think "Hmm, I probably won't get a good photo in this weather," you're probably right, it's unlikely you'll get a good photo. But, if you don't go out at all then you *definitely* won't get a good photo. I try to remember that every time I'm looking out of my hotel window at 5am (or earlier!) and feeling lazy...

HARVESTING WATER CHESTNUTS

This wife, husband, and uncle hand-paddle out to the lily pads, fingering the tendrils beneath for the little nodules that I was told would earn them enough to put "two meals on the table and a little bit." Roasted, these water chestnuts will end up as sooty piles in the market, where blackened fingers will break through to the white flesh within. "We're a fisherman caste," the husband explained. "There's no 'like' or 'dislike' to working in the water. Does a fish like to swim? We do what our people have always done. If someone told us to do this job we would never agree. The work is never-ending and the business is tiny, but it's ours and that's a joy. Better to be your own slave than someone else's."

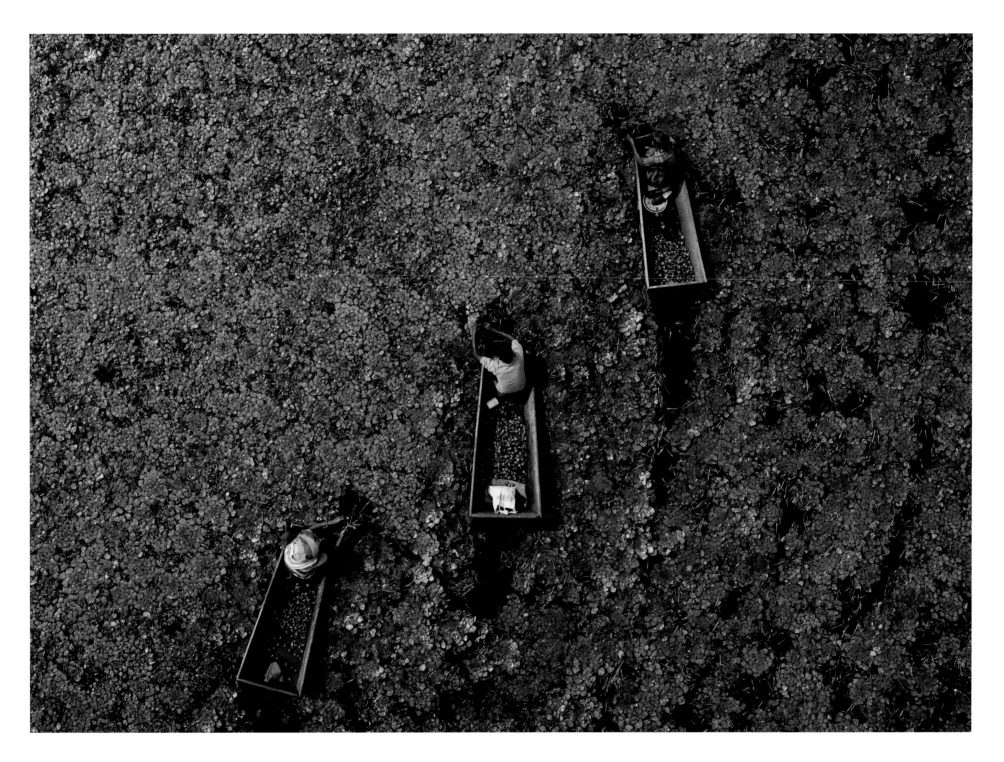

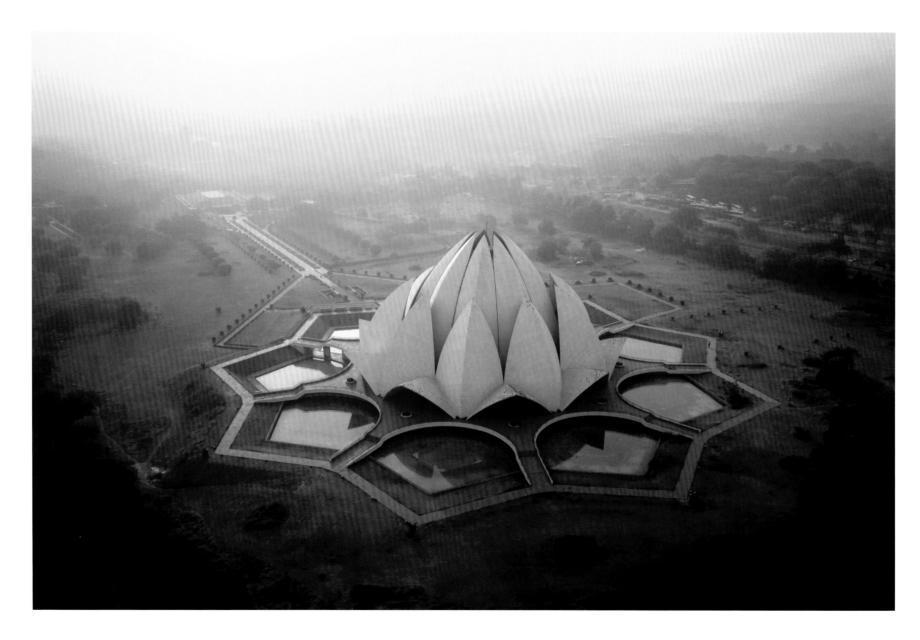

LOTUS TEMPLE

Working in India was tough because anywhere you flew would draw a (friendly) crowd. As a result, almost all my work there was done early in the morning. The Lotus Temple in Delhi is, to my mind, the most beautiful piece of modern architecture on earth, but looking at it from the ground gives you only a part of the overall design. This photo, showing the landscaping as well as the structure itself, was the moment when I realized that drones would change the photography world.

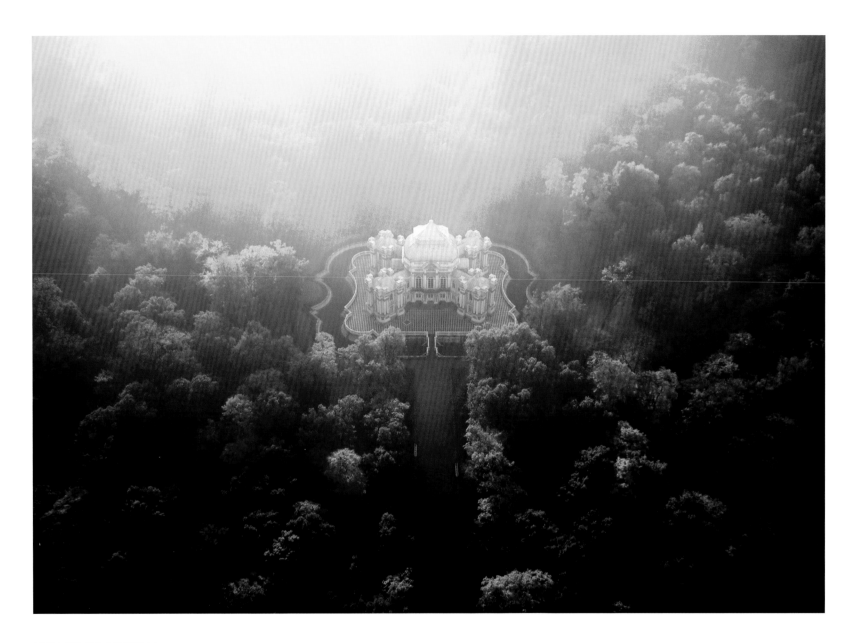

HERMITAGE PAVILION

I had attempted this picture six times, but had always been foiled by clouds. The Hermitage Pavilion is a long way from the center of St. Petersburg, so it was getting increasingly hard to commit to a 90-minute commute in the hope that I'd get a clear autumn sunrise. That morning, I remember sitting in an old bus surrounded by migrant workers, all sleeping off their night shifts, while I was chewing my nails and watching this perfect purple dawn getting brighter, hoping I wouldn't be too late. I jumped off the bus and ran the final kilometer. It was a lesson I've always tried to remember on those mornings when the weather isn't looking great: if you go, you probably won't get the photo, but if you don't go, you *definitely* won't get the photo.

Q + A

Are there any particular technical challenges when it comes to flying early in the morning?

Flying in Russia in the morning means that it's usually cold. In those early days, the batteries would only last a few minutes, so I used to head off with batteries stuffed into my underpants to keep them warm! With all those cables sticking out from my waist, I probably looked like a suicide bomber!

What techniques do you use to achieve the "dreamy" look in some of your images?

I've been photographing all my life, and I feel like there are two areas where you never really stop learning: the psychology of dealing with people, and how light works. Every year I learn a little bit more. So putting that experience of reading light into practice was fairly easy with drone photography. One shot I got of Saint Petersburg was taken on a gusty fall day, with the clouds racing by above me, but just occasionally a shaft of light would reach out and touch the city. I set the camera exposure to the sunlight and then sent the drone up with a small telephoto lens (90mm in 35mm format equivalent). Among the dozens of photographs I took there were two that were perfectly framed, with the sunlight hitting the buildings. If the camera had been set to automatic I am certain those pictures would not have worked—the camera would have just been too slow to adjust for the momentary bright light.

What are the key techniques you use in post-processing your images?

Up until this year, I only used levels and curves, and I would make selective adjustments and sometimes increase the saturation. I come from a newspaper background where if you do anything you wouldn't have been able to do in a darkroom then you lose your job instantly, and probably your career as well. I think that was a key part of the success of my early drone images. They look good, but people also feel that they're real. Now I am pushing things a little further with layers and things like selective color adjustments, and brightness and contrast sliders, but I'm trying to keep it subtle. I think there's way too much editing done to most drone photographs—for me it just kills the wonder in an image.

What motivates you to continue making photographs?

I want to feel like a worthwhile human being, and this is the thing I'm best at, so I want to keep on striving. Photography is wonderful for the way it's constantly pushing you. As you get better, your standards get higher, and so you feel like you're constantly reaching for something that's just out of your grasp.

"There are two areas where you never really stop learning: the psychology of dealing with people, and how light works."

TECHNICAL INFORMATION

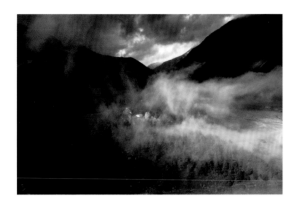

CHURCH IN THE MOUNTAINS
UKHATI, GEORGIA

Drone: DJI Inspire 2
Camera: FC6250
Lens: 30mm (35mm format equivalent) f/1.7
Aperture: f/4
Shutter speed: 1/800 sec.
ISO: 100

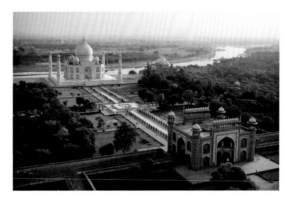

TAJ MAHAL
AGRA, UTTAR PRADESH, INDIA

Drone: Modified DJI Phantom 2
Camera: Panasonic Lumix DMC-GM1
Lens: 40mm (35mm format equivalent) f/1.7
Aperture: f/5.6
Shutter speed: 1/500 sec.
ISO: 200

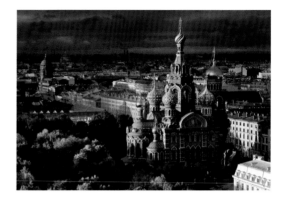

THE CHURCH ON SPILLED BLOOD
ST. PETERSBURG, RUSSIA

Drone: Modified DJI Phantom
Camera: Panasonic Lumix DMC-GF5
Lens: 90mm (35mm format equivalent) f/1.8
Aperture: f/2.8
Shutter speed: 1/4000 sec.
ISO: 400

HARVESTING WATER CHESTNUTS
JHALAWAR, RAJASTHAN, INDIA

Drone: Modified DJI Phantom 2
Camera: Panasonic Lumix DMC-GM1
Lens: 40mm (35mm format equivalent) f/1.7
Aperture: f/5
Shutter speed: 1/2500 sec.
ISO: 200

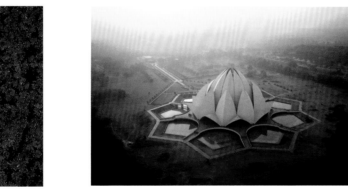

LOTUS TEMPLE
DELHI, INDIA

Drone: Modified DJI Phantom 2
Camera: Panasonic Lumix DMC-GM1
Lens: 28mm (35mm format equivalent) f/2.5
Aperture: f/7.1
Shutter speed: 1/500 sec.
ISO: 200

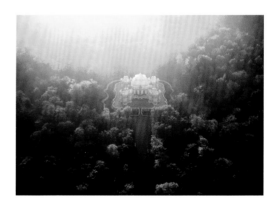

HERMITAGE PAVILION, CATHERINE PALACE,
ST. PETERSBURG, RUSSIA

Drone: Modified DJI Phantom
Camera: Panasonic Lumix DMC-GF5
Lens: 28mm (35mm format equivalent)
Aperture: f/2.8
Shutter speed: 1/1600 sec.
ISO: 250

MASTER OF RHYTHM
TUGO CHENG

Tugo Cheng is a Hong Kong-based fine art photographer who has received multiple international awards and nominations from National Geographic, Sony World Photography Awards, Hasselblad Masters, and International Photographer of the Year. Influenced by his architectural background, he pays special attention to the order and rhythm of compositions and the artistic expression of landscape photography. For more than a decade he has focused his works on the volatile landscapes in China, publishing the book *Discovering China* and the seascape series *Coastal Geometries*.

Exploring the cityscapes of Hong Kong from an aerial perspective, Tugo's *City Patterns* series reveals the hidden geometries of the city, as well as the lives of its people. His work has been showcased in exhibitions and art fairs in Hong Kong, Asia, and Europe, and featured by CNN, *The Guardian, National Geographic,* and the *South China Morning Post.* For his contributions in art and photography, he was named Perspective 40 Under 40 Artist in Asia-Pacific in 2017.

FREEDOM (FROM CITY PATTERNS SERIES)

While many Hongkongers prefer swimming in public pools along the promenade, some people—especially the elderly—find more freedom and pleasure swimming in Victoria Harbor, in the heart of the city, free-of-charge. Unlike other panoramic aerial shots that depict Hong Kong as a high-rise and high-density city, the picture reveals from a low height the lines, geometries, and details of the city, and, more importantly, tells the stories of the people and their different lifestyles. The composition emphasizes this contrast between the solid and empty at the waterfront.

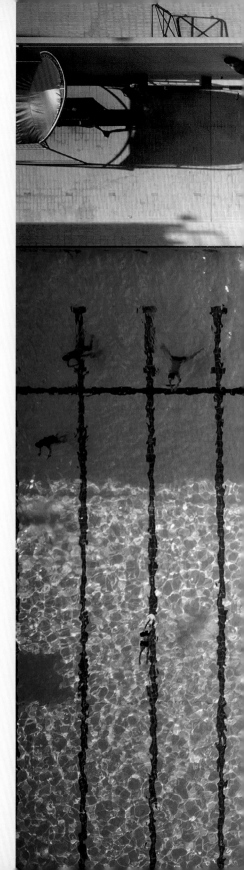

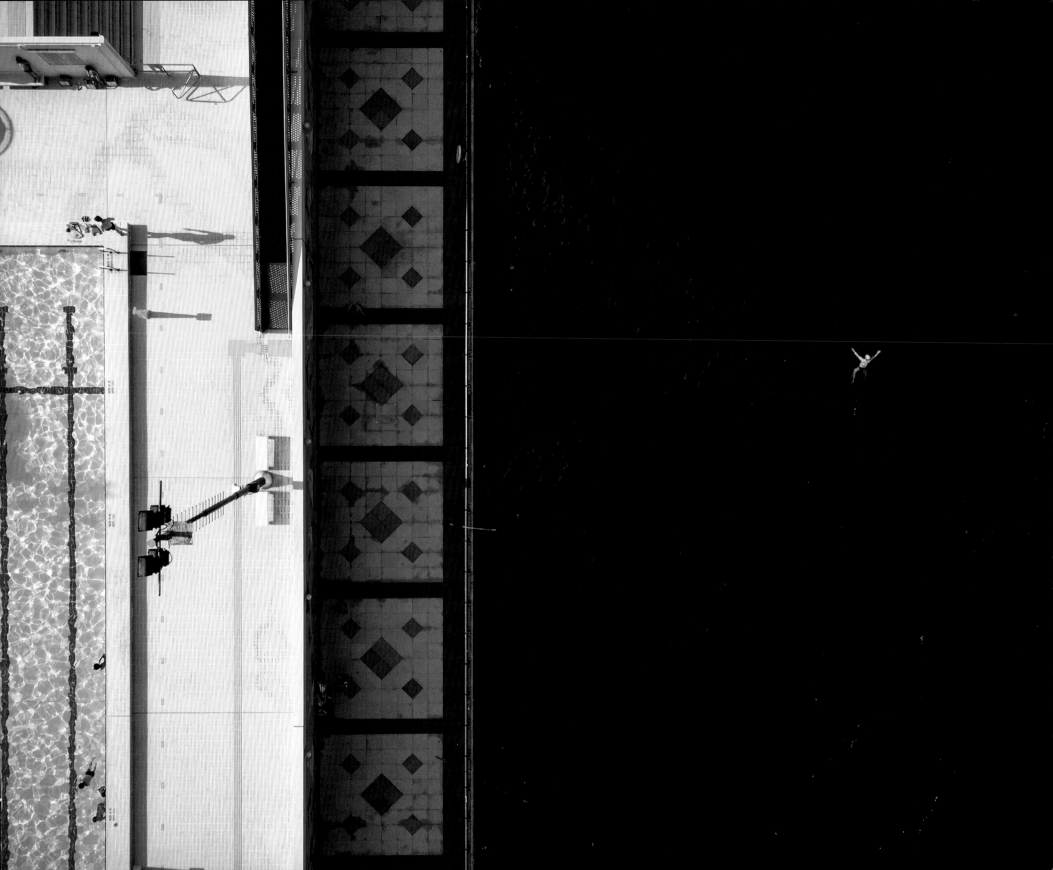

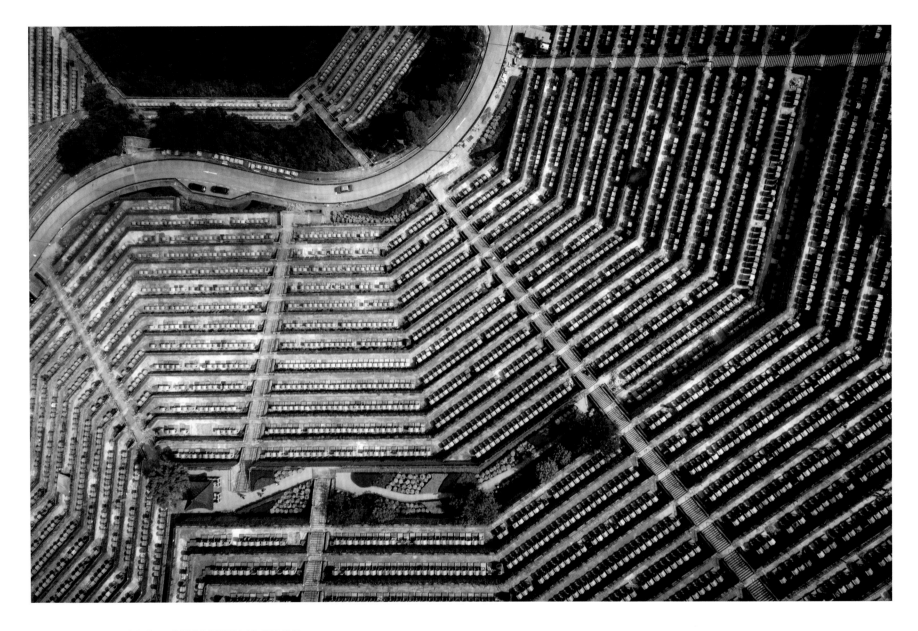

SIX FEET UNDER (FROM CITY PATTERNS SERIES)

The signature, high-density living areas of Hong Kong are found not only in the central business district areas, but also in the cemeteries. Looking down from a drone camera, the design of cemeteries shares a lot with residential planning—like a garden city, with greenbelts and roads laid out in similar geometries, but at a slightly different scale. The picture's perspective shows how the dwellings of the living and the departed are not so different when seen from above.

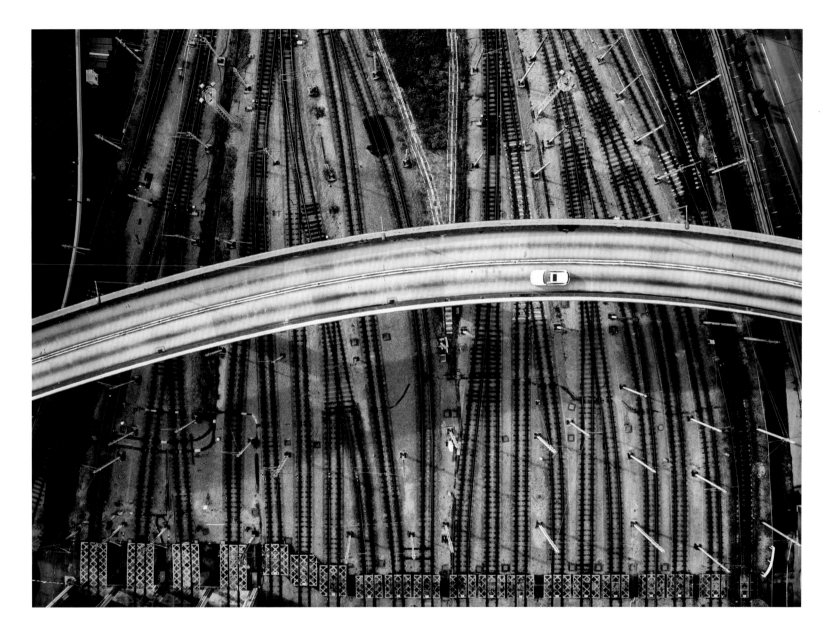

INTERSECTION (FROM CITY PATTERNS SERIES)

Capturing a flyover intersecting with the seemingly chaotic railway tracks in plan view, this image shows just one classic example of the multilayered networks of transportation and infrastructure in Hong Kong that have contributed to the fast-moving pace of the city. With strong parallel lines and curves, the picture conveys the energy of the vibrant city center of Hong Kong from a new angle.

Q + A

Your images have strong shapes and colors: what do you look for when you are creating a composition?

I am influenced by my background in architecture, and am particularly interested in lines and shapes, as well as color and texture. When I look at a landscape for a photograph I try to capture their order and rhythm as in architecture, and present their visual impact through the image.

Does your creative approach to drone photography differ from your approach to ground-based photography?

My drone-shot and ground-shot images appear very different in terms of angle and perspective. However, in both of them I try to create abstract compositions by flattening landscapes into graphical expressions. Most of my drone pictures are two-dimensional "top view" images, shot vertically down from the air. Many of my ground-shot images are captured using telephoto lenses with strong compression. In both, the sense of scale and proportion are ambiguous, and the pictures sometimes look surreal. However, the inclusion of elements such as people, animals, or vehicles in the abstract compositions complete the pictures by giving them a sense of scale.

How important is trial and error in creating successful, innovative drone photographs?

In most cases, I have an initial composition in mind, which will provide the framework of the picture. However, it is sometimes the unexpected elements that add a new dimension and give life to the image. For instance, in the picture *Freedom* (see page 42) I photographed a man swimming in the harbor on his own, in contrast to people swimming together in the pool nearby. The crucial elements that make a successful picture like that could not be planned before the drone took off. There are also occasions when planned compositions don't work out for one reason or another, so uncertainty is also a part of the trial and error process.

How do you use the internet to research a location before you visit?

Light and shadow play a very important role in drone photography, and understanding how they will work in the location prior to shooting is crucial. The internet can be very helpful for location research and Google Maps and Google Earth are excellent for helping a photographer understand the topography and orientation of a site.

GREEN MILE (FROM CITY PATTERNS SERIES)

The edge of Tai Tam Tuk Reservoir in the Southside of Hong Kong is a narrow road running on the dam that separates the turquoise water of the reservoir and the adjacent green vegetation on the hillside. It is one of the most scenic hiking trails in Hong Kong, and attracts thousands of weekend nature lovers. With the drone camera shooting vertically down, the landscape is flattened into a minimal composition of lines and contrasting colors.

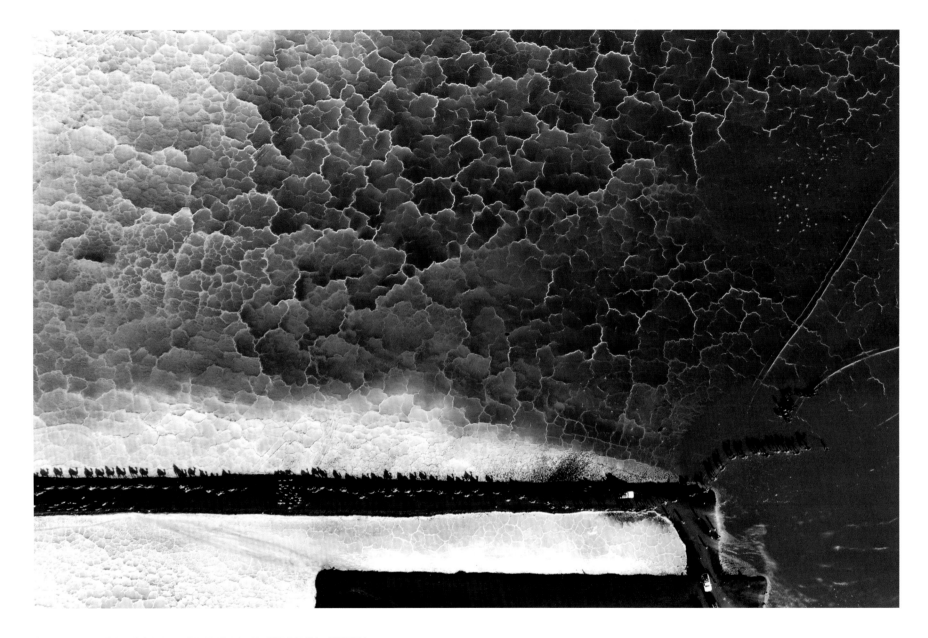

SALT MINERS (FROM ART OF THE LAND ETHIOPIA SERIES)

The salt miners in the Afar region of Ethiopia are still using the same traditional camel caravan they've used since ancient times to carry the loads of salt bricks that are extracted from the salt flats every day. This aerial image captures this unique culture from the air, and emphasizes the shadows of the camels as the rising sun casts them across the ground. The texture of the salt flats adds a natural dimension, reflecting both culture and the landscape of the country.

MEN ARE FROM MARS (FROM DISCOVERING CHINA SERIES)

China is never short of stunning natural landscapes, especially in the western regions such as Sichuan, Tibet, and Xinjiang. This image captures the otherworldly black stone forest landscape in Sichuan, with its dramatic terrain and Mars-like topography soaring over a piece of flatland. The unique landform was formed by thousands of years of geographic movements and weathering.

Q + A

What are the most important aspects of flying a drone for photography?

Creativity and safety are the most important aspects when shooting with drones nowadays. As the technology is getting more mature and popular, drones are now more accessible than in the past. To create successful and unique drone pictures, it is important to develop your own creative style and language. While flying a drone is made so easy these days, even for laymen, we should always fly responsibly and be aware of the potential risks.

What particular technical challenges do you face as a drone landscape photographer as opposed to a ground-based photographer?

The most challenging part can be the process of observation. When I am shooting on the ground, I spend considerable time walking, seeing, and finding the best composition using my own eyes. The process is an intuitive and interactive one. However, you have to focus on the remote control and display screen when shooting with a drone.

What role does social media play in your drone photography? Do you find it inspiring or time-consuming?

I believe social media can be good and bad for drone photography. While it provides good platforms for sharing pictures and getting inspiration, it can also boost the popularity of some places but destroy them at the same time. We must be extremely careful not to produce photographs for social media click-rate, but for our own interest instead.

What motivates you to continue making photographs?

I explore the world and look for new ways of seeing it through the making of photographs. While we may be easily tempted to fly higher and further, and capture as much as we can, drone photography is not a competition of height and distance—the technology comes second and the photography comes first. I believe we should tell stories with our photography, using our own perspective. Not only is photography a process of self-reflection, but it's also a medium of sharing my vision and perspectives with others. I see photographs as my second language, enabling me to communicate with people regardless of nationality.

"To create successful and unique drone pictures, it is important to develop your own creative style and language."

TECHNICAL INFORMATION

FREEDOM
VICTORIA HARBOR, HONG KONG

Drone: DJI Phantom 3 Pro
Camera: Integrated
Lens: 20mm (35mm format equivalent)
Aperture: f/2.8
Shutter speed: 1/400 sec.
ISO: 100

SIX FEET UNDER
KOWLOON, HONG KONG

Drone: DJI Phantom 3 Pro
Camera: Integrated
Lens: 20mm (35mm format equivalent)
Aperture: f/2.8
Shutter speed: 1/400 sec.
ISO: 100

INTERSECTION
KOWLOON, HONG KONG

Drone: DJI Phantom 3 Pro
Camera: Integrated
Lens: 20mm (35mm format equivalent)
Aperture: f/2.8
Shutter speed: 1/400 sec.
ISO: 100

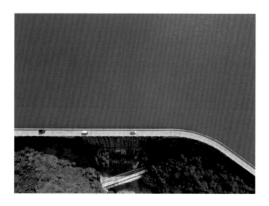

GREEN MILE
SOUTHSIDE, HONG KONG

Drone: DJI Phantom 4 Pro
Camera: Integrated
Lens: 24mm (35mm format equivalent)
Aperture: f/5
Shutter speed: 1/200 sec.
ISO: 100

SALT MINERS
DANAKIL DEPRESSION, ETHIOPIA

Drone: DJI Phantom 4 Pro
Camera: Integrated
Lens: 24mm (35mm format equivalent)
Aperture: f/11
Shutter speed: 1/200 sec.
ISO: 100

MEN ARE FROM MARS
SICHUAN, CHINA

Drone: DJI Phantom 4 Pro
Camera: Integrated
Lens: 24mm (35mm format equivalent)
Aperture: f/5
Shutter speed: 1/200 sec.
ISO: 100

MASTER OF LANDSCAPE
JEROME COURTIAL

Jerome is a French photographer with a passion for drone photography. He started to take his drone with him on his travels three years ago and it has gradually replaced his camera whenever he goes abroad. Jerome especially loves being able to capture images from angles that are not possible without a drone, and travels exclusively to locations where he knows he can shoot great aerial photographs.

Jerome has won lots of awards for his images, even though he says most of the credit rests with mother nature for creating them in the first place. His drone photography has been published in many magazines and newspapers, including CNN, *The Guardian, National Geographic, Time* magazine, and *GEO*, France's most popular travel magazine. Jerome has also been invited to speak about aerial photography by DJI in Paris, France, and Copenhagen, Denmark, and his images featured in DJI's 10th anniversary book *Above the World*.

LAVENDER, THE SUMMER HAIRCUT

I went to Valensole, hoping to find a new angle, rather than the classic view of lavender fields. I knew this was harvest season, so I looked for tractors and waited patiently until some began to harvest in a pattern that would create a pleasing composition from above. I got really lucky when one of the harvesters went straight into the middle of a field. I had to do some color correction in Photoshop to get the vibrant purple of the lavender to pop, and clean up some dry patches that ruined the aesthetics of the photo, but this has been by far my most awarded image to date.

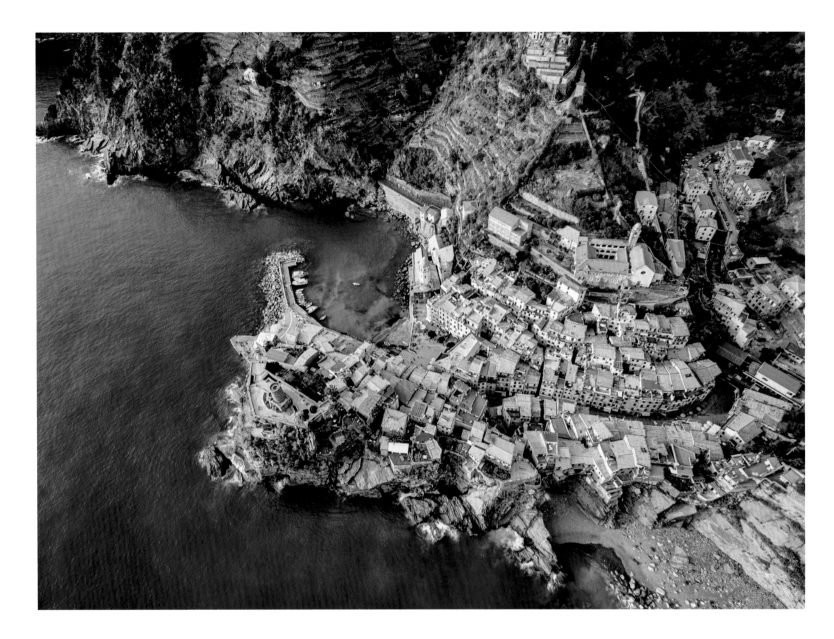

MAGICAL VERNAZZA

I had spent three glorious days in Cinque Terre, but the weather hadn't been kind. It was only on our last evening there, while visiting Vernazza, that the sun broke through for a few minutes. I climbed all the way to the top of a hill and had just enough time to capture the village bathing in the soft sunset light. This was actually a difficult picture to edit as I wanted the colors of the houses and the textures of the landscape to really pop. I also had to correct the perspective as the wide angle of the camera lens distorted the lines of the houses.

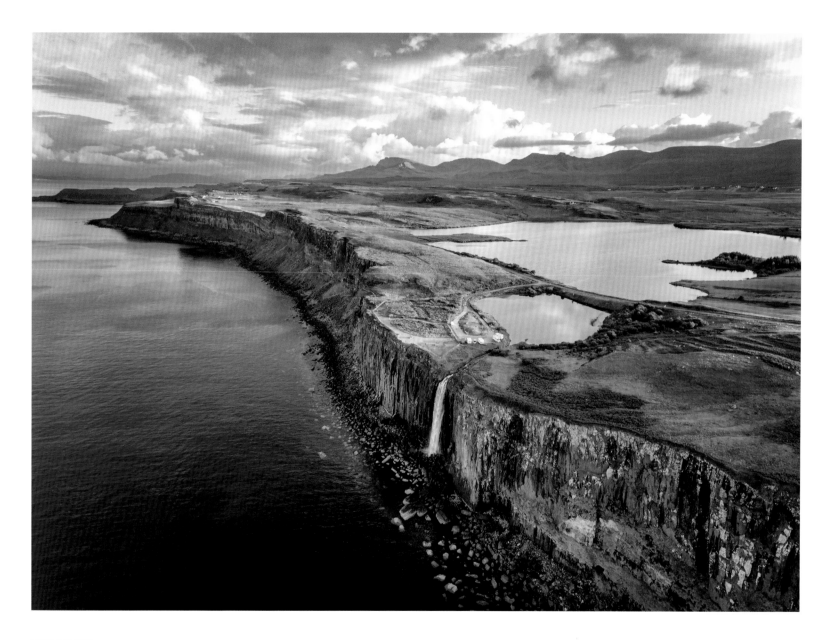

KILT ROCK

The Isle of Skye really blew my mind in terms of the sheer beauty of its landscape. On the summer evening I shot this, we had planned to capture the sunset on the Old Man of Storr. As we started hiking to the top, we realized halfway through that the sunset wasn't going to work with the rock; it was turning into a magnificent sunset, but we were just at the wrong spot for it. In a panic, I reached out for my phone to see if there were other locations we could try nearby. I had saved Kilt Rock as a highlight, so we ran back to the car, and 15 minutes later I was up in the air and could capture this magical shot.

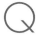

Q + A

How did you get started in drone photography?

There are a few things that drew me to drone photography. I genuinely love coming up with new angles and viewpoints on subjects that have been photographed millions of times before. I also love how many different photographs I'm able to get with a drone session as opposed to a normal photography session where you are limited by gravity and having to physically go to each spot to take a shot; I can go high, low, do vertical panoramas, top-down, and cover a wider range of angles from the same position. There's also the sheer joy of flying the drone, which, even after two years, is still there every time I take off.

What was the hardest challenge to overcome when learning to create great drone photographs?

On a photographic level, the challenges are very similar to traditional landscape photography: preparation, knowing what you want to shoot, the best time of the year to shoot it, and being patient as you wait for the best light. But you can't always visualize the scene until you start flying. Quite often, there are no existing aerial photos of the places I visit, so I have to fly to see the potential of a scene. Not every place works with aerial compositions, and it can be quite hard finding the right spots for aerial photography. Technically, the sensor on a drone's camera is still very tiny compared to a "proper" camera's, so you have to learn bracketing techniques to make sure you get the entire dynamic range of a scene.

How do you approach creating a landscape image using a drone?

I try to prepare as much as possible beforehand, using tools such as Google Earth to see the three-dimensionality of a location before I get there. This is the closest you can get to seeing the potential of a spot before you arrive, but other than that it's the same process as with ground-based landscape photography. I look for inspiration from other people's Instagram photos, and want to visit the same places to add my "twist" to it.

How do you create landscape images with such dramatic mood, colors, and lighting?

Two things: I have to keep returning to a place to ensure I get the right light for the photograph; and then I use the technical know-how I've picked up in recent years to enable me to blend the bracketed images, as well as do a few other tricks for color correction, and so on, in Photoshop.

HILL OF THE SEVEN COLORS

I went to Jujuy province in Argentina to capture the famous "Hill of the Seven Colors." It had been raining all morning in the village where we were staying, and we had almost decided not to go until we met a couple of French tourists who wanted to share a ride with us. We decided to go after all, and after driving for 45 minutes through the rain and wind we were greeted with the spectacular mountain range popping out of the clouds. I was in awe, and quickly launched the drone. However, I soon realized that the mountains were out of range for the drone's wideangle camera lens and that I would have had to fly the drone straight for four miles to get anywhere near the mountains. I decided to have a look around for other compositions, and found the river passing right below with spectacular red and green colors. This became my favorite picture of the trip. I played with the textures in Photoshop, but had to decrease the saturation of the colors to make them more believable!

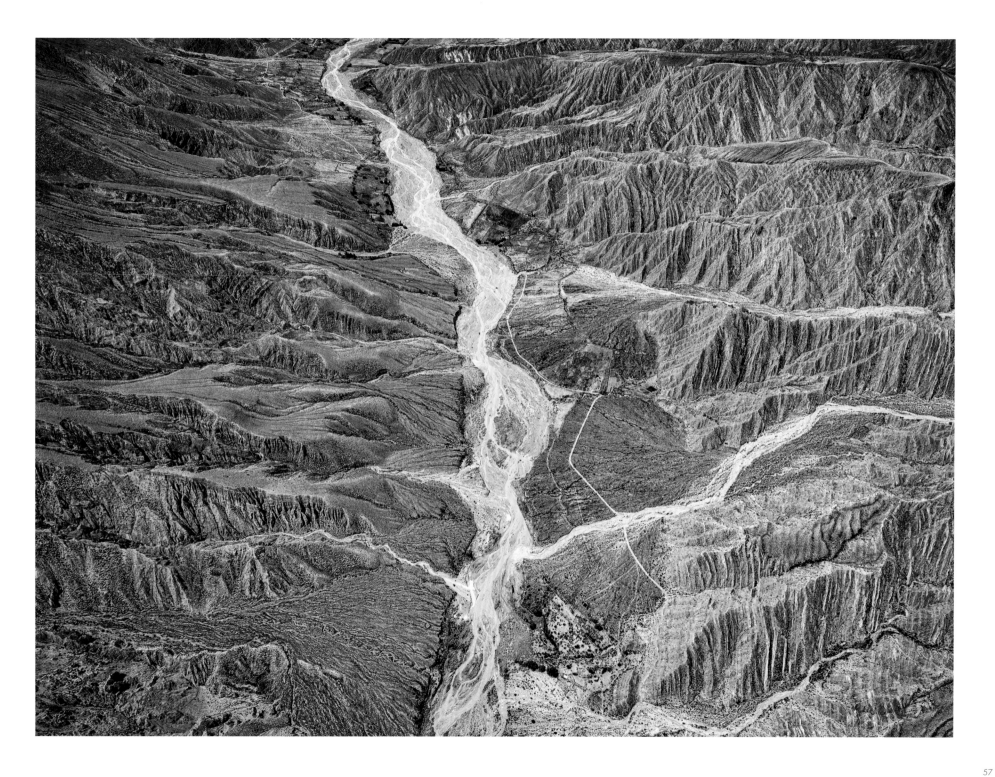

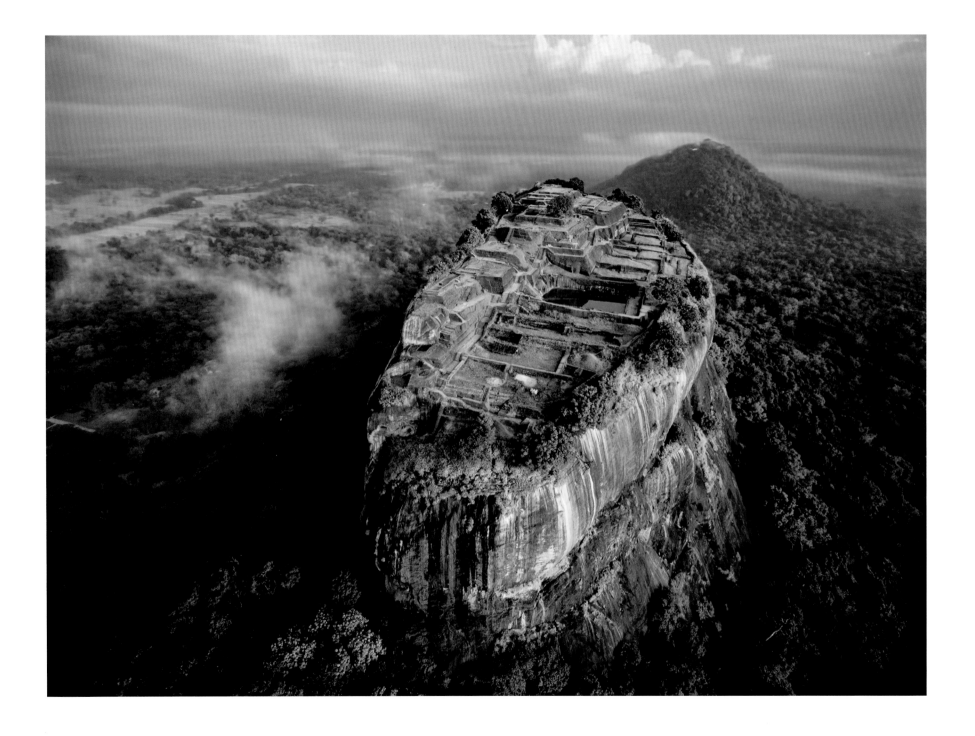

THE GREAT SIGIRIYA

This is the icon of Sri Lanka: an ancient palace built on top of a huge rock in the middle of the jungle. I went there to capture it at first light. It was hard to find a spot to take off from, as the jungle is so thick that it covers the road completely. After driving for a while, we found a small open patch in the tree canopy. As soon as I started to take off, I was joined by a group of monkeys who were curious to see what I was doing. They stayed next to me the whole time, which added to the stress of flying the drone. I was blessed to get a beautiful soft light, and the small cloud on the left makes it a pleasing composition.

MORNING MIST ON THE LAKE

I had climbed Loughrigg Fell with a few other dronists to get a commanding view of the lake surrounded by the hills. It was fall, and the morning mist was still resting on top of the water. After taking a few shots of the view from a high vantage point, I was drawn to this burst of light and low cloud. I positioned the drone literally above the top of a tree and was able to capture the stunning light coming through the morning mist. In Adobe Lightroom, I blended my bracketed shots to recover detail in the highlights, and played with the warm and cold tones to give it more dynamism.

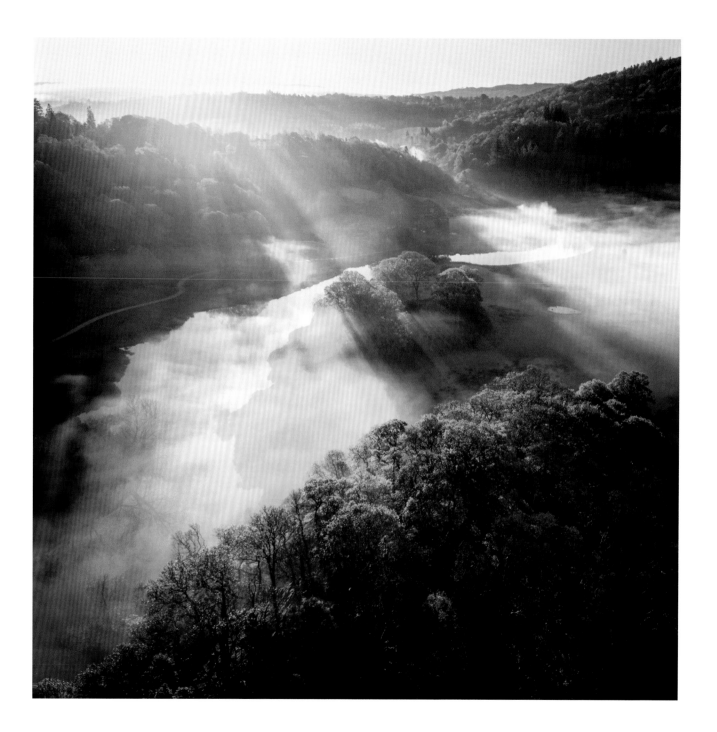

Q +

A

What particular challenges do you face as a drone landscape photographer?

The main problem is regulations restricting the use of drones. Most tourist spots have now banned drones, not just in Europe, but throughout the world, so it's getting more and more difficult to find great spots that are still open to drones. This means you have to become more creative and explore less visited locations.

Do you use specific lenses and filters for your photography?

I mainly use the DJI Phantom 4 Pro, which has a fixed wide-angle lens. Sometimes I will use a polarizing filter if I'm flying above water to reduce the glare, and I've dabbled in creating long exposures with a drone, using a neutral density filter (ND64) to smooth waterfalls. This is a technique that used to be restricted to traditional photography, but is now becoming possible thanks to the stability of the newest drones.

What post-processing steps do you typically take with your images?

I start by blending my images in Adobe Lightroom or Photoshop, depending on the complexity of the scene. Then I start getting the contrast how I want it—due to shooting in Raw, you get very flat images. Then I use color correction, which you often need to do a lot of with drone images. Most of the time I do this in Photoshop, but I also use Color Efex Pro from the Nik Collection quite a lot in my workflow, and I enjoy using the Raya Pro exposure blending plug-in from Jimmy McIntyre, which speeds up the process in Photoshop.

What one technique would you suggest to budding drone photography masters?

I would recommend that you bracket all of your shots, with -1 exposure compensation as your baseline. By using automatic exposure bracketing, you capture the entire dynamic range of the scene in your image.

"I will use a polarizing filter if I'm flying above water to reduce the glare, and I've dabbled in creating long exposures with a drone, using a neutral density filter."

TECHNICAL INFORMATION

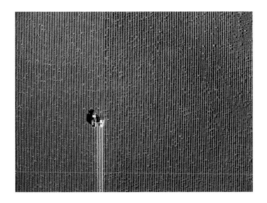

LAVENDER, THE SUMMER HAIRCUT
VALENSOLE, PROVENCE, SOUTH OF FRANCE

Drone: DJI Phantom 4
Camera: Integrated
Lens: 20mm (35mm format equivalent)
Aperture: f/2.8
Shutter speed: 1/100 sec.
ISO: 162

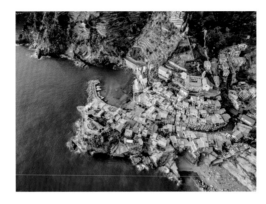

MAGICAL VERNAZZA
VERNAZZA, CINQUE TERRE, ITALY

Drone: DJI Phantom 3 Pro
Camera: Integrated
Lens: 20mm (equivalent to 35mm)
Aperture: f/2.8
Shutter speed: 1/150 sec.
ISO: 100

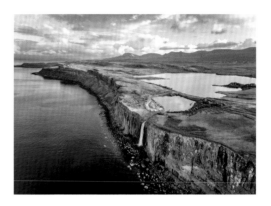

KILT ROCK
ISLE OF SKYE, SCOTLAND

Drone: DJI Phantom 4
Camera: Integrated
Lens: 20mm (equivalent to 35mm)
Aperture: f/2.8
Shutter speed: 1/280 sec.
ISO: 100

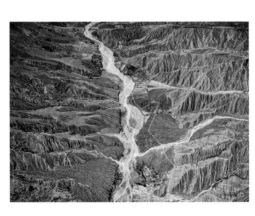

THE HILL OF THE SEVEN COLORS
SERRANIA DE HORNOCAL, JUJUY, ARGENTINA

Drone: DJI Phantom 4 Pro
Camera: Integrated
Lens: 24mm (35mm format equivalent)
Aperture: f/5.6
Shutter speed: 1/640 sec.
ISO: 100

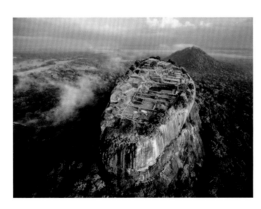

THE GREAT SIGIRIYA
THE LION ROCK, MATALE, SRI LANKA

Drone: DJI Phantom 3 Pro
Camera: Integrated
Lens: 20mm (35mm format equivalent)
Aperture: f/2.8
Shutter speed: 1/100 sec.
ISO: 100

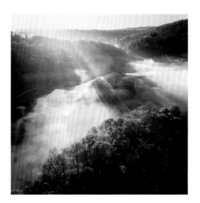

MORNING MIST ON THE LAKE
LAKE DISTRICT, CUMBRIA, ENGLAND

Drone: DJI Phantom 4 Pro
Camera: Integrated
Lens: 24mm (35mm format equivalent)
Aperture: f/4
Shutter speed: 1/240 sec.
ISO: 100

MASTER OF OCEANS
STACY GARLINGTON

Stacy Garlington was first inspired to take up photography in 2008, when kayaking in Hawaii, during a close encounter with a humpback whale—an experience that forever changed her life. Since then, she has spent much of her time studying the art of photography and creating images using small aerial drones.

Stacy soon realized the tremendous potential of aerial photography during the early stages of the consumer drone industry. She began to create impactful images, and her work is now published in *Forbes*, *Time*, and *GQ* magazines. "I never had a formal education," explains Stacy. "So how did I end up working for the world's largest drone company with offices in both Silicon Valley and Shenzhen in China? I had a dream and I made a choice to pursue what made me happy."

Stacy is now a co-owner and instructor at the DJI Aerial Photography Academy, where she teaches thousands of people worldwide how to experience the freedom of flight while operating their cameras in the sky.

ST. JOSEPH LIGHTHOUSE

A colleague and I had finished teaching a class to fly drones that day, and we were on our way home. I don't live too far from Michigan, so I knew that the east side of the lake has a lot of these beautiful lighthouses, which are perfect for photography because the sun always sets behind them. We planned to stop along the lake and this lighthouse was easy to get to, plus there were no no-fly zones—so it was the right time and the right place, with the right conditions. This is a photograph that's all about the sunset, with the leading line of the pier taking your eye to the setting sun.

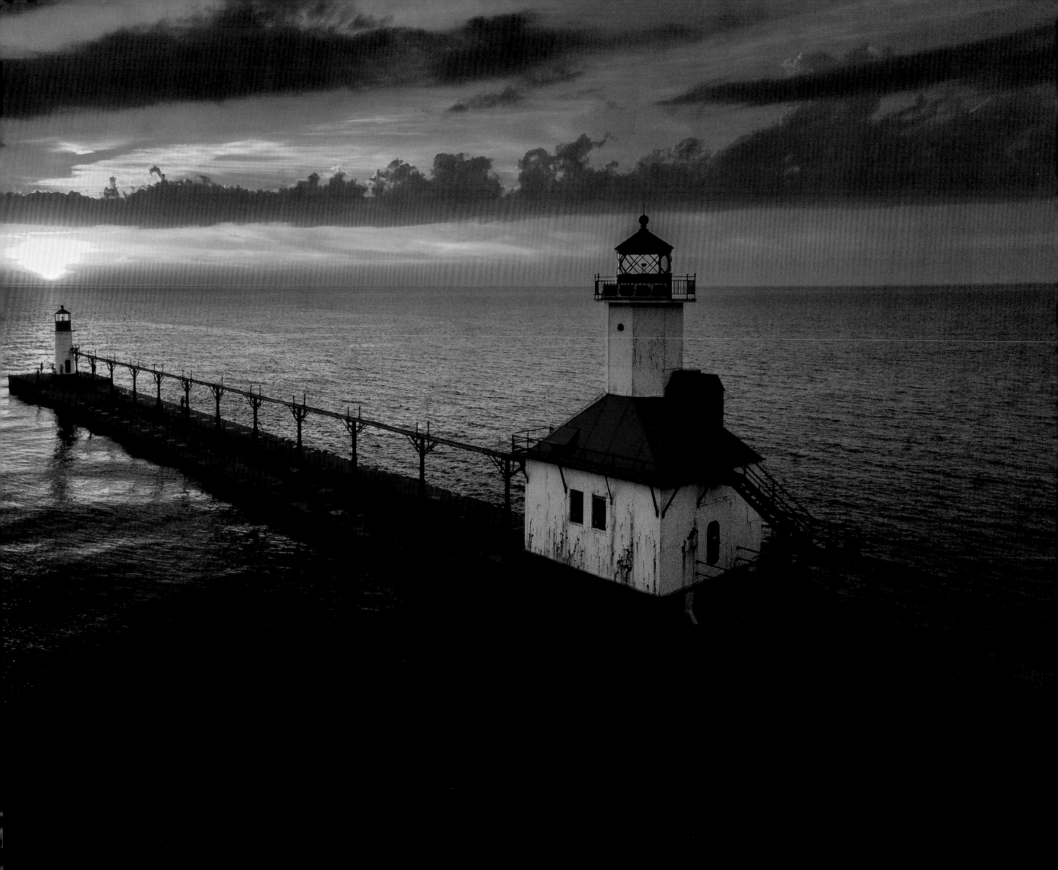

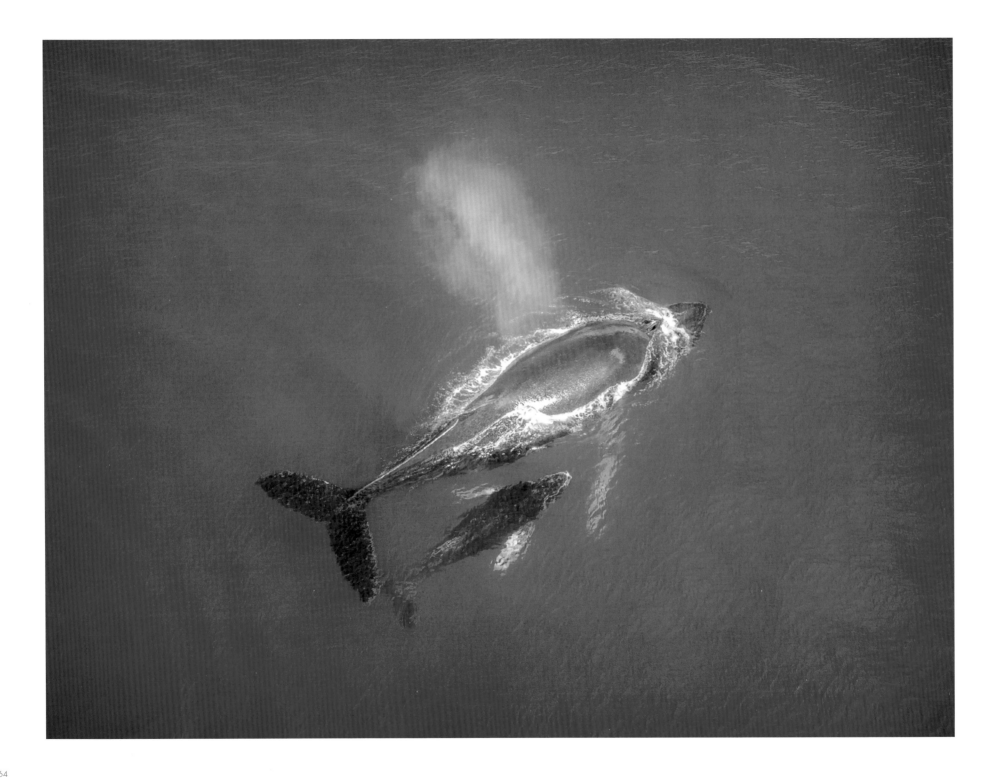

SAFE HAVEN

This was a serendipitous shot—it was honestly quite accidental. I did not see the rainbow while I was flying the drone, only when I looked at the image on the computer afterward. I did very little post-processing; I add a vignette to all my photos, but here I increased the clarity on the back of the whale that's above the surface of the water, along the dorsal fin. I also used a brush to saturate the rainbow a little bit, just to make it "pop."

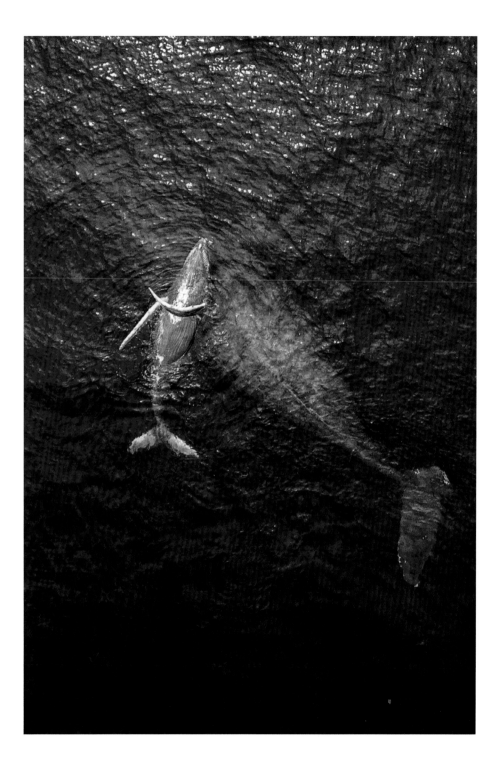

FAITH, TRUST, AND PIXIE DUST

I don't name all my photos, but this one is very special to me. This is probably the photo I'm most proud of, and is the culmination of what started for me in 2008, when I vowed to take a photograph of a humpback whale that I was proud of. I was in my kayak and had spent close to an hour with the mother and calf. The calf was very young, but they both stuck around—the mother would go underwater for 10 or 20 minutes at the time, circling me. I was very nervous because this was the first time I had ever flown my drone around a whale, but finally I got up the courage to launch the drone. The mother came up to the surface, with the calf still on top of her. I took a series of 30 or 40 images. It was a very special moment.

Q + A

How were you inspired to take up drone photography?

It started back in 2008, before drones even existed, when I had my very first encounter with whales. That experience completely changed my life. At that moment—while I was there with the humpback whales—I decided I had to be involved somehow with them. For some reason, despite not having any photographic experience, it was the photography that made sense to me as a way of giving something back to the whales. I then bought my first DSLR camera, and my number one goal was to take beautiful photographs of humpback whales. It wasn't until early 2014 that I was actually able to go back to Hawaii, specifically to photograph the whales from a kayak. I hired a local photographer, Randy Braun—who I now work with full-time— to take me out, and he was flying a Phantom 1 with a GoPro. Afterward, he sent me a photo of me in my kayak with a humpback whale directly underneath me, and when I saw it, I knew that the very next photo I took would be with a drone.

Why does drone photography appeal to you so much?

For whale photography, you don't have to wait for a whale to come above the surface of the water. Secondly, I wanted to be involved, to contribute something, and, back then, scientists were struggling to find ways to study them. The moment I saw that first Phantom 1 and GoPro image, I knew it was going to be a ground-breaking technology that would enable you to study them in a new way—to be able to monitor numbers, body condition, size, mating, giving birth, feeding— and the drone is a perfect way to do that, in a safe, non-intrusive way. So I was excited by the photos, but I was also excited by the possibility of being a pioneer in that industry, and helping with some of the scientific studies of whales.

What do you find makes interesting subjects to photograph from above? Are there any types of subjects you favor over others?

To get better at photographing whales—a moving subject—you have to practice! The reason I shoot anything else, to be honest, is so that, when I'm in a position to photograph a whale, I'm able to make the most of that moment, so I don't miss it. Having said that, I like photographing anything that's old, or has some character, such as old barns or churches, and anything in a beautiful light.

How important is the right lighting in drone photography?

As with conventional photography, the golden and blue hours provide the best light for creating the most emotional impact in an image—and as a drone photographer you're also trying to capture an emotion. When you're shooting whales you don't have the luxury of choosing when or where you find them! It took taking thousands of images of the whales for me to finally learn that directional lighting is incredibly important. When you're shooting anything over water you have to remember that the angle of incidence equals the angle of reflection, so you have to move your drone around to make sure you're not getting any nasty reflections.

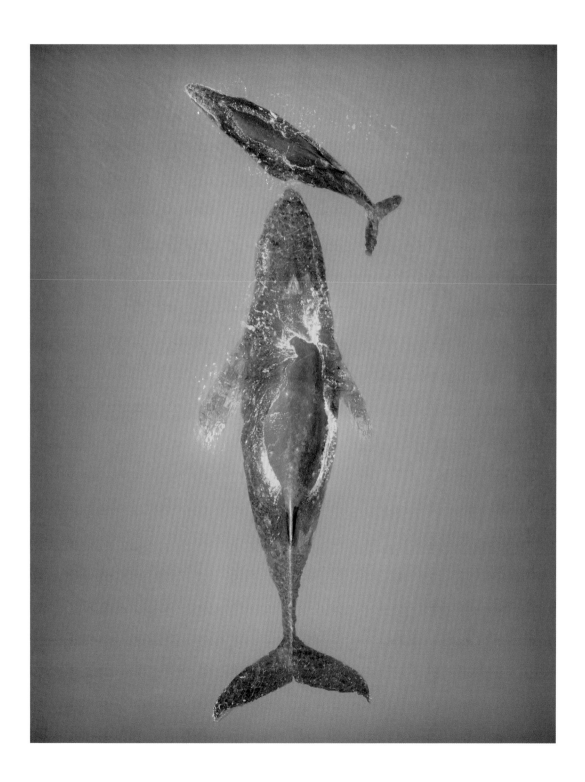

PRIDE AND JOY

This image was taken when I was on a research boat. Once we get the measurement photos with the research drone—and if the whales are being cooperative and haven't been frightened by any other boats—I have the opportunity to launch my personal drone to take some artistic photos. This pair were so calm that I was able to shoot dozens of images capturing the interaction between the mother and her calf. I thought it would be interesting to show the whole animals in the shot. During post-processing I increased the haze and decreased the clarity on the water, just to focus on the whales and not allow the movement of the water to distract from the animals.

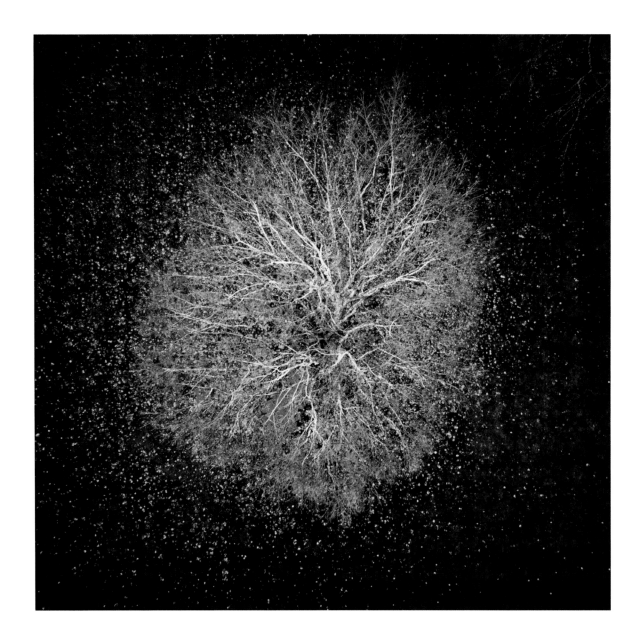

MAPLE TREE EXPLOSION

With a wide variety of deciduous trees, fall in Northern Illinois is a symphony of color for a few fleeting weeks every year. This particular maple tree had dropped its leaves overnight making it look rather empty and sad from the ground, but from above the tree comes to life for one last celebration before the long winter freeze arrives. This photo was voted by *Time* magazine among the "Most Beautiful Drone Photos of 2015" and featured worldwide as part of the Perspectives by Skypixel gallery tour.

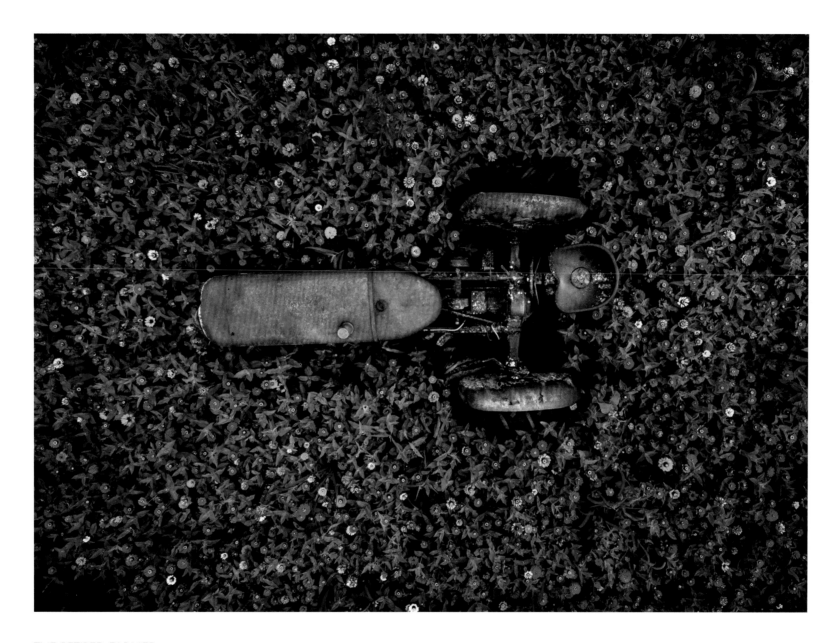

THE RETIRED FARMER

This was shot at my aunt and uncle's house, on a family farm. I sat on my grandpa's lap as a very small child
when this tractor was still in working order! It's been retired to this field where my aunt and uncle planted
these flowers. My family loves zinnias, and my grandfather would give everyone a bag full of zinnia seeds
every year, and we all plant them everywhere at our homes. It's an island of rust in a sea of flowers.

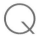

What is the most challenging aspect of wildlife drone photography?

With wildlife, in particular, the most challenging thing is to monitor the animal's behavior, and form a bond with it. The last thing I want to do is to harass a wild animal, especially an 80,000lb wild animal! The whales are very smart, and there have been a couple of times when I've encountered a whale in my kayak, while flying the drone, that it's clear the whale associates the drone with me. So if either I am or the drone is disturbing the whale, then I'll back away—it's always the animal's choice to stay. The water conditions and the stability of the drone are very important, but they're secondary to the wellbeing of the animal. I'm trying to capture its natural behavior—it's important to capture normal interaction between the mother and the calf, for example, rather than an animal that is distracted by the drone or humans.

Are there rules in the USA governing wildlife drone photography?

In the USA, there are rules governing drones: for a start, you are not allowed to fly over whales without an NOAA permit. You must always be aware of what the rules are, whatever you're shooting and wherever you go. I work with a marine biologist and we have a permit that allows us to fly. We focus on three different altitudes: 50ft (15m), 75ft (23m), and 100ft (30m). With the Phantom 4 Pro, 50ft (15m) is a great altitude because it gives you an entire humpback whale horizontally in the whole frame, which is perfect for both scientific and artistic images. Any lower, you just crop too much off, and you can easily lose where that whale is in the water.

Does flying a drone from a boat present any particular problems?

I've been flying drones for five years, and I've never once crashed one. There are many things you need to look out for, though—flying a drone off a boat is incredibly challenging. Even with a "return-to-home" feature, you have to hand-catch the drone, and the swells in the water can make that incredibly difficult. You have to take your time, and think everything through, and don't let your ego get the best of you. If you don't have much battery left, you have to give up on that shot, and allow plenty of time to retrieve the drone. Remember, the most valuable thing is not the drone—it's the SD card on board.

What one tip would you give to budding drone photographers?

When you're starting out, resist the urge to take unnecessary risks: don't fly far, fast, and high before you are experienced and know how to get your drone back safely. Oh, and remember to read the manual!

"The last thing I want to do is to harass a wild animal, especially an 80,000lb wild animal!"

TECHNICAL INFORMATION

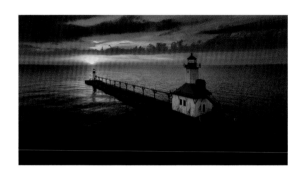

ST. JOSEPH LIGHTHOUSE
ST. JOSEPH, MICHIGAN, USA

Drone: DJI Phantom 2 Vision+
Camera: Integrated
Lens: 30mm (35mm format equivalent)
Aperture: f/2.8
Shutter speed: 1/140 sec.
ISO: 100

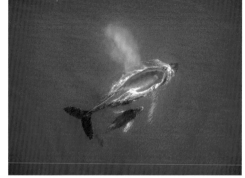

SAFE HAVEN
MAUI, HAWAII, USA

Drone: DJI Phantom 4 Pro+
Camera: Integrated
Lens: 24mm (35mm format equivalent)
Aperture: f/6.3
Shutter speed: 1/120 sec.
ISO: 100

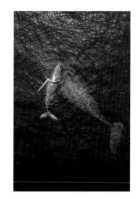

FAITH, TRUST, AND PIXIE DUST
MAUI, HAWAII, USA

Drone: DJI Phantom 2 Vision+
Camera: Integrated
Lens: 30mm (35mm format equivalent)
Aperture: f/2.8
Shutter speed: 1/1100 sec.
ISO: 100

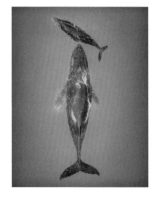

PRIDE AND JOY
MAUI, HAWAII, USA

Drone: DJI Phantom 4 Pro+
Camera: Integrated
Lens: 24mm (35mm format equivalent)
Aperture: f/5
Shutter speed: 1/120 sec.
ISO: 100

MAPLE TREE EXPLOSION
MARENGO, ILLINOIS, USA

Drone: DJI Phantom 2 Vision+
Camera: Integrated
Lens: 30mm (35mm format equivalent)
Aperture: f/2.8
Shutter speed: 1/320 sec.
ISO: 100

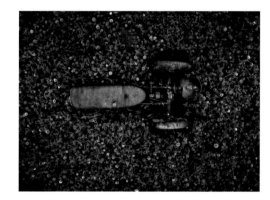

THE RETIRED FARMER
UNION, ILLINOIS, USA

Drone: DJI Phantom 3 Pro
Camera: Integrated
Lens: 20mm (35mm format equivalent)
Aperture: f/2.8
Shutter speed: 1/500 sec.
ISO: 100

MASTER OF COLOR
TOBIAS HÄGG

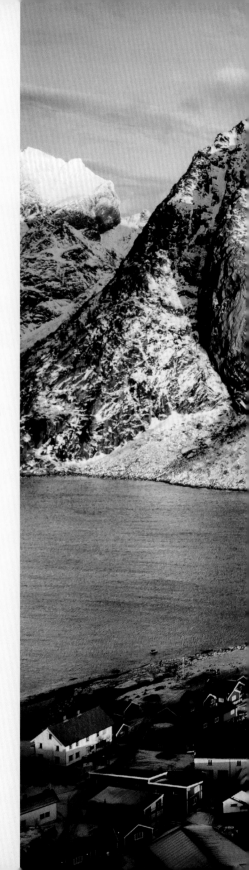

Tobias Hägg is a 31-year-old professional photographer and filmmaker from Eskilstuna, Sweden. Passionate about travel, adventure, and exploring new places from a unique perspective, Tobias says his work is inspired by nature, by the great landscapes of this world, and by all the beautiful things we usually take for granted. He is constantly looking for creative improvement and strives for perfection in everything he does.

Tobias's photographs have been published all around the world in publications including *National Geographic*, *The Telegraph*, and the *Daily Mail*. His work has also been exhibited at the Swedish Museum of Photography. Tobias travels a great deal for his drone photography, and is an official ambassador for the Swedish outdoor clothing brand Fjällräven.

REINE SUNRISE

This shot was taken at sunrise, in the beautiful small village of Reine in northern Norway. During winter in the Arctic you have the "golden hour" all day, which means you get a better chance of capturing the perfect light and rich colors on the mountains. Lofoten is famous for the colors in the water, which make it look almost as if you are in the Caribbean.

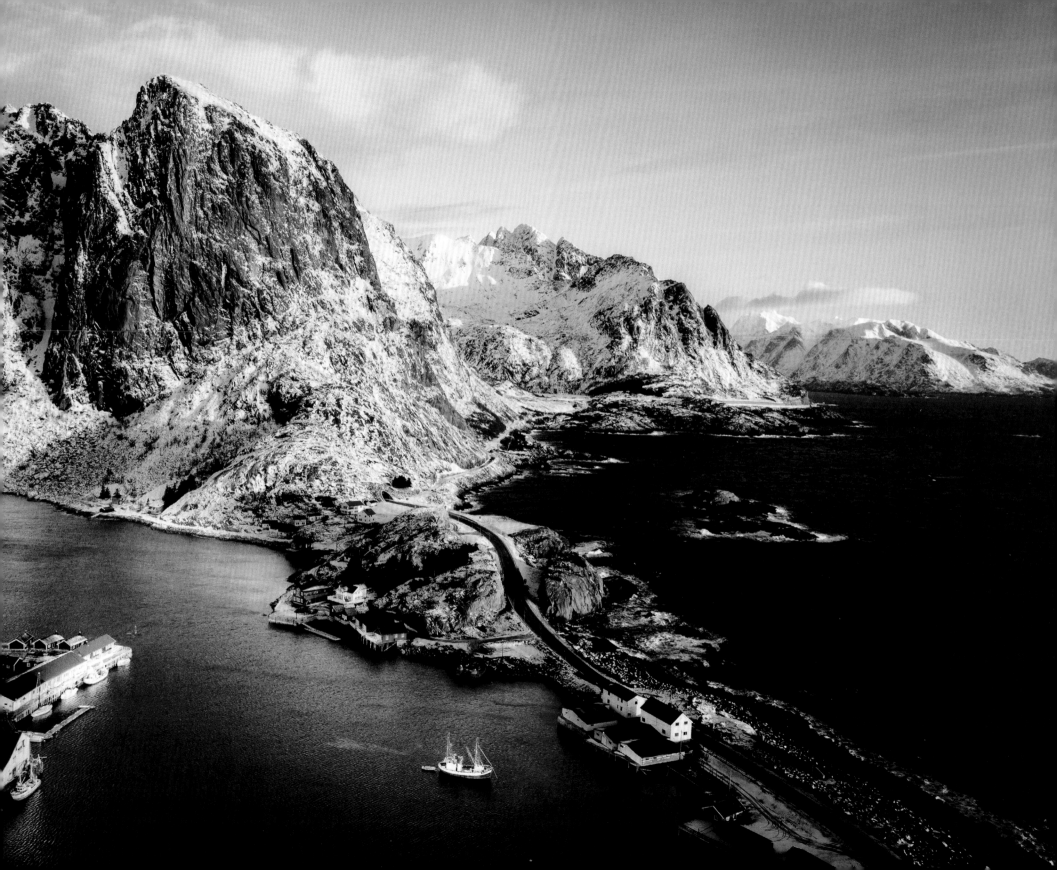

PINK LAGOON

The pink water on the salt lake in Torrevieja—which you see here at sunset—gets its amazing color from the large salt content. The water can change color when seen from above, depending on the light and cloud cover; when the sky is heavily overcast, the lake turns almost purple. Here, I composed the image so that it showed the border between the rocky barrier of salt and the colorful water in the lake.

RED CABIN

Just before spring—and before all colors start to really "pop" in Sweden—I found this scene out in a forest. The blue frozen river and red-roofed cabin provide strong color in the otherwise subdued surroundings of the white and pale brown vegetation. I chose this perspective to make the most of this color contrast.

Q + A

How do you keep your photography fresh and creative?

The best approach to photography is do it instead of thinking about it! If I get an idea, I try to execute it and see where it leads—it means that I make a lot of mistakes, but I learn from them. Also, I try not to be influenced too much by the other photographers out there. With social media it is very easy to be inspired by others, and try to copy what they do, but I don't really see the point in chasing other people's shots. Instead, I focus on the things that I like to do. There is really no end to the possibilities with drone photography. I try to find a different perspective, or a unique angle, wherever I go. And I also try to go way out of my comfort zone and explore areas that actually don't look that attractive at ground level.

Are some times of day better for capturing color than others?

I would say this depends on what you are shooting. My favorite times of the day are always sunrise and sunset, because you get that special light in your images that makes everything pop a little more. The thing I love about sunrise and sunset shoots is that I don't really know what to expect when I am stepping out. As long as you get soft light on your subject, I would say the colors come out a lot better. However, a heavy overcast sky during the day, with the light breaking through, can also be good. It is important to remember that capturing colorful shots from an aerial perspective means you have to be in a colorful area, which can be just a small area on a lake, or a really vibrant tropical scene. Colors are all around us all the time—we just have to look to find them.

How do you approach composition?

I try not to fit the whole world into my image—I like to focus on small things instead of shooting an incredibly large scene where your eyes wander all over the image. I lead the viewer's eyes straight to the subject I want to show them. This is also, I believe, one of the keys to aerial photography in general. I am trying to make one hundred per cent sure that as soon as someone sees my image, they know exactly what they are looking at, even though it is from a different perspective.

How do you ensure you capture sharp images with a drone?

I would say your settings on the camera are the most important factor, but you need a drone that is stable in the air as well. It all depends on what you shoot and how you are shooting it. For example, if I am shooting long-exposure images, I need to make sure the drone is really steady in the air, or I have to delete every image when I get back home, so I always check that the stabilization system on my drone is working properly before each flight. I need a stable drone even more for my video shoots, so I don't get a lot of shaky footage.

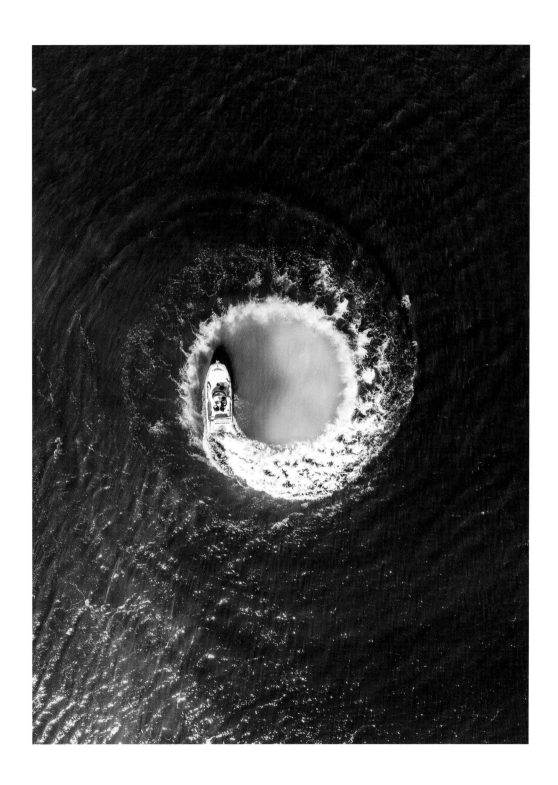

WATER DONUT

This was taken a sunny day in Spain, when I was out with a boat crew, just enjoying ourselves on a lake. I had the drone with me and, out of curiosity, we started making donuts in the water with the boat. I tried to time the shot to capture this perfect circle of the wake—it looks almost like a portal into another world.

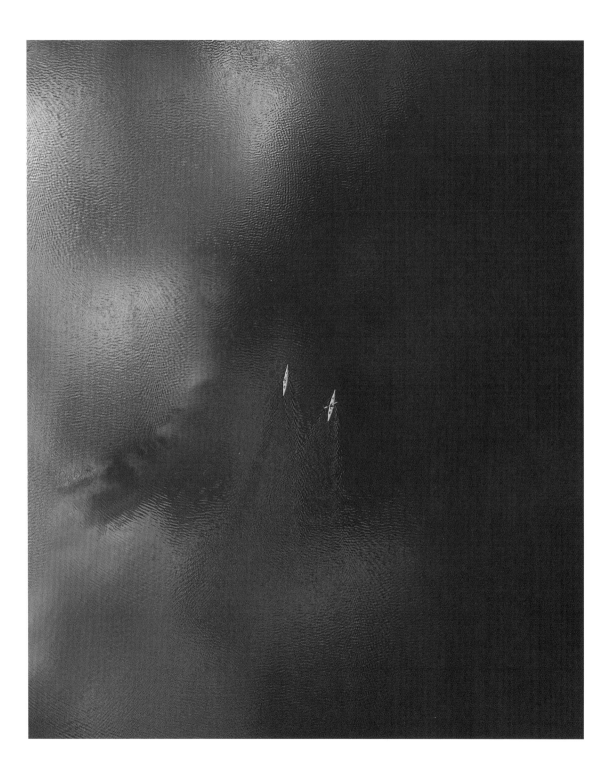

KAYAKS

Between two gigantic walls of a fjord, two adventurers set out at sunrise in their kayaks. I had seen the potential for a shot in the fjord earlier on, and tried to find the right place to capture something different from above. I found the rich colors in the water—on the left of the image—from a nearby island, and as I was looking for a composition the two kayakers paddled straight into the frame.

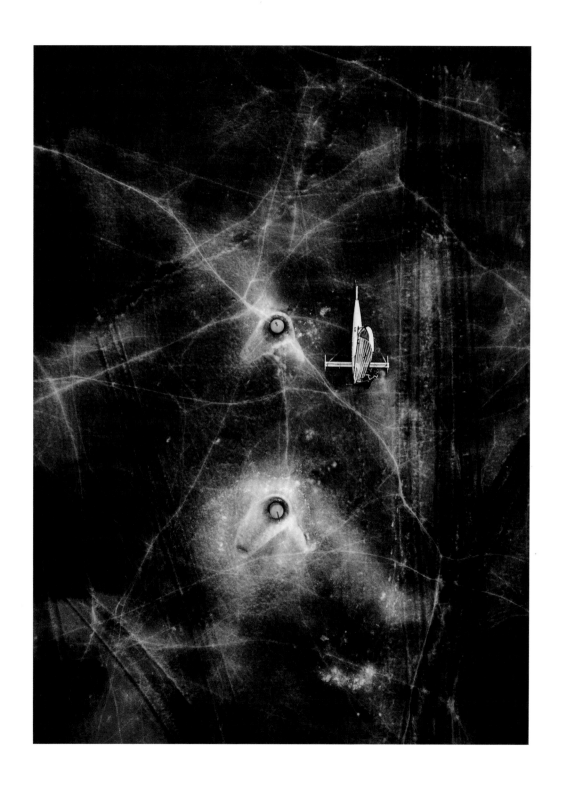

ICE YACHT

This image was taken on the outskirts of my hometown Eskilstuna, in Sweden. It was a beautiful morning and the wind had blown all the snow off the frozen lake. This meant that you could see the details—such as the cracks—and colors on the ice. Luckily for me, there were a couple of ice yachts out sailing on the lake that day, so I tried my best to capture them.

What post-processing steps do you take to achieve the effects you're looking for?

Every image is different for me when it comes to post-processing, and it depends very much on what I would like to say with the picture. Some images require very little time post-processing, while I will spend more time on others. I always try to depict the scene just as I saw it when I was there. The workflow can be very different, but most of the time I use Adobe Lightroom. I have been working with Lightroom for a long time now, and know what I can achieve in it. This is essential in my work because it means that sometimes when I shoot I can see the final image right there in the scene.

How much do you edit the color in post-processing?

I focus on the colors I like in the scene and try to enhance them. However, I don't oversaturate those colors— instead, I decrease the intensity of the other colors. To be honest, the post-processing that I do with an image really depends on how I feel at the time—I try to express my feelings through the image. For example, I struggle with editing a tropical scene if I am in a bad mood, so I go back to working on it when I feel happy again, and am better able to convey what I truly feel about the place.

What one tip would you give to budding drone photography masters?

The most important tip I can give is to make sure people understand what you are shooting—I do this by flying the drone low and close to my subjects. Work with your subject just as you would do for photography with a normal DSLR on the ground. Just because you can fly your drone at heights of 400ft (120m) or more doesn't mean that this is what will make a good image. Play around with a scene, shoot it from different altitudes and different angles, and you will start to see really good results. The more you are outdoors shooting, the better you will become at drone photography.

What motivates you to continue making photographs?

I want to improve creatively every single day, and I want to see as much as possible of this world before I sign out. I found myself through photography, and I have learned so much about who I really am because of it. It's been such as gift for me to receive so much recognition for my work in such a short amount of time, and it has connected me with amazing people all around the globe. This inspires me to just keep doing what I do.

"Work with your subject just as you would do for photography with a normal DSLR on the ground."

TECHNICAL INFORMATION

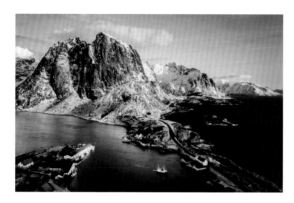

REINE SUNRISE
LOFOTEN, NORWAY

Drone: DJI Phantom 4 Pro
Camera: Integrated
Lens: 24mm (35mm format equivalent)
Aperture: f/5
Shutter speed: 1/100 sec.
ISO: 100

PINK LAGOON
TORREVIEJA, SPAIN

Drone: DJI Phantom 3 Pro
Camera: Integrated
Lens: 20mm (35mm format equivalent)
Aperture: f/2.8
Shutter speed: 1/160 sec.
ISO: 100

RED CABIN
GYSINGE, SWEDEN

Drone: DJI Phantom 3 Pro
Camera: Integrated
Lens: 20mm (35mm format equivalent)
Aperture: f/2.8
Shutter speed: 1/100 sec.
ISO: 159

WATER DONUT
BEGUR, SPAIN

Drone: DJI Phantom 4 Pro
Camera: Integrated
Lens: 24mm (35mm format equivalent)
Aperture: f/5
Shutter speed: 1/240 sec.
ISO: 100

KAYAKS
STRYN, NORWAY

Drone: DJI Phantom 3 Pro
Camera: Integrated
Lens: 20mm (35mm format equivalent)
Aperture: f/2.8
Shutter speed: 1/25 sec.
ISO: 100

ICE YACHT
ESKILSTUNA, SWEDEN

Drone: DJI Phantom 3 Pro
Camera: Integrated
Lens: 20mm (35mm format equivalent)
Aperture: f/2.8
Shutter speed: 1/100 sec.
ISO: 100

MASTER OF COMPOSITION
DAVID HOPLEY

David's interest in photography started at a very early age, but it didn't become a passion until he reached his forties. While employed in graphic design and then architecture, David developed a keen eye for detail and composition, which he took to his photography. However, he became frustrated by the lengthy time it took to produce prints in a traditional darkroom for use in exhibitions, and quickly fell out of love with rolls of film. His first DSLR changed this, though, as David was able to quickly see his results, which fast-tracked his trial-and-error approach to learning photography.

David says that drone photography has given him a whole new world of opportunities to create unique landscape images, and has completely changed his approach to landscape photography. Since starting to create aerial images, David has become regarded as one of the UK's most pioneering and inspirational fine art drone photographers, and is also a CAA-approved drone operator. He has received Highly Commended and Commended awards in the Landscape Photographer of the Year competition in 2016 and 2017, and was a finalist in the Outdoor Photographer of the Year competition in 2017 and 2018.

REAP II

Following on from a series of wheat/barley crop images I had taken over the summer I was eager to complete the series with a few images of a field being harvested. After several unsuccessful trips out into the countryside to find a combine harvester in action I spotted one as I was on my way home from work. The low evening sun helped to create some strong long shadows and accentuate the lines in the wheat crop.

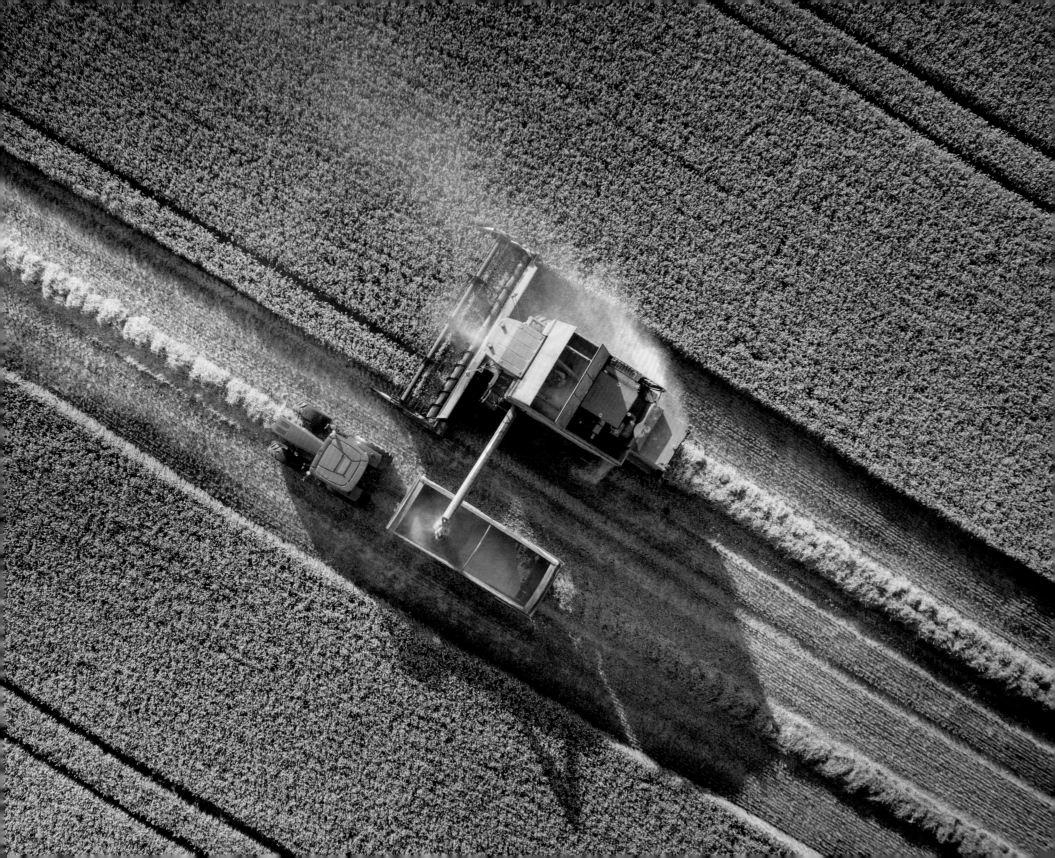

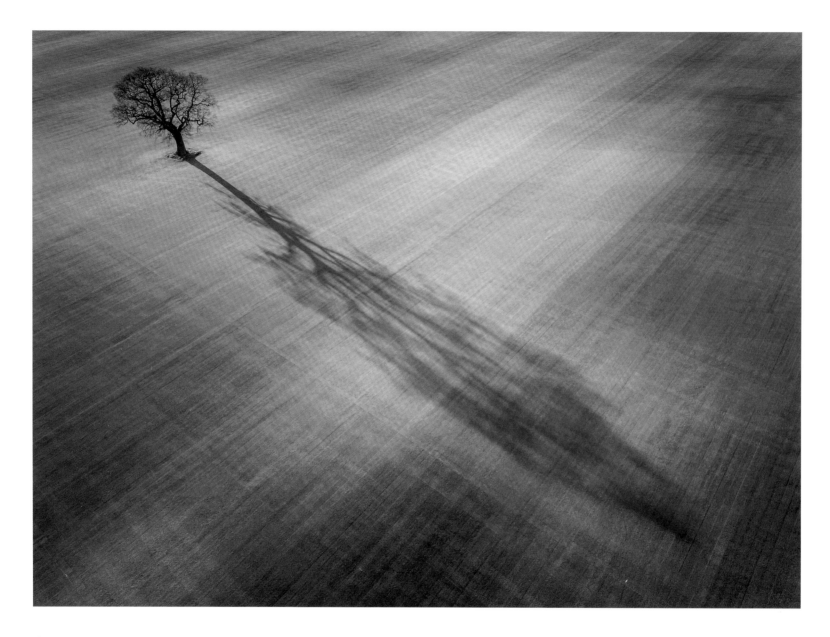

CAST

There are several fields close to my home that are used for growing grass on a massive scale. I spotted the potential in this composition while returning home from a previous photographic outing. The sun was low in the sky, which created an incredibly long shadow from the lone tree. I originally envisaged a composition with the tree in the foreground and the shadow stretching out into the distance. The drone gave me the freedom to easily try different viewpoints, though, and I felt that this composition worked best.

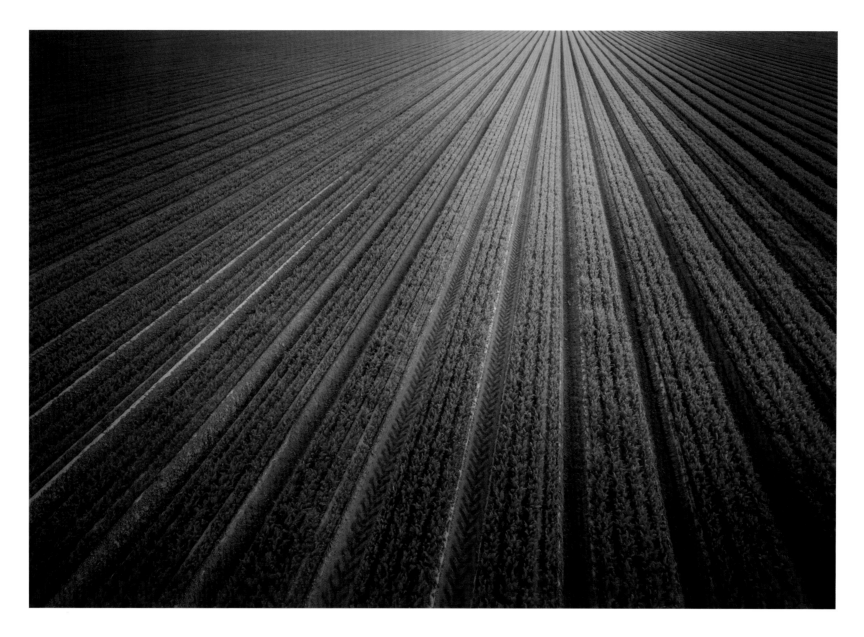

GROOVE, DEVELOPED

I had spotted this composition earlier in the year when the carrot seedlings were covered with a protective fleece. The furrows were aligned perfectly and the fresh tractor tire prints created a lovely texture between the rows. The drone allowed me to fly around the field to find the best sample of plants. An elevated position of around 10ft (3m) allowed me to compose the image so the furrows gathered at a strong vanishing point.

Q + A

Your images feature very strong graphic elements—what do you look for in a landscape to help you compose your photographs?

I try not to include too much detail in my shots. I like to keep things simple, and find compositions that have strong leading lines or a striking subject that can be placed at an intersection on the thirds grid. The location of the sun can have a dramatic impact on a shot—when the sun is low in the sky, long shadows can enhance an image no end. Shooting in the midday sun is usually avoided by most accomplished landscape photographers, but strong shadows can be used to great effect.

Are there any special compositional rules that you follow when you create your images?

I like to compose my shots by eye, but do rely heavily on the thirds grids to compose my images. I try to do my own things with regards to photography, but the rule of thirds is something that I feel cannot be ignored in most situations.

Do you do much research on a location before a shoot, or do you mostly compose your shots on the spot?

When I first started with drone photography, I would head for locations that I had previously photographed from ground level. But I quickly learned that compositions that work well at ground level do not always translate into an equally stunning aerial composition. Quite often, I find the most interesting compositions are in "ordinary" landscapes. I will occasionally look for photographic opportunities on Google Maps, but, more often than not I will head for a location and see what compositions I can find while flying the drone. Detail and texture cannot be seen on low-resolution aerial maps, and it is only when I'm at a location that I can see what's on offer. Instead of heading to an area of outstanding natural beauty, I enjoy the challenge of finding a subject that is nestled in the mundane and ordinary.

How much of creating a drone photograph is trial and error?

Apart from hunting for a location to shoot, nothing in my drone photography is hit and miss. All of my shots are carefully considered when setting up a composition—sometimes I even think about how I will post-process the image when I get back home. Minor changes in altitude and camera angle are made to ensure that objects at the edge of the frame are either fully included or completely excluded so there aren't any distracting elements at the perimeter of the image. Because of the comparatively low pixel count on my Spark, Phantom, and even my Inspire 1 Pro drones, I also try to avoid cropping the image in post-processing, so that I retain the maximum image size.

HAUL

A trip to the Northumberland coast in the north east of England allowed me to spend time exploring this beautiful part of the country from above. It is often difficult to find compositions at ground level, so I typically arrive at a location and launch my drone to find abstracts and patterns in the landscape. On this occasion, there did not appear to be anything of significant interest, but in the distance I could see a fishing boat heading back to shore. After a quick change of batteries, I flew over to the boat just in time to capture it being retrieved by the tractor.

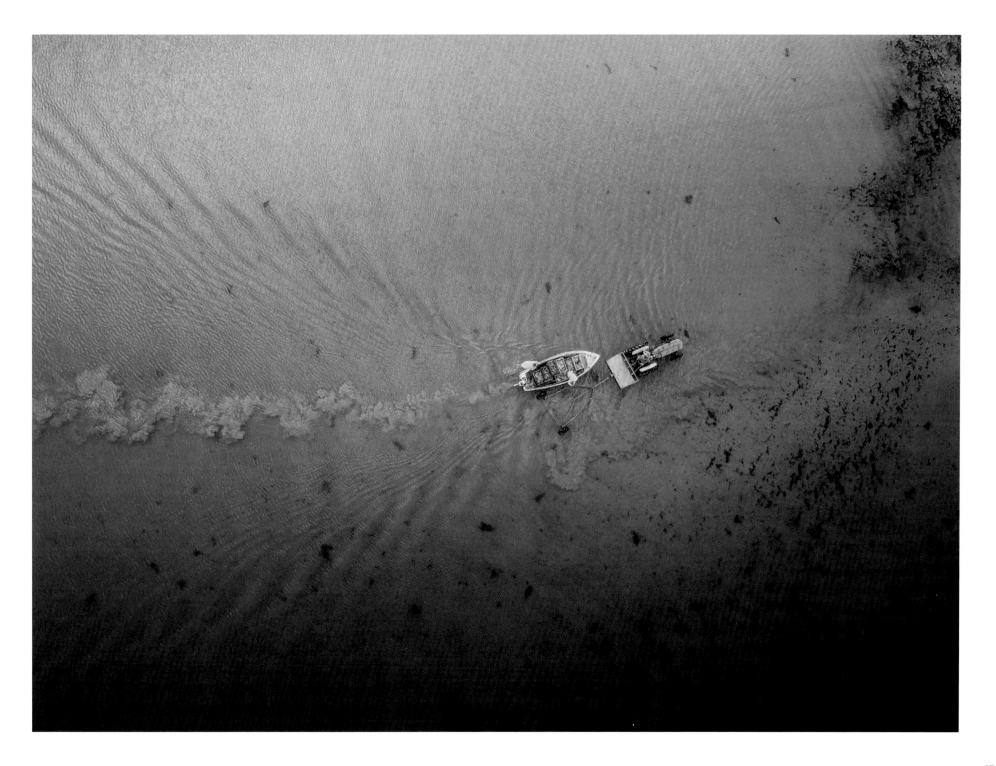

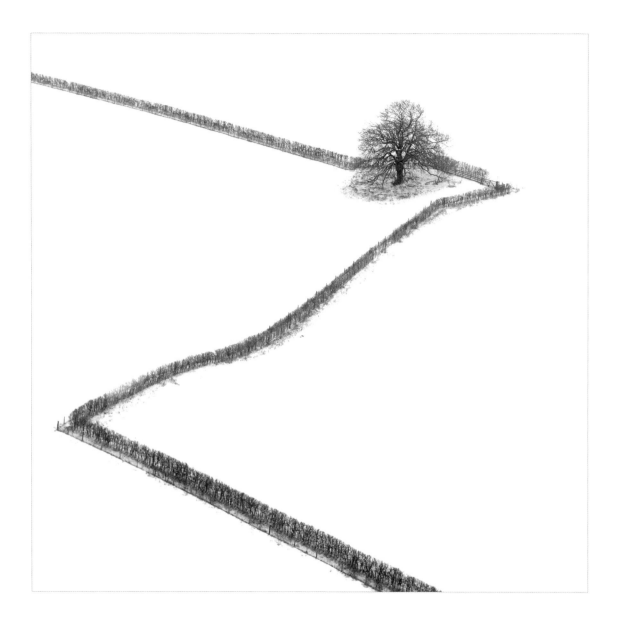

MEANDER

I had been keen to photograph a snowy landscape with a drone for quite some time. The first snow of the season gave me an opportunity, so I headed over to the Pocklington Wolds in East Yorkshire, England, to find a composition that suited my style of photography. I spotted this tree and zigzag fence on the opposite side of the valley to me and switched to a 45mm lens (90mm equivalent) so I could capture the shot without having to fly too far away. The telephoto focal length also reduced the diminishing perspective that would have minimized the impact of the tree in the distance.

CHILL

I've shot this lone tree in a field near my home many times, but either the conditions weren't ideal or the ground cover was messy. After a chilly afternoon photographing the landscape during a brief winter storm, I thought I'd head over to see what this composition looked like in the snow. However, from ground level it appeared that there wouldn't be enough snow cover to hide the newly sprouted crop. Having already unpacked and packed up the drone several times, and feeling tired and cold in the fading light, I lost motivation and almost turned the car around to head home! However, I'm glad I didn't, and after I lined up the shot I made about five or so exposures at different altitudes, with this one being my favorite.

A second after clicking the shutter my tablet died because of the cold temperature and I lost the data link with the drone. Fortunately, I still had control of the craft via the controller, and managed to return it safely.

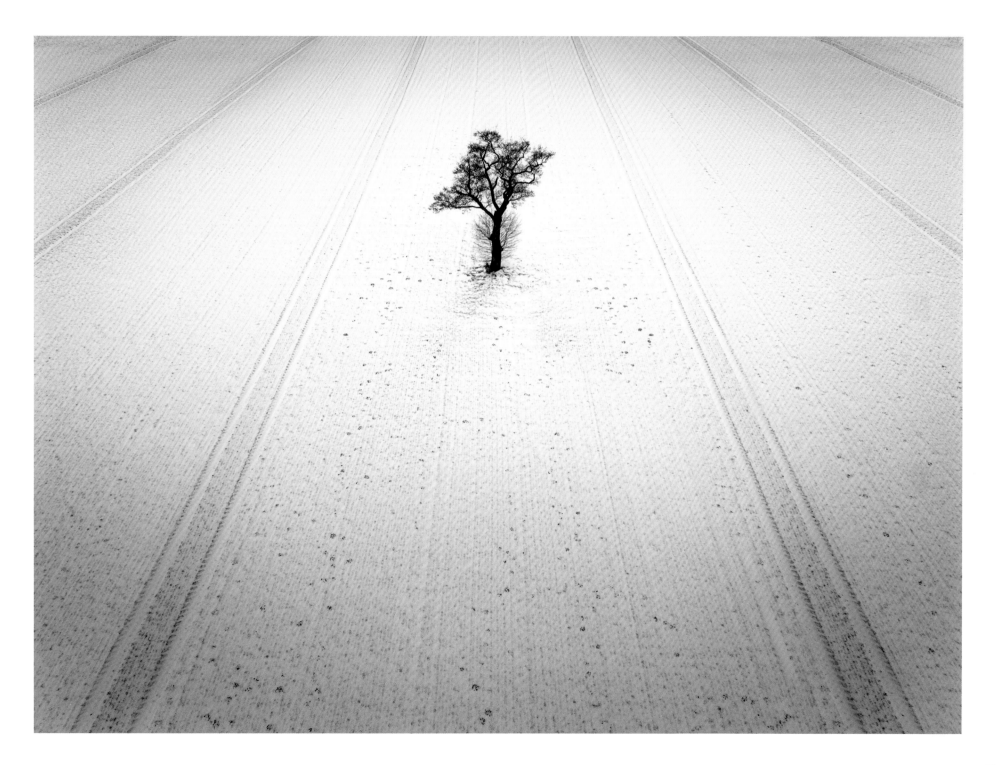

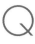
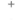

What equipment do you prefer to use for your photography?

In terms of image quality, my Inspire 1 Pro with its 16MP Micro Four Thirds sensor is by far the best drone I have used. However, with all the associated equipment it is rather heavy (about 28lb/13kg) and bulky to carry on a hike. Setting the drone up before a flight can also become a bit of a chore. Ideally, I need to lay out a landing mat to create a clean area to set it up. Then, turn it on to lower the legs, turn it off, install the camera, turn it back on, calibrate the craft, and then install the propellers. However, the DJI Spark is much more compact, and barely makes an impact on the weight of my backpack. The camera is permanently attached and even the propellers can be left on for transit. This little drone can also be launched from the palm of your hand, and being able to quickly get it in the air to grab a momentary change in the lighting and weather conditions is a real advantage.

Do you use physical filters at all, and how much work do you do in post-processing to create your images?

I have never used filters on my drone. An ND graduated filter might sometimes be useful, but shooting in bracketed mode is an easy way of capturing a high-contrast scene. These bracketed shots can easily be merged in Adobe Lightroom. Most of my images are shot looking straight at the ground, and the full dynamic range can often be captured easily in one shot, even with less sophisticated sensors. I mainly use Adobe Lightroom to process my images, and it is here where I like to create a sense of mood in my images. Some images do not require much editing, but I create light and shade using dodge and burn techniques, adding "depth" to the image.

What one composition technique would you suggest to budding drone photography masters?

Rather than trying to capture a large expanse of landscape, try and pick out features that make up the entirety of the view. Consider how the light and position of the sun will affect the scene. For top-down shots, ask if a shadow in a particular direction will help the composition. You can use apps such as *The Photographer's Ephemeris* to help you plan your outdoor photography in natural light, and this will show you how the light will fall on the land—day or night—at any location on Earth.

What motivates you to continue making photographs?

When I started to take landscape photography seriously, I headed to social media to find photographers who inspired me. Seeing the work that other people were producing motivated me to try new techniques and photograph different genres of photography. I have never consciously forced a style on my work, but have developed it over a period of a few years. I enter my work in various Twitter-based competitions, some of which run weekly. The online community and the competitiveness these competitions encourage provides me with the drive to try and head out at least once a week to get a shot. I also try to do well in some of the national and international photography competitions, including the annual Landscape Photographer of the Year and Outdoor Photographer of the Year.

"Rather than trying to capture a large expanse of landscape, try and pick out features that make up the entirety of the view."

TECHNICAL INFORMATION

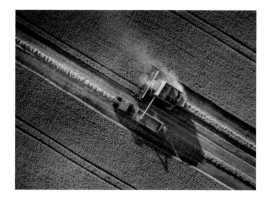

REAP II
DUNNINGTON, YORK,
NORTH YORKSHIRE, ENGLAND

Drone: DJI Phantom 3 Advanced
Camera: Integrated
Lens: 20mm (35mm format equivalent)
Aperture: f/2.8
Shutter speed: 1/220 sec.
ISO: 100

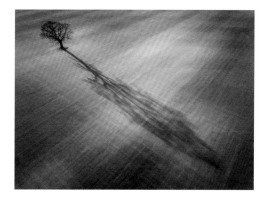

CAST
EVERINGHAM, EAST RIDING OF YORKSHIRE,
YORKSHIRE, ENGLAND

Drone: DJI Inspire 1 Pro
Camera: DJI Zenmuse X5
Lens: DJI MFT 30mm (35mm format equivalent) f/1.7 ASPH
Aperture: f/4
Shutter speed: 1/160 sec.
ISO: 100

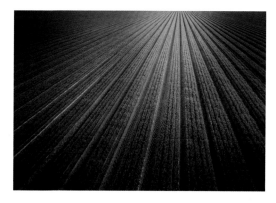

GROOVE, DEVELOPED
MELBOURNE, EAST RIDING OF YORKSHIRE,
YORKSHIRE, ENGLAND

Drone: DJI Phantom 3 Advanced
Camera: Integrated
Lens: 20mm (35mm format equivalent)
Aperture: f/2.8
Shutter speed: 1/100 sec.
ISO: 122

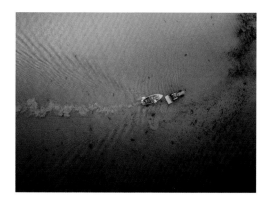

HAUL
BOULMER, NORTHUMBERLAND,
ENGLAND

Drone: DJI Spark
Camera: Integrated
Lens: 20mm (35mm format equivalent)
Aperture: f/2.6
Shutter speed: 1/60 sec.
ISO: 100

MEANDER
MILLINGTON, EAST RIDING OF YORKSHIRE,
YORKSHIRE, ENGLAND

Drone: DJI Inspire 1 Pro
Camera: Olympus
Lens: Olympus M.Zuiko 90mm (35mm format equivalent) f/1.8
Aperture: f/2.8
Shutter speed: 1/250 sec.
ISO: 100

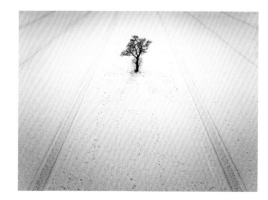

CHILL
MELBOURNE, EAST RIDING OF YORKSHIRE,
YORKSHIRE, ENGLAND

Drone: DJI Inspire 1 Pro
Camera: Olympus
Lens: Olympus M.Zuiko Digital Ed 24mm (35mm format equivalent) f/2
Aperture: f/4
Shutter speed: 1/90 sec.
ISO: 100

MASTER OF TRAVEL
KARIM ILIYA

Karim Iliya is a professional drone pilot, underwater photographer, filmmaker, and whale-swimming guide based in Hawaii. Born in the United Kingdom, he grew up in the Middle East and Asia, and now spends about half of the year traveling the globe with a focus on photographing and filming wildlife and marine environments using free-diving and drones. Karim spends the summers in Tonga, guiding trips while photographing the South Pacific humpbacks that migrate from Antarctica to breed, socialize, and give birth to their young.

Karim's greatest passion is for documenting underwater environments and wildlife, including whales, elephants, big cats, and other threatened species, in an effort to increase appreciation of them, and to help protect our delicate ecosystems on Earth. Karim's humpback whale photography has been published in *National Geographic*, and won the 2018 Hasselblad Masters Wildlife category.

BARCELONETA BEACH

On summer days in Spain, the beaches are filled with people looking to escape the hot sun. This photograph from a drone shows beachgoers relaxing on the beaches of Barcelona. As you get closer to the water, the real estate is better and the density of people increases, making it increasingly difficult to find a place to sit. The beach is an interesting place, as there are plenty of colors and people are lying down, already perfectly posed as "flatlanders," living in a two-dimensional world.

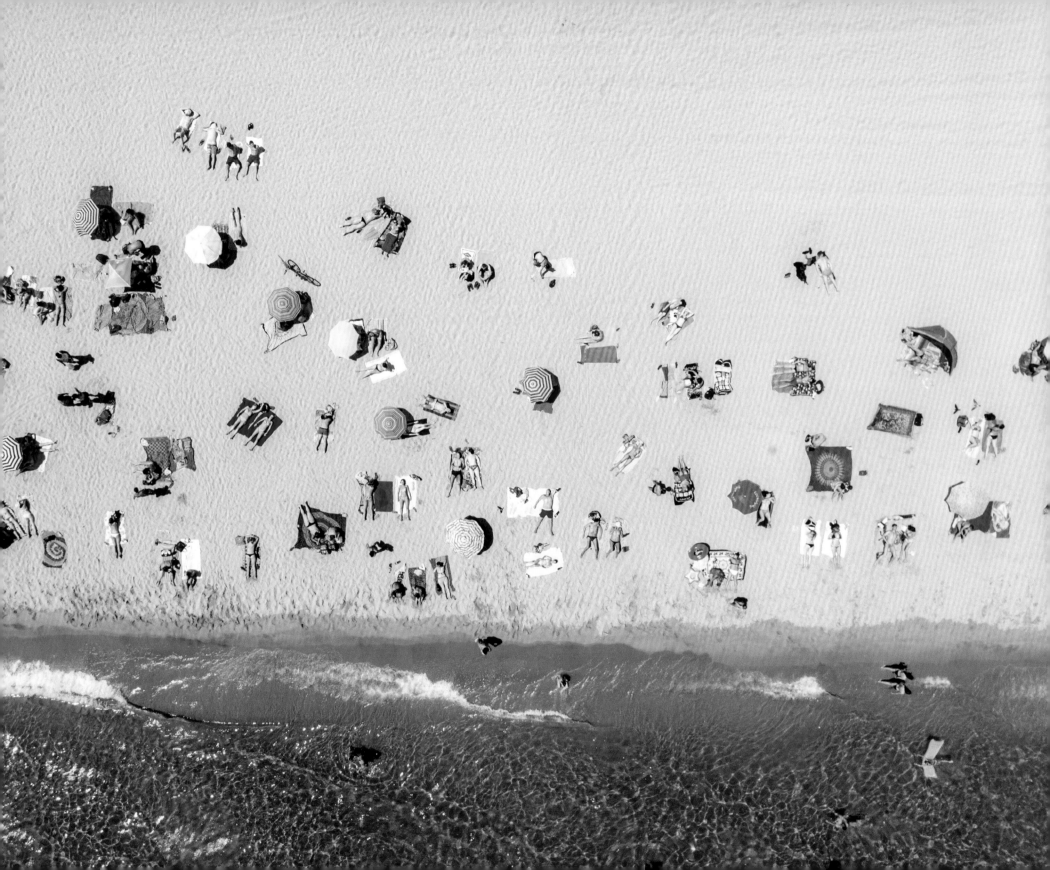

DESERT WINDS

The desert is one of the most peaceful yet harsh environments on the planet. The animals and plants that live here are tough
and incredibly well adapted, but are always struggling to find the next meal. There are vast, empty spaces where often the only
sound is the sand blowing in the breeze. Scale can be lost in the desert, especially when viewed from the air, but the way that
light and shadows lie across the sand is unlike anywhere else on Earth. In this image, the blowing sand gives a sense of scale
to a place in which it might otherwise not exist.

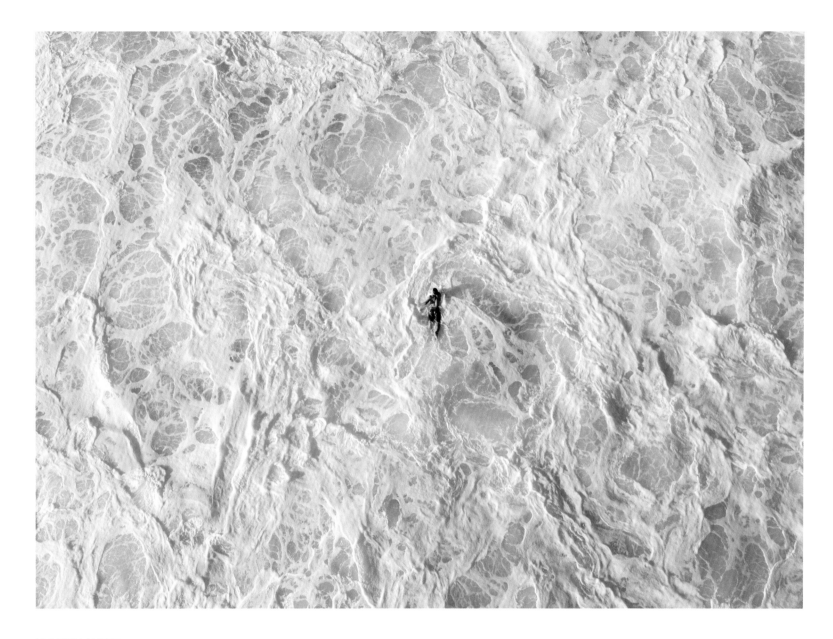

WHITE WATER

There is something special about swirling white water after a wave breaks. When you are under it, it looks like thunder clouds, and when you are in it, it's like snow—an avalanche rushing at you and then bubbles and foam everywhere. This is what it looks like from above, like ink mixing, the white fading and swirling as waves pass over, changing from pure white to a shade of blue. To me, one of the most beautiful scenes in surfing is after the wave breaks. Below and on the surface it can be chaos, but from above it is a moment of calm. Water is a dynamic element, and in seconds the colors can change from a sea of white to the blue of the ocean. Here I wanted to show how small the surfer is against the power or the sea.

What challenges do you face when you are traveling the world for your drone photography?

There are a few challenges when it comes to traveling with drones, both logistical and legal; some places don't even allow you to bring drones into the country. Drone batteries also don't last very long and often the best places to fly are remote and without electricity. In the Peruvian Andes we had to put a generator on the back of donkeys and find a place under a rock to keep it dry from the rain. One of the most interesting scenarios was taking a drone through North Korea on our way to Russia to film reindeer. The drone had to stay in the hands of the North Korean officials, and it would show up and disappear many times throughout the trip; I would sometimes be called into rooms where North Korean generals were inspecting the equipment, and they would then dismiss me. Of course, there is always the possibility that the technology will act up as well, so I always take two drones with me now.

How do you set about looking for subjects that create impact in your images?

The interesting thing about drone photography is that you often don't have any idea what it will look like from the air. I have been to places that are absolutely beautiful at ground level, but when I send up the drone there is very little of interest. Other places may look boring, but have incredible shapes and compositions when seen from the sky. This is one of the most exciting things, and it's always a surprise. I've learned to send the drone up just to have a look, and then immerse myself in what I am seeing and go exploring. My drone can fly quite fast, so I can cover long distances, and with three dimensions to explore I have the freedom to experiment with my photographs. When I can, I'll try to place someone in the shot, and I tend to prefer top-down shots, as this is an angle that we rarely get to see normally.

How do you compose a successful drone photograph?

If you are not shooting straight down, it is much like having a high vantage point—being on a mountain or a tall structure. In this case it is generally similar to landscape photography, but with an inferior camera. I tend to favor the top-down shots, which are a little different. Unless you are photographing something with changing elevation, you are basically turning your landscapes into two-dimensional scenes. Depth is no longer a priority and often not even a possibility. It's a bit like photographing a flat surface. Your direction of light is also quite different. While I will often shoot backlit with regular landscape photography, it is not possible with top-down drone shots. Your light is either coming from behind your drone, or, as it gets closer to sunset, up to 90 degrees from the sides, top, or bottom of your frame. This all creates a different dynamic that is hard to visualize without having a drone up in the sky. Generally, though, the same ideas of aesthetics and composition apply.

Your work covers a wide range of locations and subjects—is that a personal or commercial choice?

I love variety in photography. You can find light almost anywhere on Earth, and so there is no shortage of things to photograph. There are strange animals living in different ecosystems, people living vastly different lives, complex weather, deserts, ice worlds, jungles, small worlds, and the night. There are things too fast for the eye to see, and incredible natural phenomena. All different types of photography feed on each other, and what you may learn photographing bugs will apply to photographing volcanoes. Of course, work and money are essentials, so I also do commercial photography to fund all my personal projects. My favorite subject is the underwater world. Much like flying a drone, it allows you to explore in three dimensions, except this time, you get to be there. Strange animals fly through the blue, and light beams dance on the reef.

THE BLUE CITY

A woman in yellow stands among the rooftops in the "blue city" of Jodhpur, in India. I had been flying around the city looking for interesting compositions when I came across some monkeys, but they moved quickly and unpredictably across the multiple levels of houses. Unfamiliar with the habits of city monkeys, I moved on, looking for higher densities of blue, which is the feature that makes this city special. I found this woman standing on her roof: the pop of yellow and the clothes hanging beside her are what I find most interesting in the image.

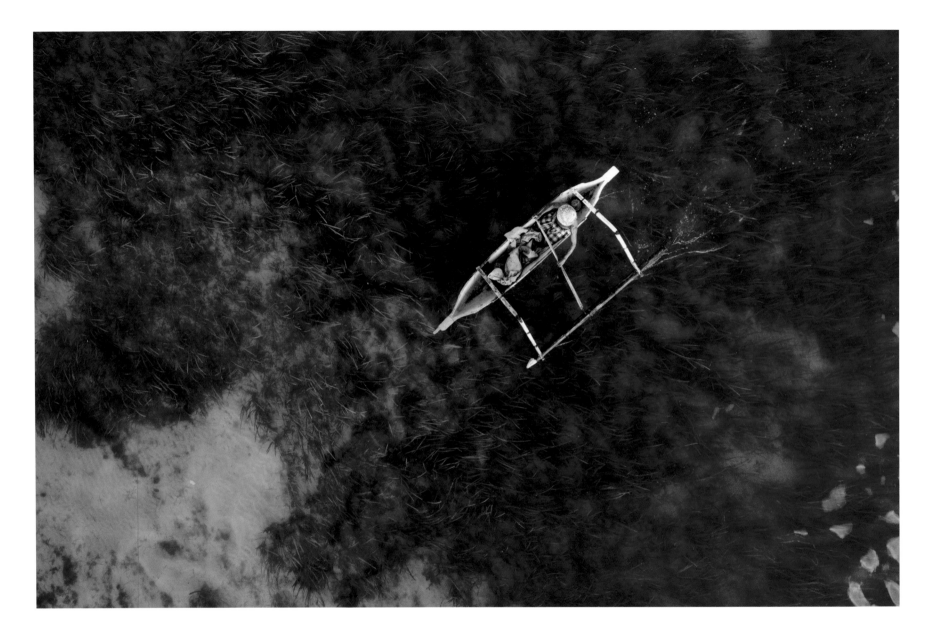

FISHERMAN IN THE GRASSES

An Indonesian fisherman drifts above the sea grass in his small canoe while checking his fishing lines. I originally launched my drone to photograph a friend who was floating in the water among the grass. This fisherman caught my attention in the distance, and I quickly abandoned my friend and flew over him. I have found that people at work or adults playing sport pay little attention to the drone and go about their business. This fisherman was no different. The shallow clear water allows us a glimpse into two worlds.

THE WATERING HOLE

A small herd of elephants enters a watering hole during the dry season in Mole National Park in northern Ghana. Many animals come
to this watering hole and at the center right of the frame you can see a crocodile, although it poses no threat to the large elephants.
This was my first encounter with African elephants and I sat on a hill with a ranger by my side as I flew my drone. Many animals
do not like the sound of drones, as they sound like angry bees, so I flew very slowly, taking 10 minutes to approach the elephants.
Although the elephants were nervous at first, they quickly realized the drone was no threat to them and relaxed.

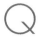

Q + A

How did you start out in professional drone photography?

As you do something you love, you get better at it, and eventually people start to pay you. I realized that photography could be a vehicle for me to see and document the world. I taught myself by doing it, trying new things, and letting my curiosity take hold and guide me. As a kid I played video games, and at university we would battle remote control helicopters and race miniature quadcopter drones. People kept asking if my drone had a camera on it. At some point it made sense—I knew how to fly and I'd been doing photography for years. Operating a drone and being creative use two completely different types of thinking. The biggest challenge was to merge the two so that the flying became automatic and I could focus on the creative aspect.

What tips do you have for those thinking of pursuing a career in travel photography?

Practice as much as you can. The better you are as a pilot, the more you'll be able to do. Your biggest limitations are your imagination and your ability to make the drone do what you want. Most photographers and film-makers already have the imagination part, and there will never be a shortage of things you want to shoot, but you need to develop the flying skills to do it. As far as a career goes, diversify. It would be very hard today to make a good living doing only one type of photography. I fly drones, shoot underwater, lead trips, licence footage, write articles, take on commercial shoots, and make videos. On top of that you need to know how to run a business entirely on your own. It's not easy, but absolutely worth it, and as with anything, you get better with practice.

How does your passion for nature and the environment influence your drone photography?

I spend a lot of times outdoors and in nature. I try to go to remote places, and always have a drone with me. I try to show the beauty of our planet and its ecosystems—my hope is that people will realize how important it is to protect such places. Drones definitely have their place and limitations, so I'll try to make a decision on whether to use my land camera or the drone, so if what I'm trying to capture has more impact from the air, I'll send the drone up.

What single piece of kit is most useful in your work?

A head lamp. Quite often the light gets really good and I find myself flying or photographing until it's hard to see. As I spend a lot of time in remote locations, packing up and getting back in the dark is not the easiest thing to do. A head lamp is not something I thought about until I had one, but now I never leave home without it; it's very useful in making sure you haven't left gear behind and means you never have to pack up and leave early.

"Your biggest limitations are your imagination and your ability to make the drone do what you want."

TECHNICAL INFORMATION

BARCELONETA BEACH
BARCELONA, SPAIN

Drone: DJI Phantom 4 Pro
Camera: Integrated
Lens: 24mm (35mm format equivalent)
Aperture: f/2.8
Shutter speed: 1/800 sec.
ISO: 100

DESERT WINDS
ALTAR DESERT, MEXICO

Drone: DJI Phantom 4 Pro
Camera: Integrated
Lens: 24mm (35mm format equivalent)
Aperture: f/4.5
Shutter speed: 1/100 sec.
ISO: 200

WHITE WATER
HO'OKIPA, MAUI, HAWAII

Drone: DJI Phantom 4 Pro
Camera: Integrated
Lens: 24mm (35mm format equivalent)
Aperture: f/2.2
Shutter speed: 1/1000 sec.
ISO: 100

THE BLUE CITY
JODHPUR, INDIA

Drone: DJI Phantom 4 Pro
Camera: Integrated
Lens: 24mm (35mm format equivalent)
Aperture: f/5.6
Shutter speed: 1/160 sec.
ISO: 100

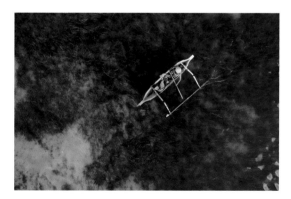

FISHERMAN IN THE GRASSES
LOMBOK, INDONESIA

Drone: DJI Phantom 4 Pro
Camera: Integrated
Lens: 24mm (35mm format equivalent)
Aperture: f/4.5
Shutter speed: 1/400 sec.
ISO: 200

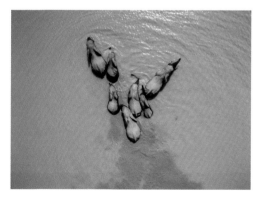

THE WATERING HOLE
MOLE NATIONAL PARK, GHANA

Drone: DJI Phantom 4 Pro
Camera: DJI FC300X
Lens: 24mm (35mm format equivalent)
Aperture: f/2.8
Shutter speed: 1/400 sec.
ISO: 100

MASTER OF PANORAMA
FERGUS KENNEDY

Fergus Kennedy is a freelance photographer and marine biologist, based in Lewes, East Sussex, on the south coast of England. He has been flying drones for the last five years and has worked as a commercial drone pilot with his company Skylark Aerial Imaging for a wide variety of clients. His work has been featured on prime-time television by the BBC, ITV, Channel 4, Channel 5, and ABC. Commercial clients include Canon Europe, Toyota, Nissan, Worldwide Fund for Nature, and many others.

Fergus has flown drones in a wide variety of environments around the world, from baking-hot deserts to freezing-cold mountains, and has 20 years of experience in photography and video work. His photography has been Highly Commended in the Wildlife Photographer of the Year competition, and he is a judge on the Outdoor Photographer of the Year judging panel.

PARAMOTORS AT SHOBAK FORT

The extensive ruins of a Crusader-era fort sit atop a hill at Shobak in Jordan, giving it a commanding view over the surrounding area. At the invitation of the Jordanian Government, five paramotor pilots were allowed to fly in close proximity to a number of historical sites in Jordan. I had an assignment to photograph the project, both from a drone and from the ground. This required extensive coordination with the pilots, to avoid collisions and to get the shots I was after. We used ground-to-air radios, and kept talking as the light changed. As the sun set, we had about 20 minutes when the light was perfect, and both the ruins and the paramotors were backlit.

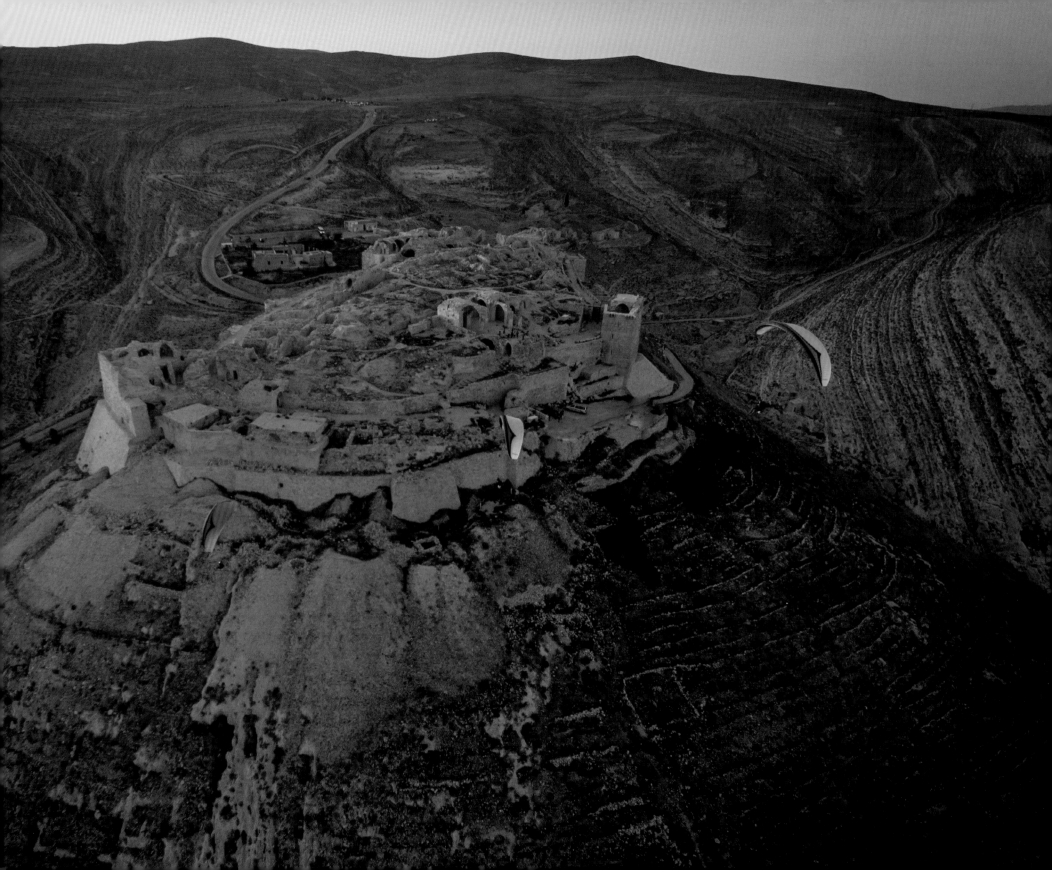

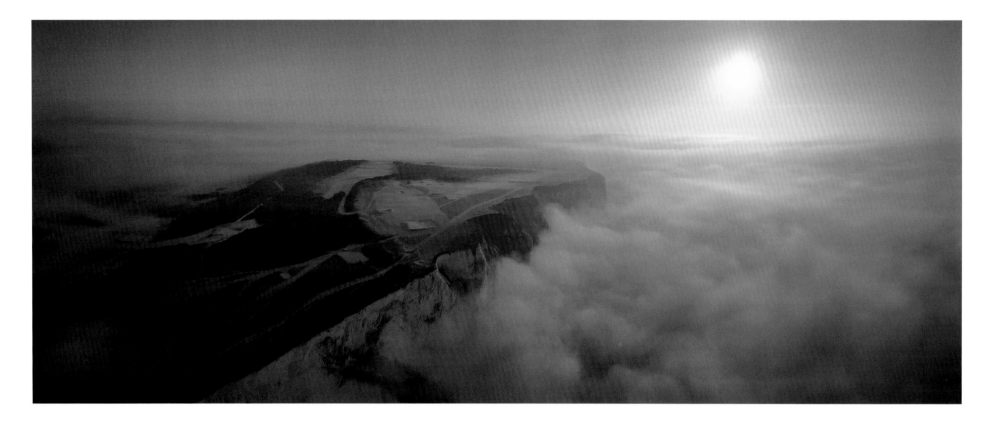

CLIFF FOG

This spot is very local to where I live. I had seen from the forecast that there was a possibility of fog, so I drove down to the coast. If the fog is too thick there's no way to get the drone above it and still maintain visual contact with the drone. Luckily, on this particular morning the fog was quite patchy and I was able to take off from the beach and get a great view back towards the chalk cliffs, emerging from a sea of fog. The panorama is made from three shots stitched together, to give a wider angle of view.

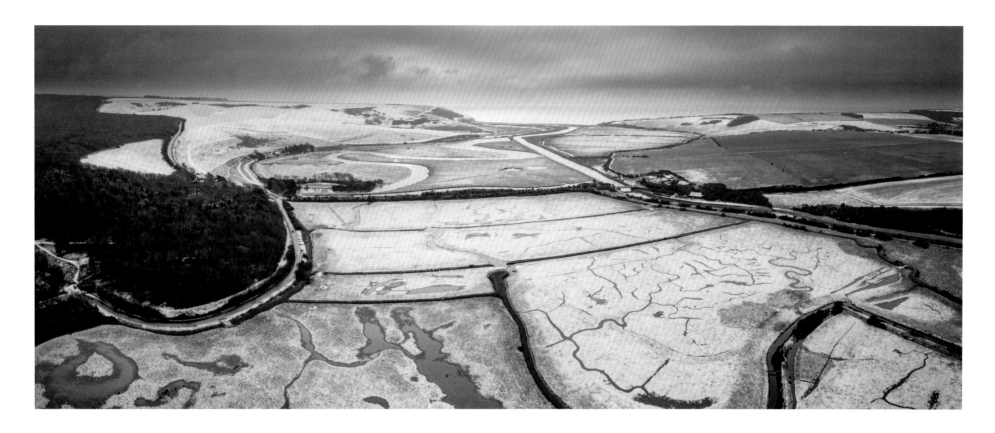

WINTER VALLEY

Whilst working on a video project on the seasonal life of a river valley, we had been waiting for a day with snow or heavy frost. After some light overnight snowfall there was a light dusting that was almost entirely gone within an hour of my visit. Having shot the video I needed, I switched the camera to stills mode and shot several images. I was worried that being so overcast, the light was too flat, but with a little tweaking in Lightroom I like the mood. It's a three-photo panorama, achieved by yawing the drone slightly between shots.

Q
+
A

What inspired you to take up drone photography?

I've always loved taking unusual photographs that push the limit in some way—for example, I have long been an underwater photographer and also love taking my camera up into the mountains. I'm also a bit of a sucker for new technology, so when camera drones first started to appear, I was instantly interested. Before drones, I took pictures from fixed-wing aircraft, paragliders, microlights, hot air balloons, and even gyrocopters, but it's expensive and limiting in some ways, so there's a big appeal to a portable device that you can take anywhere and use to get aerial shots within minutes. It quite literally expanded my horizons, and enabled shots that I had previously only dreamed about. Since the early days, it has become easier to get the camera in the air, so now I can focus more on the photography and less on the technical aspects of flying.

What particular drone-flying skills is it important to master when starting out?

The single most important flying-related skill is simply being able to fly the drone safely. You should be aware of the local regulations and adhere to them. Being cautious is very important here. I've seen quite a few drone flyers getting overenthusiastic in the early days, flying flat out or too far away, and it often ends in a crash. For stills photography, smooth flying is not nearly as important as it is for video, you need to be able to get the drone to where you want it, and this is not difficult with a basic understanding of the controls and a bit of practice. Most decent camera drones have GPS stabilization now, so when you let go of the controls they will hover pretty accurately. You should have a keen awareness of weather conditions (particularly wind) and the presence of any obstacles. You'll find it much easier to fly safely if you position yourself as close as you can to the drone—this gives you a much better understanding of the surroundings. I can also highly recommend my book, *Drone Photography and Video Masterclass*!

How do you approach photographic composition differently when using a drone?

Many of the rules of composition remain the same in the air. The main difference is the freedom to move your camera in three dimensions, and fast. If your compositional elements aren't quite coming together as you intended, you can quickly elevate your drone. You also have the freedom to point the camera straight down and take really interesting and unusual abstract shots, again tweaking your position very easily until the composition is just right. The other big difference is that you can't fly, so it takes a bit of imagination before you take off to work out exactly the composition you are after. Often, once in the air, the reality differs from how you'd imagined it, and you need to adapt your ideas, but that is all part of the fun—it's a journey of discovery.

What are the biggest technical or photographic problems you've encountered?

Fortunately, I rarely have major technical problems, but they have cropped up from time to time. I've lost a large drone with an SLR on it in the sea, when a LiPo battery went bad. While I love the convenience of small drones, I occasionally get frustrated by the limitations of small sensors, particularly in low light. Other than that, the main technical problems I have had have been relatively minor software and firmware glitches, most of which can be resolved with a reboot or a software update. My overall feeling is that, given how complicated they are and how little development time they have had, consumer camera drones are actually pretty reliable.

SEA OF CLOUDS STEREOGRAPHIC

This photograph was taken above the forested slopes of Tenerife, in the Canary Islands. The volcanic landscape often rises above a sea of clouds and I wanted to capture this scene as a 360 degree panorama. These days many drones can capture these 'little planet' panoramas automatically and some even stitch them together in the drone. But I took this image a few years ago, so had to do it manually. I took 13 overlapping images, covering about 360 degrees around by 270 degrees on a vertical axis and stitched them together with panorama software (PTGUI). This 'little planet' view is technically known as a stereographic projection.

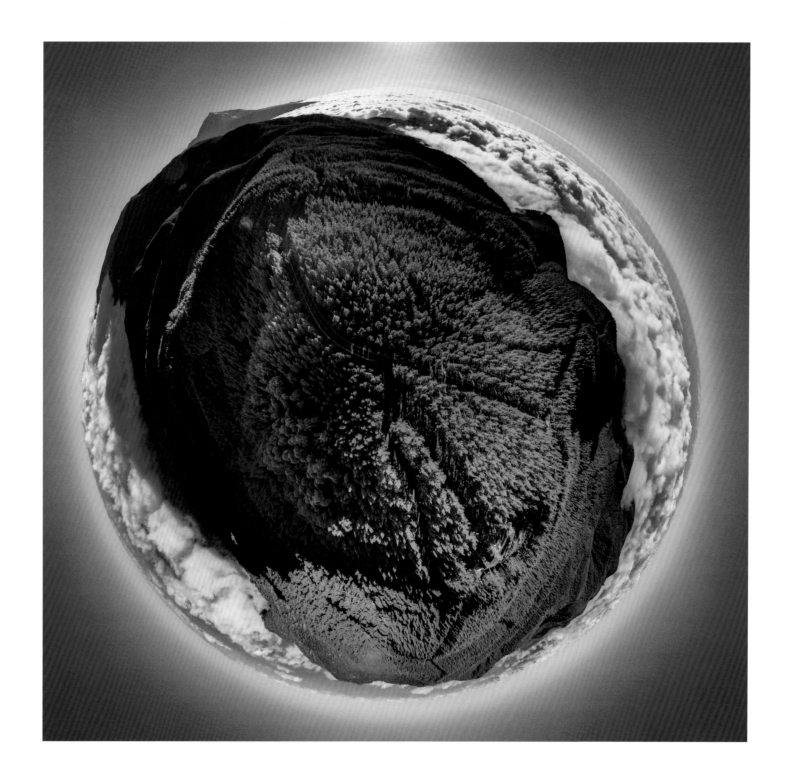

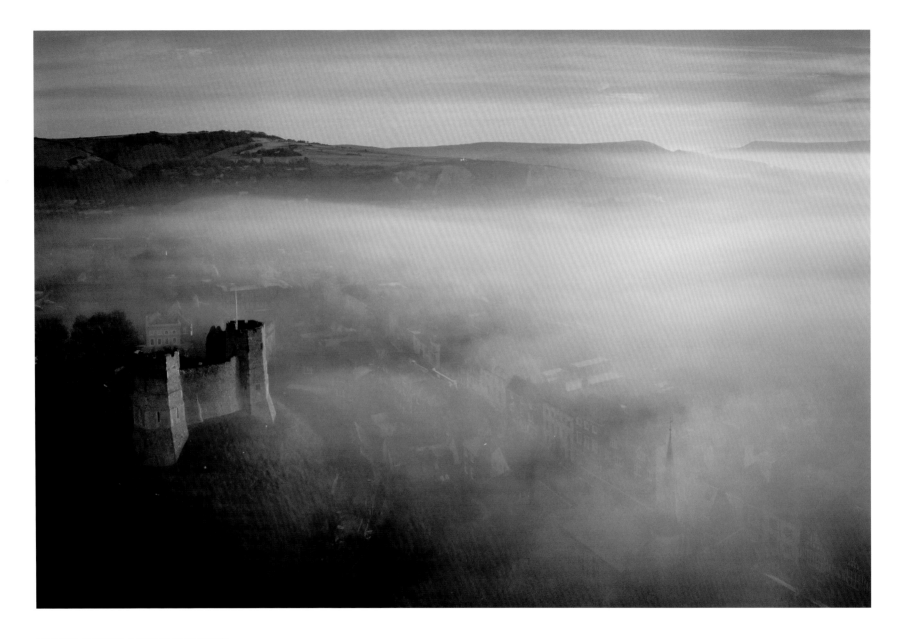

LEWES CASTLE ABOVE THE FOG

I love this shot because it shows my home town of Lewes. For years I'd hoped to get a shot like this, firstly from ground level, but I was never in the right place at the right time. Early one winter morning, I could see there was a temperature inversion and fog was forming in the Ouse Valley. I grabbed the little Mavic drone, and headed out. I'd already planned a take-off spot that allowed a safe flight, avoiding flying too close to people or buildings, and fortunately a gap in the fog allowed me to take off and get the shot, while maintaining a direct line of sight with the drone. In terms of composition, I wanted to get an angle where the South Downs were visible in the background, rising above the fog, while the buildings of the town can just be made out beneath the fog layer. Minutes after I took the shot, the fog started to dissipate.

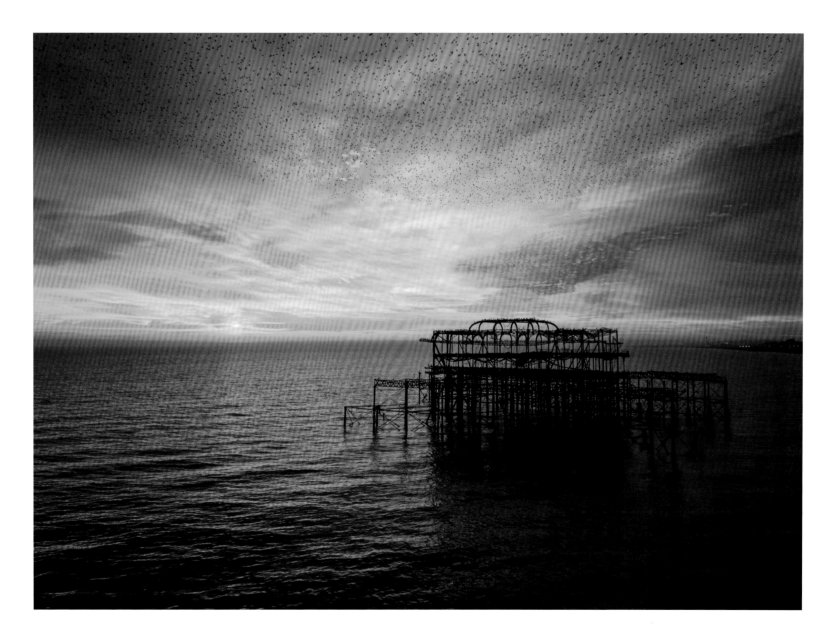

STARLING MURMURATION

I had my drone in the office, and I'd been looking out of the window most of the day. It was a pretty dull and overcast winter's afternoon. A few minutes before sunset, it looked like a small gap was opening on the horizon—perfect conditions for a great sunset. When the tide is out at Brighton there is just enough space for a take-off point at the water's edge, while maintaining a legally required minimum distance of 165ft (50m) to the busy seafront road. I took off and flew straight out over the water to get a view that you can't achieve from the beach. Shooting mainly video, but pausing to take stills, I was amazed by the changing colors and the mesmerizing dance of the starlings before they roosted on the pier wreckage. I became so fixated on the screen of my tablet that I barely looked up to take in the spectacle through my own eyes.

What are the biggest commercial challenges and opportunities facing drone photographers today?

As with so many fields, there is no shortage of talented drone photographers, so standing out from the crowd can be difficult. The old adage "It's not what you know, it's who you know" often applies, so networking and being positive and easy to work with are key. By far the bulk of my work has come from people I already knew before I started drone flying, or through personal recommendations. But while there is a lot of competition out there, the market is also growing. If you are willing to explore new areas and expand your expertise, new opportunities often present themselves. Having other skills that are peripherally related to drone photography is also a big plus. You could be an excellent ground-based photographer or videographer who offers drone photography as an extra, for instance. You might have a great knowledge of surveying, mapping, or inspection work. All of these skills will add to your value.

With so many photographers using drones now, how can you make your images stand out?

Be imaginative, take inspiration from the work of others, but don't slavishly imitate them. Great aerial photographs don't just happen by luck. A great deal of thought has gone into them, often involving months of thought and planning for a single shot. You should be prepared to persevere. Don't give up on a shot until you're satisfied. You might have to return multiple times before the light and conditions are exactly right. Don't be afraid to come up with novel solutions to a problem. If you want to shoot a wide area top-down, for example, but you are already at your maximum flight altitude, you can stitch a panorama, taking multiple photographs and stitching them together afterward (allow a 50% overlap between images). Careful processing can also be the difference between a good shot and a great one. The results should not appear over-processed (unless that's the look you're going for), but a surprising amount can be achieved, especially with a Raw image. It's a question of being able to recognize the aspects of an image that need attention.

What one tip would you give to budding drone photography masters?

I would say that you need to be self-critical and patient. In order to improve your photography you need to be aware of how your images could be improved, both from a technical and artistic point of view. Once you realize this, you need to have the persistence to go back and improve on your previous work, by visiting a different place, waiting for better conditions, changing composition, or altering the technical camera settings.

What motivates you to continue making photographs?

The simple answer is that I enjoy it. Like most people, I do occasionally get into a creative rut, when I seem to run out of ideas. The fact that I spend a reasonable amount of time working commercially, photographing what I'm told to photograph, means that when I have the freedom to pursue personal projects, I enjoy it that bit more. It's the whole process from hatching an idea, not really knowing whether it's possible or not, then detailed planning, multiple visits to a location, solving problems, and carefully processing the shots. Often it ends in slight disappointment and the feeling of not quite achieving what I wanted, but that's what keeps me coming back for more!

"If you want to shoot a wide area top-down… but you are already at your maximum flight altitude, you can stitch a panorama, taking multiple photographs and stitching them together afterward."

TECHNICAL INFORMATION

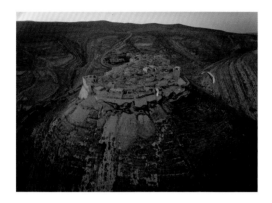

PARAMOTORS AT SHOBAK FORT
SHOBAK FORT, JORDAN

Drone: DJI Phantom 4
Camera: Integrated
Lens: 20mm (35mm format equivalent)
Aperture: f/2.8
Shutter speed: 1/640 sec.
ISO: 100

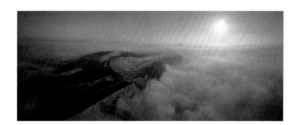

CLIFF FOG
EAST SUSSEX, ENGLAND

Drone: DJI Mavic
Camera: Integrated
Lens: 28mm (35mm format equivalent)
Aperture: f/2.2
Shutter speed: 1/80 sec.
ISO: 100

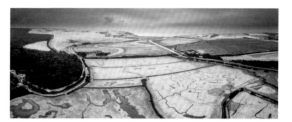

WINTER VALLEY
CUCKMERE, EAST SUSSEX, ENGLAND

Drone: DJI Inspire 2
Camera: DJI Zenmuse X5S
Lens: Olympus 24mm (35mm format equivalent) f/2
Aperture: f/7.1
Shutter speed: 1/50 sec.
ISO: 100

SEA OF CLOUDS STEREOGRAPHIC
TENERIFE,
CANARY ISLANDS

Drone: DJI Phantom 3 Pro
Camera: Integrated
Lens: 20mm equivalent
Aperture: f/2.8
Shutter speed: 1/125 sec.
ISO: 100

LEWES CASTLE ABOVE THE FOG
LEWES, EAST SUSSEX,
ENGLAND

Drone: DJI Mavic
Camera: Integrated
Lens: 28mm (35mm format equivalent)
Aperture: f/2.2
Shutter speed: 1/160 sec.
ISO: 100

STARLING MURMURATION
WEST PIER, BRIGHTON,
EAST SUSSEX, ENGLAND

Drone: DJI Inspire 2
Camera: DJI Zenmuse X5S
Lens: Olympus 24mm (35mm format equivalent) f/2
Aperture: f/2.0
Shutter speed: 1/200 sec.
ISO: 200

MASTER OF GEOMETRY
PETRA LEARY

Petra Leary is an award-winning photographer from New Zealand, whose creative energy has been driven by her travels. Petra prefers to avoid what she calls "monotonous perception," and instead sets out to create out-of-the-ordinary views. Whether this involves using symmetry or motion in architecture, or patterns that can only be discovered from above, the resulting photographs tell a story from a completely different perspective.

Since picking up a camera, Petra's creative journey has taken her across New Zealand, over "the ditch" to Australia, and beyond the Southern Hemisphere to countries including Cuba, Canada, and the United States. Petra's images have been featured in publications and websites around the world, including *Condé Nast Traveler*, *Australian Photography*, and *Lufthansa Magazine*.

3X3

I was helping out as the drone operator for a documentary and music video project that a couple of my friends were putting together. We had originally come to this location earlier in the day, but were caught in a huge downpour. After shooting at some other locations, we headed back to the courts for a second attempt. This court (designed by Parklife NZ) is my favorite of all the basketball courts in Auckland, so I was super-stoked to be shooting here. The court was still quite wet when we arrived, which really made the colors and markings pop, but I used a Polar Pro CP filter to enhance them further. I captured this as a tighter composition to give a more detailed view of what was going on in the game, and to emphasize the color palette of the court.

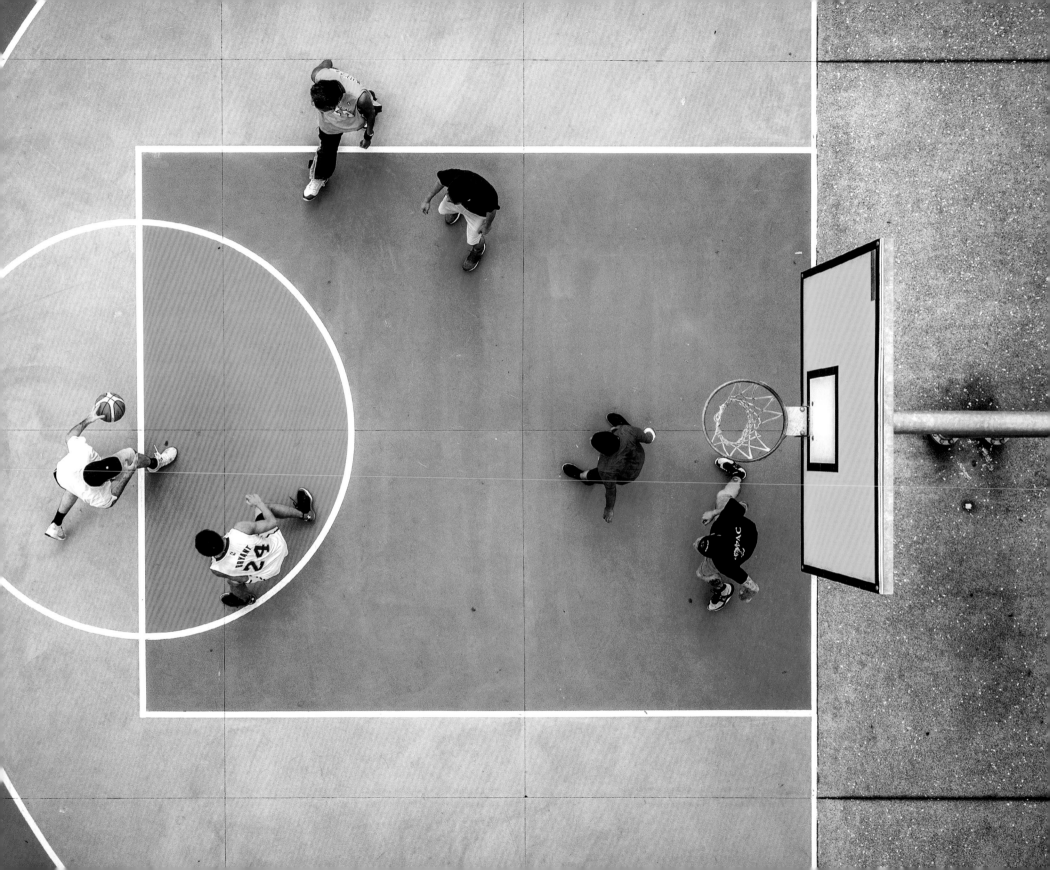

SUNDAY

This old church courtyard in the side streets of downtown Auckland, New Zealand, was one of the first places where I used a drone. Unfortunately, I lost the files from my original shoot, so the plan was to reshoot the same concept of colorful umbrellas against the tiled patterns. I convinced my friend, Marie, to be my umbrella holder, and we headed downtown early on a Sunday morning, when I knew the city would be nice and empty. The weather was gray and overcast, which I usually don't like for drone photography as it can make everything look very flat and dull. For this composition it worked nicely, though, as it meant no shadows were being cast and the focus was purely on the juxtaposition of the bright umbrellas against the grimy courtyard tiles.

100% B

These tennis courts have always stood out for me—I'm drawn to the vibrant blues and subtle variations of blue between the inner and outer courts, contrasting with the clean white lines. I had tried shooting here before, but ran into some technical difficulty at take-off. On this morning, I had headed out toward the eastern cliffs of Auckland with a friend to catch the sunrise. We were returning home, but decided to try to capture some shots of these tennis courts on the way. The weather was clear and warm, and the sun was still rather low, so the light wasn't too harsh, but was also high enough to create the proportioned shadows that give another dimension to the forms of the players on court. I took a five-shot sequence and chose this as the best frame, as it includes the player serving the ball.

Q + A

Your work features strong, graphic compositions, featuring shape, line, and color—how do you come up with such fresh and innovative images?

I spend my spare time walking or skateboarding around different areas in Auckland, in New Zealand, looking for objects, architecture, or places that I think would look interesting from above—often these are the places you would pass without even taking notice of them. Sometimes I'm out with friends and I see a location and think that would look awesome from the air! I also use Google Maps to find interesting locations, and look for new public spaces or buildings that pop up around the city, as I think aesthetics have become far more important with today's designs—they usually include cool shapes and patterns in the structures, shapes, and materials. I think it's important to try different concepts out, and not to get tied up in the subjects you see a lot on social media and the web.

What do you look for in a location for your images?

I look for places that include objects with symmetry, such as climbing pyramid netting on a playground, and that use strong, graphic colors and shapes—these can be colors painted on roads, or materials such as matting on basketball courts or in parks. I look for objects that can create subtle interest in an image. For instance, a yellow container on a courtyard creates a really eye-catching focal point, especially in plain surroundings. I also try to find repetition and balance in a scene. I think this comes from my graphic design background and my perfectionist side—I like lines to be straight or evenly placed, especially when I am shooting courts. When I'm looking for a location for a skateboarding photo, I look for a place where someone can skate, such as a ledge, bench, or rail, as well as surroundings. This is fun because I get to use the things I love doing to come up with ideas for my photography.

Do you use much experimentation in finding concepts for your image, and is timing important to capture your composition in the right light?

If possible I will always shoot either early in the day or late afternoon to try and avoid the midday light; I usually don't shoot if it is overcast and there's little sun. This is just a personal preference, but I find that for the majority of aerial photography subjects, having a lot of cloud can really take away the depth and detail in an image. I like to incorporate shadows into my photos as they add a lot of information as to what something may actually be, and provide a better idea of what the subject is doing than just seeing a top-down view of them. This almost adds another dimension to the photograph. I shoot a variety of compositions from different heights and angles, and like to get close-ups as well as some wide shots, so I have options to play with in post-processing. Experimentation is a big part of drone photography for me—at the moment I am organizing some new concepts for upcoming shoots that involve bubbles, skateboarding, and balloons!

Are you inspired by any other photographers or artists?

There are lots of amazing artists and photographers! One aerial photographer whose work always inspires me is Costas Spathis (@Spathumpa on Instagram)—I find I'm always drawn to his images, he has a really great eye for simple yet captivating photos. Another photographer I recently saw was Massimo Colonna. His work features a lot of really nice architecture, with complimentary colors and minimal environments, but he also throws some unusual objects into the mix, and creates compositions that create a surreal look.

DROUGHT

During a visit to Australia, I planned some day trips to outer areas of the city that I had scouted using Google satellite maps. The plan on this day was to drive two-hours west of Adelaide to Lake Bumbanga, a large pink salt lake that is easily accessible from the road. During the drive, I was amazed by the rich reds and oranges of the soil, created by the constant extreme heat and lack of rain. When we arrived at the car park area next to the lake, I launched my drone and discovered that the combination of the tracking patterns left by farming machinery and the dead crops and fencing created these very intense patterns across the fields surrounding the lake.

PIXELATION

I drove out to the Auckland suburb of Massey with my friends, Tim and Charlie, to skate a newly made courtyard that had recently opened to the public. I shot a bunch of skating sequences before flying my drone further down the pathways where I came across this pedestrian crossing. The bright yellow of the new tiling really stood out against the clean grays of the road and pathways, and it instantly reminded me of an old 8-bit video game. I shot the crossing from various heights, but felt that the tighter composition worked best as the patterns were more obvious and the image seemed rather abstract.

PLAY

This photograph was taken as part of a series of skateboard photos with a friend. This location has to be one of my favorites in Auckland—the color combinations of yellows and pinks, as well as the patterns painted across the concrete, really pop against the dark asphalt and white road markings. I captured this as part of a seven-shot sequence, and used a Polar Pro CP filter to enhance the color saturation. I shot this image with the road as the vertical center line, as I felt that it pulls the viewer's eye to the skateboarder, along with the colored splats that seem to draw into the center point.

Q + A

What do you find is the most difficult aspect of flying and controlling a drone in urban situations?

One problem I have found in urban areas is running into strong magnetic frequencies that affect the signal link between my drones and controller—this happens around structures that contain a lot of metals. Some of the urban areas I photograph involve a lot of planning regarding the timing of the shoot—public spaces in the city have some great locations, but it's always a matter of photographing these in the early morning at the weekend, or during public holidays, as they are too busy otherwise.

What restrictions do you regularly come across using drones in your photography?

The legal restrictions can be a bit annoying sometimes. I understand why they are in place, but at the same time it can be a bit over the top. I find that when I am out in public flying, the majority of people are very welcoming and interested in what I am doing, but I have had a couple of run-ins with security guards and overly paranoid people who assume I am photographing them or say that drone photography is an invasion of privacy. We have a lot of air domes and helipads around Auckland, so I try to keep my flights sheltered from the flightpaths, which has contributed to my style of photography, focusing on close-up compositions from a slightly lower altitude.

How important is it to find a "style" of your own in developing a successful career as a drone photographer?

Having your own style is definitely the way to get your name known—there are so many people taking photos now that being able to stand out and have your work catch people's eye is vital. I originally started doing drone photography just for fun, and not long afterward I was being contacted by people about jobs. One of the first things a client would say is that I had a unique eye and that was what caught their attention.

What motivates you to continue making photographs?

I can't imagine ever stopping drone photography—I enjoy the whole process. I'm really energetic, so being able to walk or skateboard around with the goal of scouting out new places is an awesome way for me to burn energy, and I come up with my best ideas while I'm out and about. The idea of being able to find new places that I have never seen before is definitely a motivation for me.

"Having your own style is definitely the way to get your name known—there are so many people taking photos now that being able to stand out and have your work catch people's eye is vital."

TECHNICAL INFORMATION

3X3
POTTERS PARK, AUCKLAND,
NEW ZEALAND

Drone: DJI Mavic Pro
Camera: Integrated
Lens: 28mm (35mm format equivalent) with Polar Pro CP filter
Aperture: f/2.2
Shutter speed: 1/1250 sec.
ISO: 100

SUNDAY
CENTRAL BUSINESS DISTRICT,
AUCKLAND, NEW ZEALAND

Drone: DJI Mavic Pro
Camera: Integrated
Lens: 28mm (35mm format equivalent)
Aperture: f/2.2
Shutter speed: 1/200 sec.
ISO: 100

100% B
PARNELL, AUCKLAND,
NEW ZEALAND

Drone: DJI Phantom 3 Pro
Camera: Integrated
Lens: 20mm (35mm format equivalent)
Aperture: f/2.8
Shutter speed: 1/1000 sec.
ISO: 100

DROUGHT
LOCHIEL, SOUTH AUSTRALIA

Drone: DJI Mavic Pro
Camera: Integrated
Lens: 28mm (35mm format equivalent)
Aperture: f/2.2
Shutter speed: 1/2000 sec.
ISO: 100

PIXELATION
MASSEY, AUCKLAND, NEW ZEALAND

Drone: DJI Mavic Pro
Camera: Integrated
Lens: 28mm (35mm format equivalent)
Aperture: f/2.2
Shutter speed: 1/2000 sec.
ISO: 100

PLAY
AVONDALE, AUCKLAND, NEW ZEALAND

Drone: DJI Mavic Pro
Camera: Integrated
Lens: 28mm (35mm format equivalent) with Polar Pro CP filter
Aperture: f/2.2
Shutter speed: 1/2500 sec.
ISO: 100

MASTER OF LOW LIGHT
ANDY LECLERC

Andy Leclerc is a drone photographer based in Connecticut, in the United States. Such was his passion for photography from a young age, that he was known as the "camera guy" by family and friends. Andy began creating aerial photography in 2015, after he was introduced to drones by one of his friends—a moment that completely changed his perspective on the world, by giving him what he describes as "a tripod in the sky."

The east coast of the United States provides Andy with a wide variety of landscapes to shoot, ranging from mountains to coastlines. To develop his own creative vision, he has begun shooting more and more in low light or darkness, creating a mood in his images that he hopes makes a special connection with the viewer. He believes passionately in developing new techniques, and in sharing his vision with everyone, explaining his philosophy as "community over competition." His drone photography has been featured on the Skypixel website and at DJI photography exhibitions.

DESOLATION

This shipyard is truly a one-of-a-kind location, offering aerial photographers the potential for unusual and dramatic images like this. Here I used gradual and radial filters in Adobe Lightroom to achieve the light painting effect.

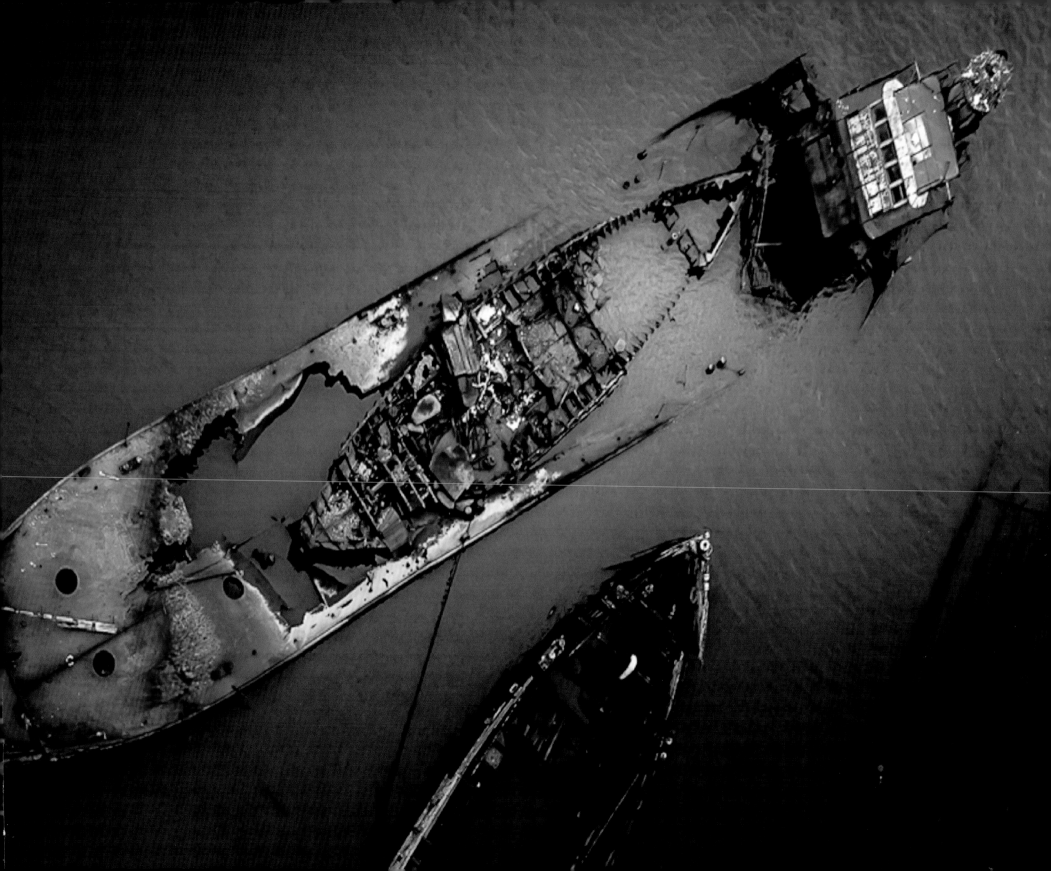

ICE ICE BABY

We had a period of heavy snowfall during winter, which was followed by a cold spell, then a huge thaw and some rain, which resulted in the creation of these giant ice dams, as well as severe flooding. The blocks of ice look like gemstones, but sometimes measured up to 10ft (3m) across.

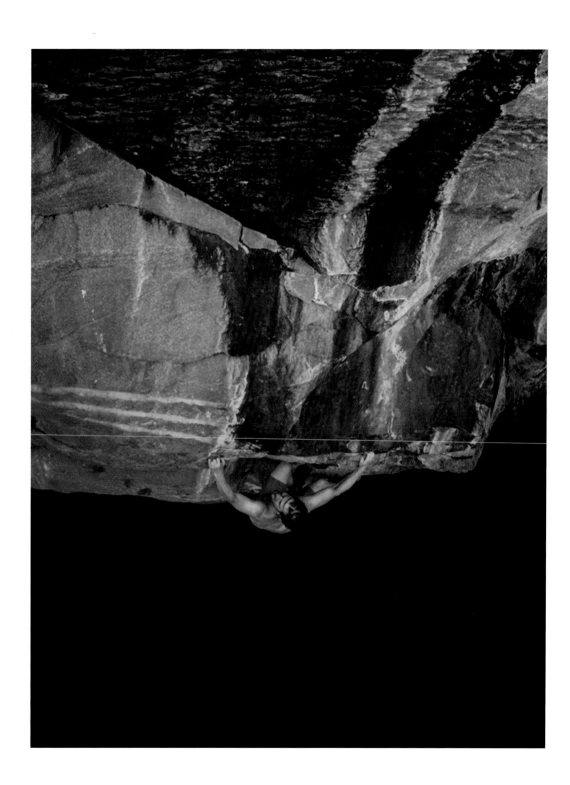

FREE SOLO

This is my friend attempting a "deep water solo" climb, with only the protection of the water below to catch him if he falls. Before drones, we used to have to rope up and take some time to rapel down and take the shots from this sort of perspective, but now you can shoot these in just a few minutes, without as much effort!

Q + A

How did you get started in drone photography?

I never really was a professional photographer, but I always had a camera in my hand. A good friend of mine, Jeff Masotti, introduced me to the world of drones—he said, "Let's go fly my drone," and that changed everything. Within a week, I'd purchased a DJI Phantom 2 with a GoPro Hero 3. Fast-forward to today, and I have DJI Inspire 1. I always had that creative passion, but I never knew how best to use it, but when I got into aerial photography it all kind of made sense to me.

What do you find the most challenging aspects of drone photography overall?

Honestly, I think coming up with your own creative style is what I find the most interesting, and challenging, part of drone photography. Learning how to fly with skill—and doing it safely—just takes time, but the industry has become so saturated with exceptional talent, that learning to separate yourself from everyone else in the field is the main challenge. That's what separates every creative talent, including artists, musicians, and photographers.

Many of your images are taken in low-light or twilight conditions—what attracts you to capturing these types of photographs?

I am moving into that kind of photography now. There's this new style of drone photography—which isn't mainstream yet—called "spotlight" photography, using a drone with an LED light to light up a landscape or a subject. I think that there's scope to bring that to a new level, and I'm exploring that style more. I like shooting in low light or darkness because it helps me create a mood in a scene that I hope the audience can connect with. Sunrises and sunsets also provide unique lighting conditions that you wouldn't be able to repeat any other times, and so they all help me to create something different.

What particular challenges are involved in flying a drone at night?

Obstacles, obstacles, obstacles! Wires are the worst! I always recommend visiting your location at least once beforehand. That way you can make a note of visual markers for yourself, even taking pictures of the area. This helps you to build up an image in your mind of the space in which you're flying. Then, when flying at night, I tend to crank up the ISO, to overexpose—just to brighten up the picture—and that helps me move the drone into position, set up the shot, and then I bring all my settings down for the shot. But it's important not to be a screen-flyer, even in the daytime—you have to always have a line of sight, and be able to see the drone, know where it is, and know what it's doing.

EROSION

Some of the shorelines on Rhode Island can provide really great color contrast and lighting, as here with the surf striking the rocky beach at Newport.

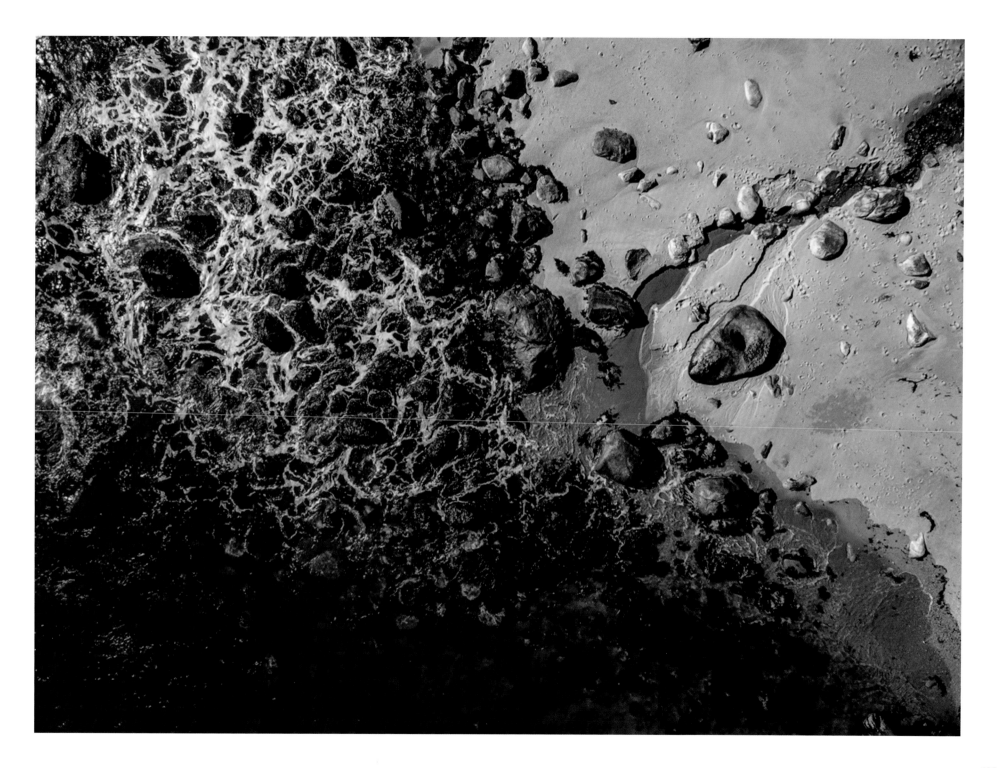

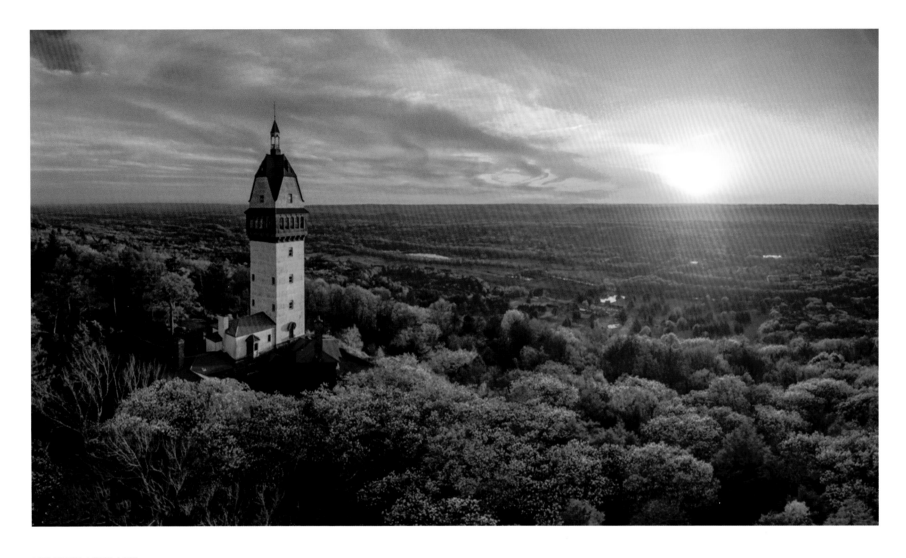

HEUBLEIN TOWER

I've always wanted to capture an epic sunset landscape, and I'm very pleased with this shot of the Heublein Tower. This picture is a composite, made from 24 images, converted into high-dynamic range files, and then stitched together to create the final panorama. In Adobe Lightroom, I used a graduated filter over the upper third of the image to pull the colors of the sunset back.

INCEPTION

I've always enjoyed learning new photographic techniques—they keep inspiring me and firing my imagination. Ever since I saw the movie *Inception*, I've always wanted to try this particular technique. For this picture, I shot three automatic exposure bracketed images, then merged them as a high-dynamic range file, before creating the mirror effect in Adobe Lightroom.

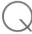 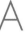

Q + A

What special camera settings do you use in low-light conditions?

Drones are not very stable platforms, so shooting in low light can be very challenging. Usually, I play with the shutter speed and ISO, but depending on the sensor you're working with, you can't crank up the ISO too much, because this generates a lot of noise in the picture. I generally don't shoot at higher than ISO 200, and then I have to play with the shutter speed to compensate, but no more than three seconds. I set the white balance to 3,000K for night photography, especially for cityscapes, as this makes the image look more natural. Also, I turn on the "rule of thirds" grid on the screen on my iPad, and that helps me see if the drone is moving around, which helps, because, especially at night, you can't see a heck of a lot!

How do you create your panoramic shots?

There are a few settings I turn on before I fly. The "rule of thirds" grid helps me frame each image in my panorama accurately, and I set the aspect ratio to 4:3 so I'm using the camera's full resolution. Once my drone is in position, I frame my shots carefully, and shoot a sequence of images from left to right, simply rotating the camera with the left stick in a smooth manner. The most important thing to remember is to overlap each image by at least a third to ensure the software can stitch the images together—nothing is more annoying than having to go back and shoot it all again!

What one tip would you give to a budding drone photographer?

Always use your own creative license, and create from your heart. Remember that when people hire you, they're not hiring you for the drone or camera you have, they're hiring you because of your own creative vision and imagination. That is something you cannot buy—it has to come from within. Better drones and cameras will only enhance the vision you have. It's good to look up to others, but don't compare yourself to them—a good friend of mine said "Comparison is the thief of joy!"

What motivates you to continue making photographs?

Locations, locations, locations! And the people I meet along the way, with their willingness to share their knowledge. Social media has had huge benefits for me—I follow a lot of people and I want to go to the places they go to, and they want to go to the places I go to! They really inspire me, and I love being able to inspire them as well.

"Remember that when people hire you, they're not hiring you for the drone or camera you have, they're hiring you because of your own creative vision and imagination."

TECHNICAL INFORMATION

DESOLATION
ARTHUR KILL, NEW YORK, USA

Drone: DJI Inspire 1
Camera: Integrated
Lens: 20mm (35mm format equivalent)
Aperture: f/2.8
Shutter speed: 1/400 sec.
ISO: 100

ICE ICE BABY
EAST HADDAM, CONNECTICUT, USA

Drone: DJI Inspire 1
Camera: Integrated
Lens: 20mm (35mm format equivalent)
Aperture: f/2.8
Shutter speed: 1/400 sec.
ISO: 100

FREE SOLO
BECKET QUARRY, MASSACHUSETTS, USA

Drone: DJI Phantom 4 Pro
Camera: Integrated
Lens: 24mm (35mm format equivalent)
Aperture: f/2.8
Shutter speed: 1/240 sec.
ISO: 100

EROSION
NEWPORT, RHODE ISLAND, USA

Drone: DJI Inspire 1
Camera: Integrated
Lens: 20mm (35mm format equivalent)
Aperture: f/2.8
Shutter speed: 1/600 sec.
ISO: 100

HEUBLEIN TOWER
SIMSBURY, CONNECTICUT, USA

Drone: DJI Phantom 3 Pro
Camera: Integrated
Lens: 20mm (35mm format equivalent)
Aperture: f/2.8
Shutter speed: 1/1000 sec.
ISO: 100

INCEPTION
BOSTON, MASSACHUSETTS, USA

Drone: DJI Inspire 1
Camera: Integrated
Lens: 20mm (35mm format equivalent)
Aperture: f/2.8
Shutter speed: 1/840 sec.
ISO: 100

MASTER OF THE ARCTIC
FLORIAN LEDOUX

Florian Ledoux started photography when he was 12 years old while traveling with his family, but he never imagined that it would become his purpose in life. A self-taught photographer, he began to develop his knowledge until he became skilled enough to become a photojournalist in the French military navy. It was during this time that Florian returned to what had started his passion in the first place—his love of the beauty of nature, and of the isolated and wild places of the Arctic—and he began his own photography project in Greenland.

Florian was inspired by many great nature photographers, including Vincent Munier, Paul Nicklen, Sebastião Salgado, Paul Souders, and Brian Skerry, and is always in search of wild places, where the colors of the Earth are never the same, and encounters with nature and people forge the spirit. Florian travels the world with the aim of sharing his passion and, above all, making people aware of nature's fragility.

GREENLAND COLORS

East Greenland is known as one of the most isolated and wildest places in the world. With its jagged mountains and deep fjords filled with giant icebergs, it is a truly unique and mesmerizing landscape. Here, as the sun rose above the bay of Tasiilaq, the sky turned red; there are lots of colors to be seen every day in Greenland.

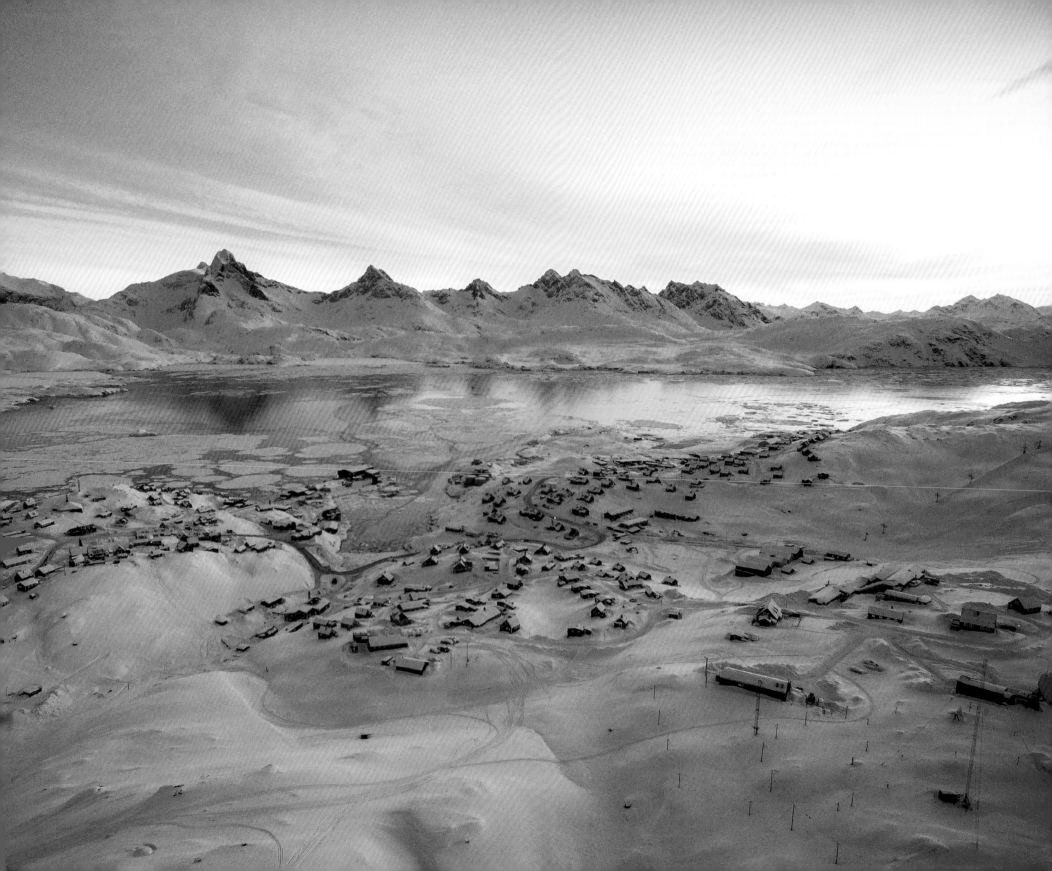

NATURE JEWELRY

As the pack ice starts to form in East Greenland, it takes many different, beautiful shapes when seen from above. During a flight from the Kulusuk settlement to an iceberg out in the water, my drone was attacked by two gyrfalcons, so I decided to turn return to land. On the way back, looking down with the camera, I saw these beautiful ice patterns. Despite their beauty, it is sad that I was able to record these patterns in February: the sea ice has been forming later and later in recent years.

VEINS OF THE EARTH

On a road trip in Iceland, driving a random valley in the north of the country, this river took on a totally different perspective once I viewed it from the air with the drone. The view from above reveals incredible lines and patterns. The rivers in Iceland get wider during the summer as the glaciers melt. During this time, they often look like the veins of our blue planet as they drain the sediments into the fjords and out to sea.

Q + A

What draws you to photograph the Arctic and its wildlife in particular?

I love the Arctic for its immense landscape and nature—it remains so wild and almost untouched by human activity. You can sail, hike, and explore for several days or weeks without any sign of human presence. The scale of the landscapes, where such incredible species live, draws me there. I was deeply touched while I took my first journey above the Arctic Circle when I was 10 years old, and this feeling is something that is still growing in intensity as I explore further. When I find myself in the remote Arctic, and encounter and engage with the people and wildlife that call it home, everything makes sense to me. This is what I live for. This is, I guess, "passion."

Do you already have an image in mind before drone take-off, or do you look for images when airborne?

Drones allow me to fly where a helicopter could not. Before flying, I study maps and satellite images to see where the landscapes and patterns are the most appealing. However, when it comes to wildlife, it is hard know what I will find and where. Most of the time, I am surprised by the amazing beauty of Earth from above— like the day I shot belugas in turquoise water, or when I took off above the ice pack. Every flight is such a wonderful moment.

What special challenges do you face when using drones in such cold and remote locations?

Every time I fly a drone in the Arctic, I am super-stressed! Indeed, flying in the high Arctic can be very difficult for the drone, and risky—I've crashed few drones shooting my images! The Arctic is remote and close to the magnetic pole, so there is a lot of interference, causing compass errors that totally inhibit a drone. Controlling a drone is more difficult from a sailing boat as well, as it is a constantly moving reference point for the operating system. Also, because drone batteries can discharge quickly in very cold temperatures, I have to keep them close to my warm body until the last possible moment before take off. However, the batteries in the latest DJI Phantom 4 Pro+ aren't so much of a problem, and the Inspire 2 and Zenmuse X7 camera use batteries that are self-heating.

Does the light from snow and ice-covered landscapes present exposure problems, and how do you solve them?

The dynamic range depends on the drone model. With a basic model, it can be hard to find a good exposure level because of the difference between the brightness of the sky and the ice. Also, when shooting top-down on snow and ice the camera—just like a normal DLSR—will tend to underexpose the photograph, so you need to be ready to use exposure compensation.

THOUSAND BELUGA

During the summer, beluga whales migrate north in the Arctic. When we arrived at the estuary, we first saw white lines far away and thought it was the waves, but we realized after a while that it was thousands of belugas all around us. Beluga whales live in pods in the shallow waters of the estuaries, where they spend the summer rubbing their old skin on gravel and sand on the estuary bed; they sometimes get stuck ashore, struggling until the next tide comes in.

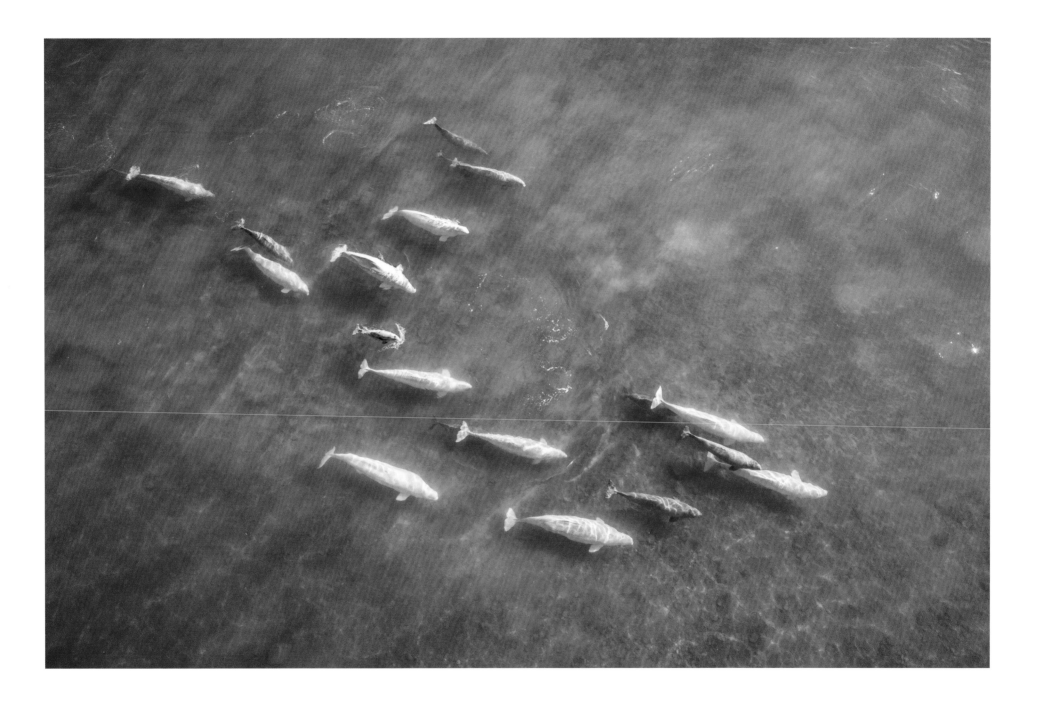

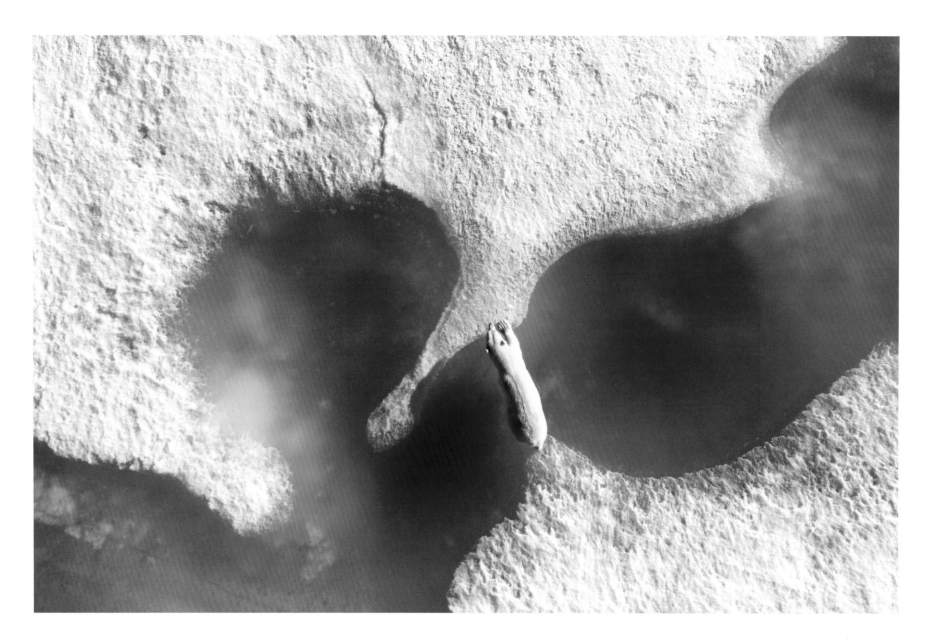

MAJESTIC BEAST

This polar bear was crossing the melting ice during the summer. Polar bears are facing a range of threats that might impact their future; they are among the first refugees of climate change. I will always remember my first polar bear encounter—I cried during the three hours we stayed close to them! It is such an incredible animal, a combination of power and control, they walk with majesty and stand with wisdom.

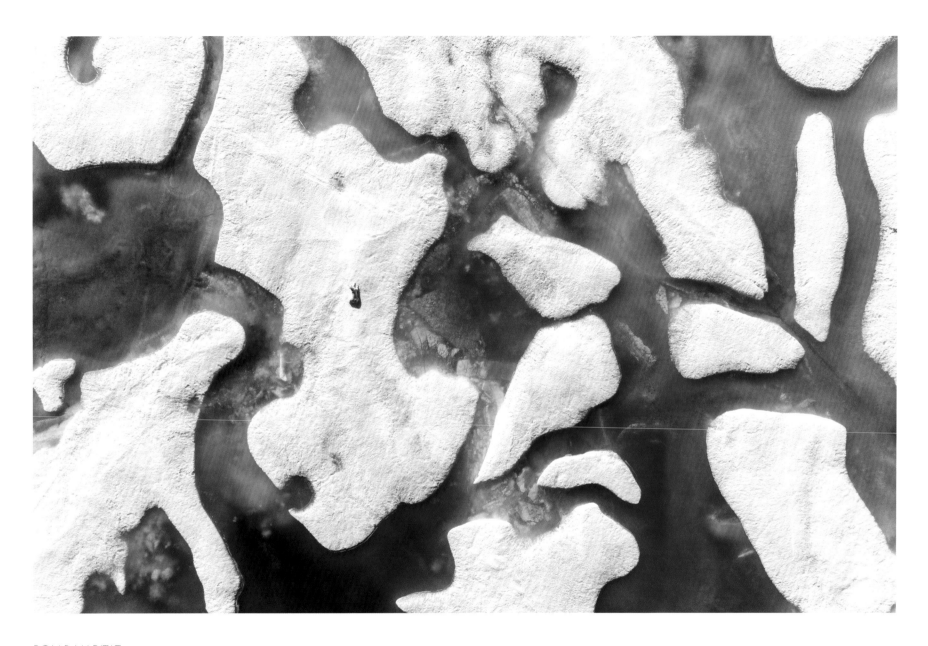

POLAR HABITAT

On our last expedition in 2017, we spent most of the time sailing between small pieces of pack ice that were too thin to hold a polar bear. Polar bears are excellent swimmers, but they need the pack ice to hunt seals (their preferred prey) and to rest. Much of the time, we found polar bears on shrinking pack ice or—in the worst cases—swimming or on shore in fjords with no ice at all. In these circumstances the bears need to expend more effort and energy to feed themselves and their cubs than they can eat, pushing them to starvation. This image shows a polar bear in its habitat in Nunavut during the summer.

Q + A

Do you spend a lot of time post-processing your images? What are the main steps you take when editing images?

I love the fact that we can shoot in Raw format now with drones. However, you do need to do some post-processing on an image, just as you would do with film in the past. The first step I take during editing is to add some sharpness in the image, then I adjust the contrast and colors. The final step is to add logical file names and numbers, write captions, and add metadata to ensure I can find my images easily after I've archived them.

When photographing Arctic wildlife with a drone, what are the most important things to remember?

As well as all the technical challenges of flying a drone in the Arctic, you have to remember that normal regulations still apply there. It goes without saying that you must not fly above or close to an airport, or over people. But not disturbing wild animals and birds is of utmost importance as well. I often visit any animals I wish to photograph first, without using the drone. I study their natural habitat, learn about their behavior, and document them. I spend up to eight hours approaching them and with them, ensuring they are not threatened by my presence. Only after spending this time with them do I fly my drone. You can see on the different photographs and video footage I shoot that the wildlife is not stressed by me or the drone. Sometimes, I can end up quite close to a polar bear, for instance, and it doesn't really mind.

What has been your most memorable experience shooting in the Arctic?

On our most recent expedition in the Canadian Arctic, we sailed 3,700 miles (6,000km) in eight weeks, and encountered thousands of beluga whales in a bay, swimming under our dinghy, narwhals in the next fjord, a colony of walruses hauling out onshore, as well as musk oxen and Arctic foxes. But the highlight of the expedition was definitely the encounter with the polar bear standing just 20ft (6m) away from us. For me there is no better feeling than being close to these majestic animals and sharing space with them. I will always remember the moment I saw my very first polar bear.

What motivates you to continue making photographs?

I set out to bring a new perspective to the wildlife that we already know well from traditional photography. Drones allow us to observe and document the behavior of wild animals from new angles and with a new approach, showing them and their wider habitats in a way not possible before. I want my photographs to help inform people about wildlife conservation, and I would like to take part in more scientific projects to help protect these wonderful animals.

"Not disturbing wild animals and birds is of utmost importance as well. I often visit any animals I wish to photograph first, without using the drone."

TECHNICAL INFORMATION

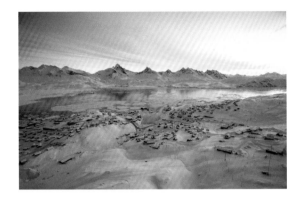

GREENLAND COLORS
TASIILAQ, EAST GREENLAND

Drone: DJI Phantom 3 Pro
Camera: Integrated
Lens: 20mm (35mm format equivalent)
Aperture: f/2.8
Shutter speed: 1/50 sec.
ISO: 178

NATURE JEWELRY
KULUSUK, EAST GREENLAND

Drone: DJI Phantom 3 Pro
Camera: Integrated
Lens: 20mm (35mm format equivalent)
Aperture: f/2.8
Shutter speed: 1/25 sec.
ISO: 131

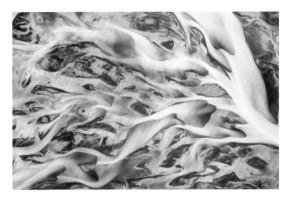

VEINS OF THE EARTH
VARMAHLID, ICELAND

Drone: DJI Phantom 4 Pro+
Camera: Integrated
Lens: 24mm (35mm format equivalent)
Aperture: f/5
Shutter speed: 1/50 sec.
ISO: 100

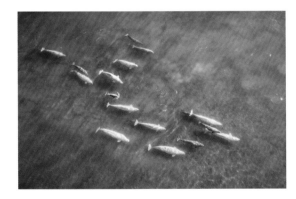

THOUSAND BELUGA
SOMERSET ISLAND, NUNAVUT, CANADA

Drone: DJI Phantom 4 Pro+
Camera: Integrated
Lens: 24mm (35mm format equivalent)
Aperture: f/8
Shutter speed: 1/200 sec.
ISO: 100

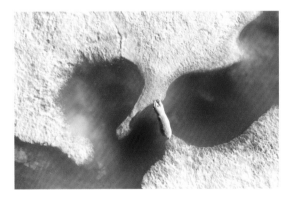

MAJESTIC BEAST
TREMBLAY SOUND, NUNAVUT, CANADA

Drone: DJI Phantom 4 Pro+
Camera: Integrated
Lens: 24mm (35mm format equivalent)
Aperture: f/8
Shutter speed: 1/640 sec.
ISO: 100

POLAR HABITAT
TREMBLAY SOUND, NUNAVUT, CANADA

Drone: DJI Phantom 4 Pro+
Camera: Integrated
Lens: 24mm (35mm format equivalent)
Aperture: f/8
Shutter speed: 1/800 sec.
ISO: 100

MASTER OF ARCHITECTURE
BACHIR MOUKARZEL

Bachir was born and raised in Lebanon, in a village in the mountain province of Kahale, and is now based in Dubai. His love of photography and videography began with action cameras, and has grown and developed with the introduction of drone technology. Bachir started his drone photography career by capturing breathtaking, never-before-seen images of Dubai. His work has since attracted worldwide attention, and has been featured around the globe on CNN and in publications including the *Daily Mail*, *Houston Chronicle*, and local newspapers.

He is a certified commercial pilot and PolarPro brand ambassador, and works for and contributes to different government entities in Dubai, including the Government of Dubai Media Office and Dubai TV. Bachir has recently begun to tour the Philippines, capturing aspects of the country from his unique aerial perspective.

CONCRETE JUNGLE

This image won first prize in the Urban category of the Dronestagram International Drone Photography Contest of 2017. The photograph features Dubai Marina, which has been named as the "tallest block in the world" as it is home to six of the 10 tallest residential buildings in the world. It took me months to capture this image—I had to wait a long time for clouds in the sky to eliminate the shadows at ground level, so it was possible to see the details of the area around the skyscrapers. For me, the image symbolizes the evolution of Dubai, from a desert to a concrete jungle.

THE ENDLESS FLIGHT OF NATURE

More than five million fresh plants were used to create this life-size version of an Emirates A380 airplane at the Dubai Miracle Garden. This is one of my most famous images, and frequently features in publications and online. The story behind the plane and gardens has helped the success of the image. This unusual perspective, with its wide angle to capture the lines and colors of the gardens, gives life to the photograph.

TETRIS GAME

Dubai is famous for its communal architecture and road planning, and the best way to see these urban layouts is from above, using a top-down viewing angle. In this image you can see how the roads and buildings form wonderful geometric shapes. I shot this picture after sunset in order to avoid any shadows, and to provide a clear view of the patterns made by the architecture.

Q + A

What is your background, and how did you get into drone photography?

My background is far from photography—I studied finance at the American University in Dubai and went on to work as a financial controller for a hotel chain in the Middle East. When drones started to emerge on the market, I bought one immediately, as I knew that they offered the perspective that I was looking for in my photographs. I always wanted to capture the urban lifestyle and architecture of Dubai from a new angle, one only seen from airplanes and helicopters. The immense skyscrapers, roads, and desert are perfect for being captured from the air, with their huge sizes, structures, and shapes.

What particular hazards or problems do you face flying drones in city environments?

The main hazard in Dubai is the busy sky—it has got one of the busiest airports in the world and there are plenty of helicopters and seaplanes for tourists flying around. This means an approval is required before flying, preferably at sunrise, when the city sky is quiet. The next problem is the high amount of interference with the drone's signal, with lots of skyscrapers and WiFi connections everywhere. Lastly, it can be very windy in Dubai in winter, and it is very important to check before you fly so you can control your drone.

What are the steps you take before and during a flight to ensure a safe and successful drone photography session?

First of all I check the batteries of the remote controller and the drone, to make sure I have sufficient power for my flight. I also check all the rotors and the temperature of the drone, since Dubai is a hot city, especially in summer. I then check my planned flightpath to ensure that it is clear of any high buildings or helicopter routes. I always undertake low-altitude maneuvers to check the behavior of the drone before I go higher.

What key piece of advice do you have for people flying drones in these environments?

The best advice is to choose a very open space in the first place for your take-off and landing, such as an empty parking lot or a wide-open area. This provides a good signal for the drone, away from any signal interference, and means that you can keep your drone in your line of sight during the flight.

SAFE AT HARBOR, WILD AT SEA

This image is of a dock in old Dubai. Trading by sea has long been a traditional part of life in the city. Here, the colorful old wooden ships are being loaded with their cargoes and prepared for sailing early in the morning. I used an ND4 polarizing filter in this shot to avoid any reflection of the sun on the water.

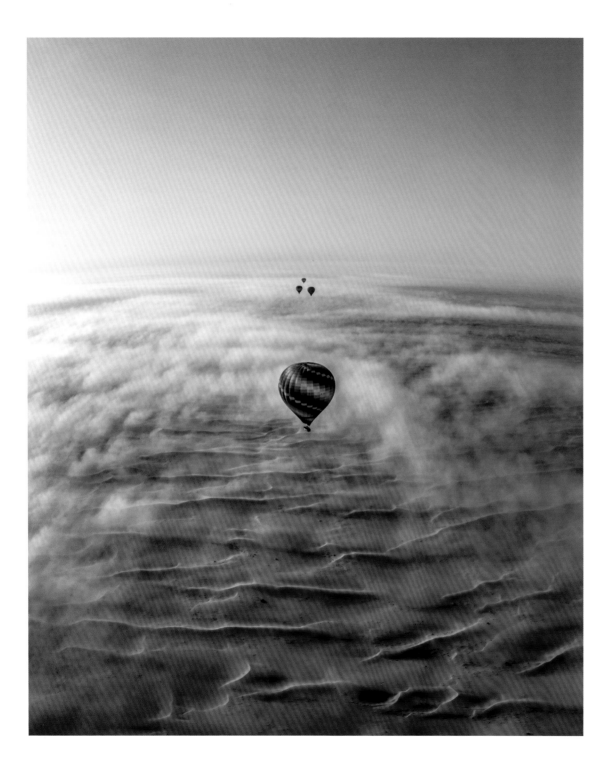

A PLACE TO GET LOST IN YOUR DREAMS

Although I've been a drone photographer for quite some time, I wanted to challenge myself and shoot in a different environment, away from the cityscapes and urban sprawls I am used to—I wanted to chase a hot air balloon with my drone. The day that I set out into the desert of Dubai, I was both excited and scared, as there were many potential dangers involved. But as soon as the white clouds settled between the balloons, I knew it was worth it—the view was simply incredible.

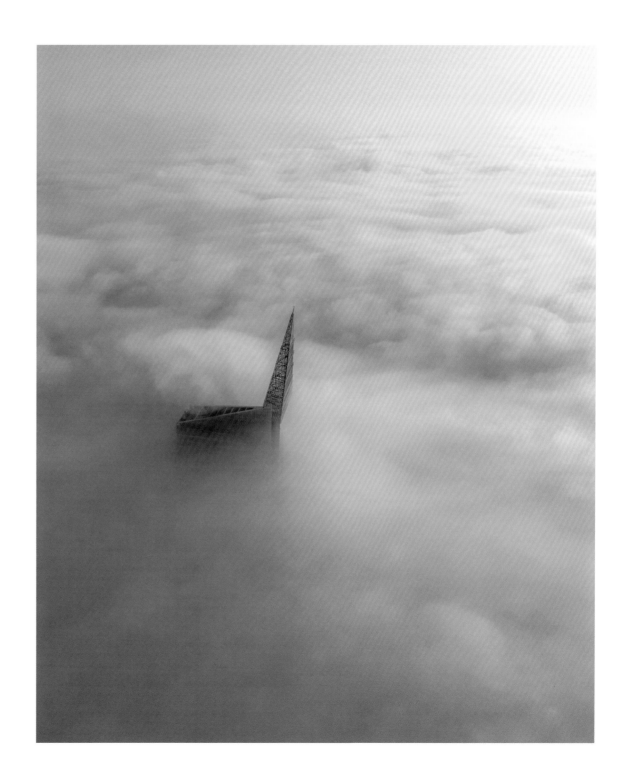

LAST SURVIVOR

Fog has long been a common phenomenon in Dubai, but the rise of the skyscrapers in the last 10 years has made it more interesting visually. Sometimes, we wake up to a blanket of fog first thing in the morning that covers all of the city, except for the tops of the buildings. I called this image "Last survivor" as this skyscraper was the last to stay above the fog that day.

How do you envisage a shot and plan your flight?

Planning a shot is very important; I don't take off and then search for an image when the drone is in the air. I use Google Maps to help me envisage my shots—I look for nice geometrical shapes, such as roads, buildings, and other architectural features, and plan my composition. I then plot the flight in advance by first choosing the best location to take off from, to ensure a fast, efficient flight to the viewpoint from which I will shoot the image. I use Google Maps to plot the angle and the timing of the shot (at sunrise, midday, or sunset, for instance)—this is the most important part.

Why do you choose such high altitudes to shoot your images?

Dubai is home to the tallest skyscrapers, and this is what makes my drone photographs so interesting. Great altitudes are needed in order to capture these buildings, and to fit a lot of information in a frame. I don't always need to fly so high to capture such details, but Dubai is very different to other cities—with its immense architecture and urban spaces.

What do you find so inspiring about being able to capture artificial structures from the air?

I'm inspired by being able to capture the progress of a city. When I came to Dubai in 2002, a lot of the towers and buildings didn't exist—it was just desert and sand lots. The architecture here proves to me that nothing is impossible. They built a city in a very short time from scratch, and now it has become home to the best architecture communities in the world. And I find all of that very inspiring.

What motivates you to continue making photographs?

The online engagement and the support I get from people all over the world motivates me every day. I feel I have a responsibility to perform and deliver the best aerial photographs to keep inspiring them in turn, and to showcase the spectacular city of Dubai. Many people in Dubai follow me on social media and look forward to seeing their city from a different, new perspective.

"I use Google Maps to plot the angle and the timing of the shot (at sunrise, midday, or sunset, for instance) —this is the most important part."

TECHNICAL INFORMATION

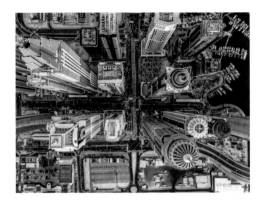 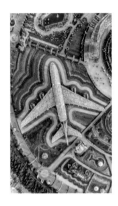

CONCRETE JUNGLE
DUBAI MARINA, DUBAI,
UNITED ARAB EMIRATES

Drone: DJI Phantom 4 Pro
Camera: Integrated
Lens: 24mm (35mm format equivalent)
Aperture: f/4.5
Shutter speed: 1/1000 sec.
ISO: 100

THE ENDLESS FLIGHT OF NATURE
DUBAI MIRACLE GARDEN, DUBAI,
UNITED ARAB EMIRATES

Drone: DJI Phantom 4 Pro
Camera: Integrated
Lens: 24mm (35mm format equivalent)
Aperture: f/4.5
Shutter speed: 1/2000 sec.
ISO: 100

TETRIS GAME
DISCOVERY GARDENS, DUBAI,
UNITED ARAB EMIRATES

Drone: DJI Phantom 4 Pro
Camera: Integrated
Lens: 24mm (35mm format equivalent)
Aperture: f/3.5
Shutter speed: 1/320 sec.
ISO: 100

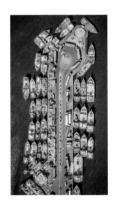 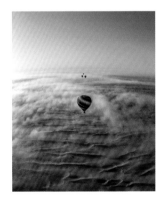 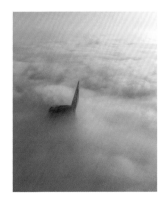

SAFE AT HARBOR, WILD AT SEA
DUBAI CREEK, DUBAI,
UNITED ARAB EMIRATES

Drone: DJI Phantom 4 Pro
Camera: Integrated
Lens: 24mm (35mm format equivalent), 2-stop ND4 polarizing filter
Aperture: f/4
Shutter speed: 1/1000 sec.
ISO: 100

A PLACE TO GET LOST IN YOUR DREAMS
MARGHAM, AL AIN ROAD, DUBAI,
UNITED ARAB EMIRATES

Drone: DJI Phantom 4 Pro
Camera: Integrated
Lens: 24mm (35mm format equivalent)
Aperture: f/4.5
Shutter speed: 1/2000 sec.
ISO: 100

LAST SURVIVOR
SHEIKH ZAYED ROAD, DUBAI,
UNITED ARAB EMIRATES

Drone: DJI Phantom 4 Pro
Camera: Integrated
Lens: 24mm (35mm format equivalent)
Aperture: f/4
Shutter speed: 1/1000 sec.
ISO: 100

MASTER OF COASTS
KARA MURPHY

Kara Murphy was born and raised in California, in the United States, and spent the better part of 15 years working for top music industry and tech brands in the Bay Area, before moving to Michigan. She has been a professional photographer since 2009, but was primarily working on the music festival circuit as an in-house photographer for Outside Lands and Noise Pop; her images have appeared on CNN and in mainstream publications including *Fortune* magazine. After picking up a drone for the first time in 2014, her aerial photography has featured regularly in *Drone360 Magazine* as well as online at The Drone Girl and AirVuz.

Kara has worked as both a Part 107-certified remote pilot and marketing consultant for top industry brands including Intel, DroneDeploy, and Flying Robot International Film Festival. An avid writer, she is currently a columnist for iQ by Intel and Dronelife. Her online print store, Aerial Print Shop, launched in April 2018.

BLACK SAND BEACH

Iceland boasts over 130 volcanoes. Eighteen of these have erupted since settlers arrived in the ninth century. Blackened basalt lava flowed into the sea and has been gradually ground up into fine gravel, giving the appearance at a distance of black sand. There were hundreds of seabirds flying around this popular tourist destination on the southern coast of the island and I happened to catch this one by accident.

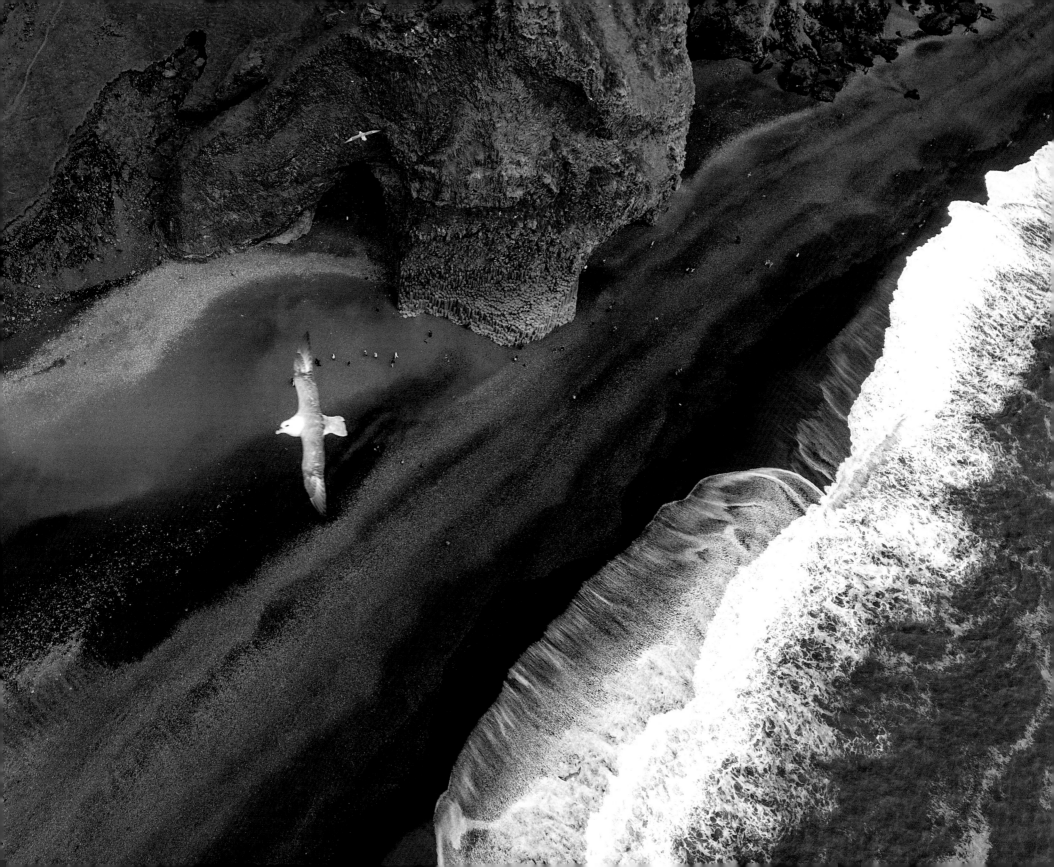

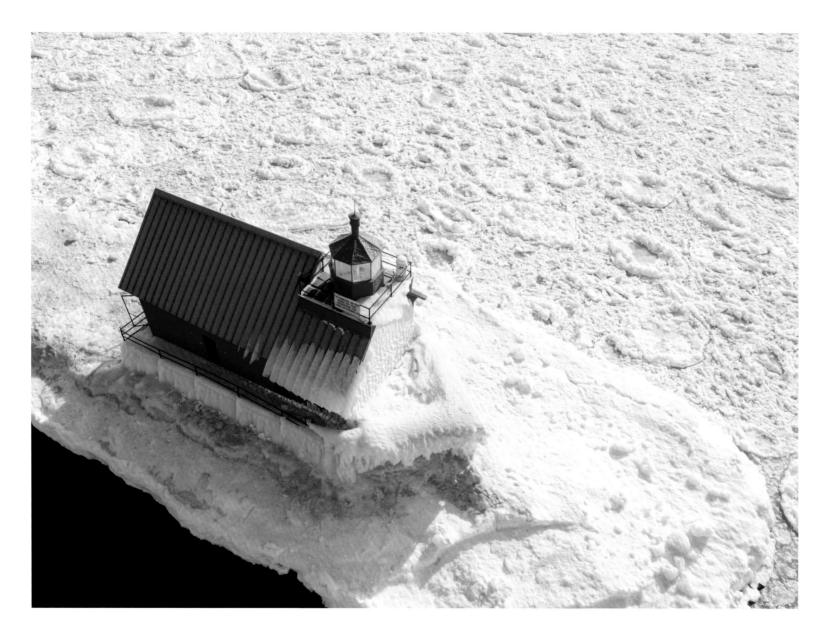

GRAND HAVEN LIGHTHOUSE

The coasts of Michigan and Wisconsin are outfitted with numerous lighthouses. Grand Haven Lighthouse, an iconic landmark in the small beach town located 45 minutes northwest of Grand Rapids, is covered in ice at the peak of winter and surrounded by ice pancakes—circular formations that result from swirling sections of water that freeze slowly.

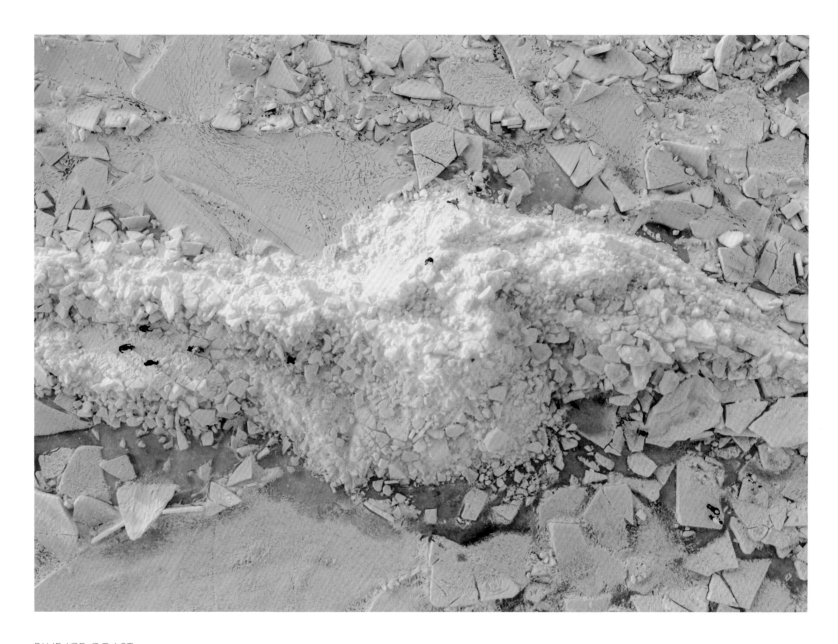

BLUE ICE COAST

Every year, fragments of blue ice get swept into piles along the coast of Mackinaw City. Because the ice doesn't have bubbles, it lacks chlorophyll and only reflects the blue parts of "white light." The PolarPro ND4 filter I used on this sunrise shot brought out its unique hue.

You were a live music and event photographer—what inspired you to take your photography to the skies?

I've been a music fan since I was a child and, as a result, worked in the music industry for most of my career. Entering the photo pit at a show or festival, and capturing artists in their raw essence was thrilling for me. However, after a while, I became restless and my output started stagnating. I'd look at music sites or their respective social feeds and realize that many of my peers were capturing similar images to mine. I wanted to find some other way to create unique work that I could put my signature style on, in a space that wasn't saturated yet. That's when, in early 2014, I happened across my friend Nate Boltron's nadir image of Martha's Vineyard coastline, taken from about 60ft (20m) off the ground. At that moment, I knew I needed to learn how to fly a drone.

How do you set about planning one of your drone photography shoots?

There are several ways I go about finding new places and subject matter to photograph. I sometimes find myself browsing Google Earth far past my bedtime for unique structures and landscapes. I also belong to local drone groups where members share their work, and tune into regional social media channels to keep aware of any unique phenomena or events. And I keep a copy of the book *Atlas Obscura* on my nightstand for inspiration. Before I head out, I go through a checklist to make sure that I have all my gear, that it's charged and functioning properly, and that I have authorization to fly the airspace my subject occupies. Finally, I check the weather forecast, including wind speed, to ensure it's safe to fly.

When flying a drone to shoot coastal images, what are the important things to remember?

First and foremost, always use a polarizing filter. If it's even slightly sunny, you're going to have glare on the water, so a filter is mandatory. I didn't take this step a few times, in my early days of flying, and found myself post-processing images far more than necessary. Sometimes glare simply isn't fixable. So check the weather conditions before you take off, including wind speed—especially if you're flying near a shoreline that has cliffs or ledges.

Are there any other subjects that inspire you?

I really enjoy urban settings. My grandfather was an architect and taught me how geometric concepts were fundamental to the structural design of buildings. When I fly in cities like San Francisco and Grand Rapids (where I'm currently based) I always look out for the patterns that inform the city's architectural landscape. Besides the coast, I enjoy other natural settings such as lakes and forests. I always keep an eye out for contrasting elements and abstract formations.

GRAY WHALE COVE

Even though gray whales can often be seen at this state beach, 18 miles (29km) south of San Francisco, I was able to capture a different kind of beauty at sunset. I added some saturation during post-processing to enhance the coppery tones of the cliffs and hills.

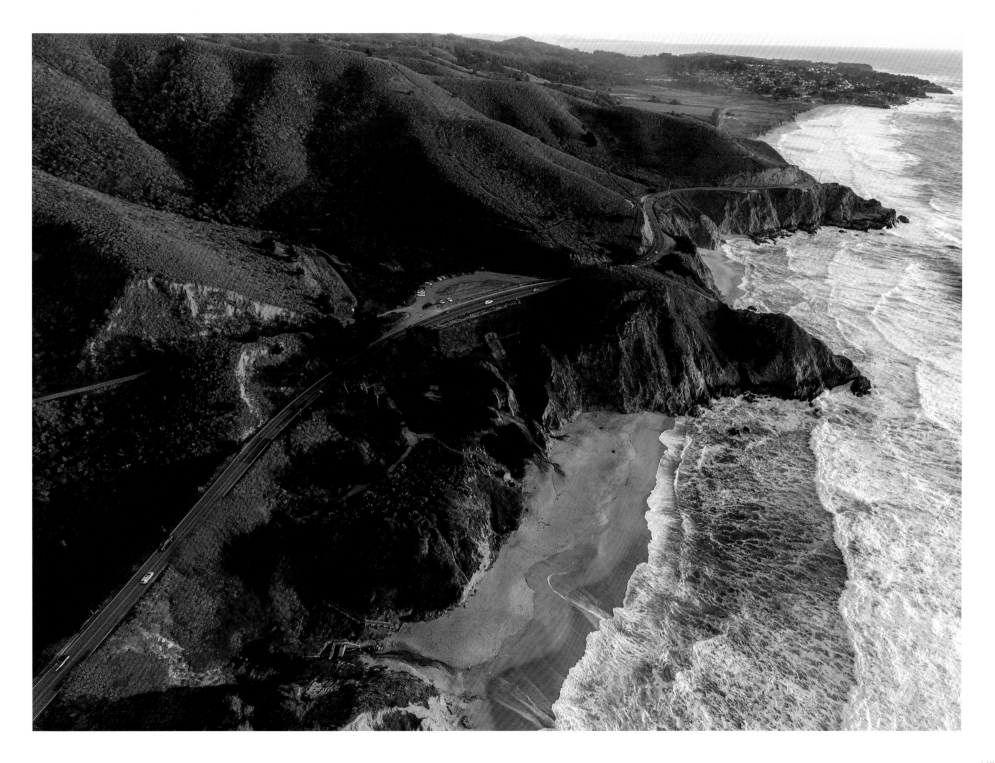

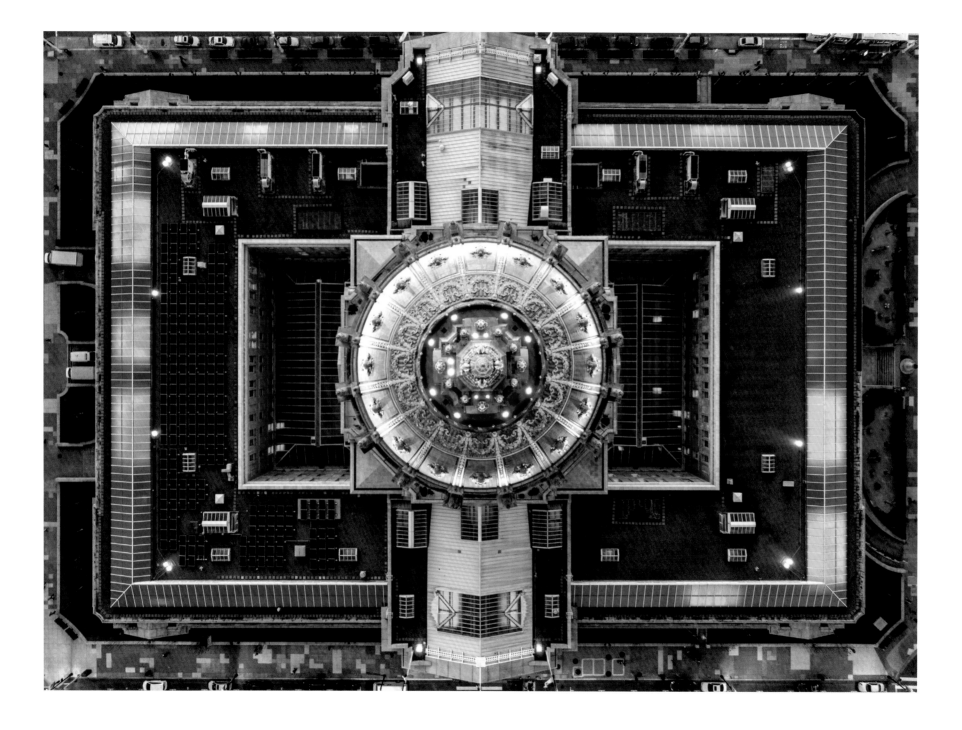

CIVIC CENTER

This is a top-down perspective of San Francisco's beautiful, historic City Hall building. It was taken on January 2017 at dusk, right after the sun officially set. Although I receive many questions about this, the shot was taken perfectly legally; most of San Francisco is open, as the downtown area is located 10 miles (16km) from the airport.

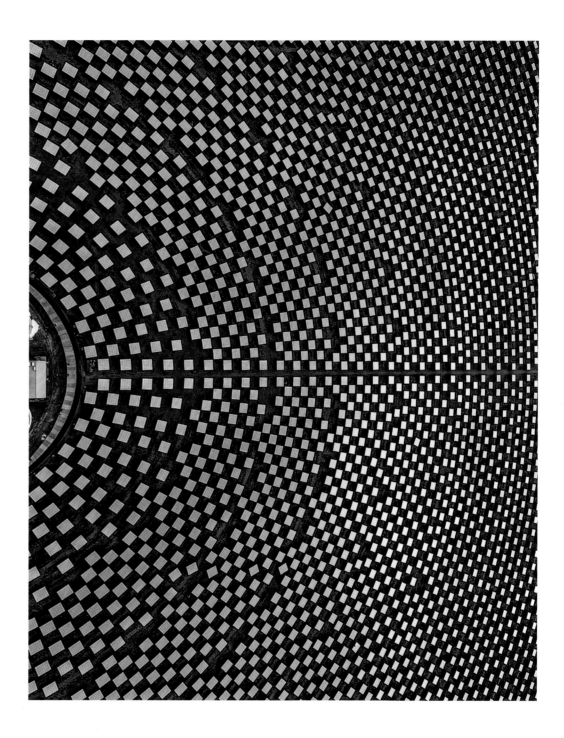

SOLAR PANELS

The first of its kind, this facility consists of more than 10,000 mirrored panels and generates enough energy to power over 75,000 homes in the area. I was looking for an abstract image that captured the patterns created by the huge number of panels.

Q

+

A

What settings do you favor to maximize image quality?

While some of the more modern cameras are capable of capturing decent images with automatic settings, you're really missing out on the potential to create the most stunning image possible by not taking manual control. I like to activate automatic exposure bracketing (AEB) and shoot either three- or five-bracket sets if I'm unsure of optimal settings, or if I want to layer them later in post-processing. I recommend that everyone learns how ISO, shutter speed, and aperture work together, although with a drone I typically shoot at ISO 100 for the crispest images possible and rarely deviate from this setting. I like to keep the white balance in automatic mode unless it's particularly cloudy, and I always shoot in Raw. Even though the files are substantially larger, you have many more options when you are processing your images.

How do you think drone photography will change in the future?

While drones are giving users an entirely new perspective, the market is beginning to get saturated as commercial-grade UAVs become more affordable. This is starting to reflect in the "sameness" I see with certain landmarks and compositions. With this new demand, however, drone manufacturers are developing better drones with higher-caliber cameras. The quality of photos has improved over the past few years as sensors have gotten larger and megapixels increased. I've seen a few remote pilots, including one of my favorite artists, Reuben Wu, get innovative by attaching a Lume Cube to their drone and using it as an instrument to create something unique and new. People who dream up atypical ways of using this relatively new technology, and create something that resonates with a larger audience, are going to make a lasting impact.

Do you have any recommendations— or words of warning—regarding the importance of social media in being a successful photographer?

I know people who are remarkably talented and have produced incredible work. Unfortunately, they're too afraid to share it on any public platform. It's truly a shame and a loss for the artistic community. No one is immune to criticism and cutting remarks, but when that happens it means you're making enough of an impact to elicit a reaction. My best-selling print is an overhead shot of San Francisco's Lombard Street, which receives plenty of praise, peppered with the occasional comment that it's "overly saturated"— someone will always have an opinion! If you choose to be active on social media, and share your work through channels, try to be as consistent as possible with your updates. Don't let long periods of time go by where you don't post anything. Your fans will lose interest. Pick three or four platforms that make sense and build larger, more engaged followings. Also, stick to your specific theme. I sometimes post something off-topic and it doesn't get any response. My followers are interested in drone-related content so that's what I overwhelmingly deliver. Be specific and drill down into a niche that helps your brand stand out.

What motivates you to continue making photographs?

My favorite part of being a photographer is that it makes you view the world differently. I know that sounds like a cliché, but it's true. You begin to notice things in your everyday life that usually wouldn't capture your attention. It's also true with aerial photography. I'll be walking around or driving somewhere and see something that makes me wonder what it would look like from a drone's perspective. Drones, and the advantageous aerial perspective they provide, give you so many more options to capture unique imagery in places that may have normally been inaccessible. My photography is the best medium to express my personality and vision. Having a medium that offers up an infinite amount of possibilities both thrills and motivates me no end.

TECHNICAL INFORMATION

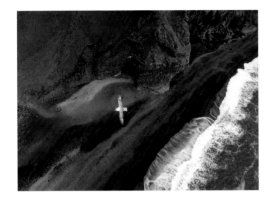

BLACK SAND BEACH
VIK BEACH, REYNISFJARA, ICELAND

Drone: DJI Phantom 4
Camera: Integrated
Lens: 20mm (35mm format equivalent)
Aperture: f/2.8
Shutter speed: 1/800 sec.
ISO: 100

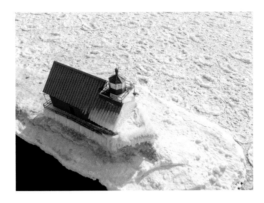

GRAND HAVEN LIGHTHOUSE
GRAND HAVEN, MICHIGAN, USA

Drone: DJI Phantom 4 Pro
Camera: Integrated
Lens: 24mm (35mm format equivalent), Vivid ND16 filter
Aperture: f/4
Shutter speed: 1/400 sec.
ISO: 100

BLUE ICE COAST
MACKINAC STRAITS, MICHIGAN, USA

Drone: DJI Phantom 4 Pro
Camera: Integrated
Lens: 24mm (35mm format equivalent), Vivid ND4 filter
Aperture: f/2.8
Shutter speed: 1/60 sec.
ISO: 100

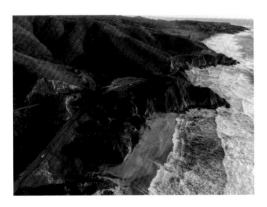

GRAY WHALE COVE
STATE BEACH,
CALIFORNIA, USA

Drone: DJI Phantom 4
Camera: Integrated
Lens: 20mm (35mm format equivalent), Vivid ND8 filter
Aperture: f/2.8
Shutter speed: 1/100 sec.
ISO: 200

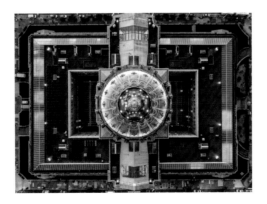

CIVIC CENTER
SAN FRANCISCO CITY HALL,
SAN FRANCISCO, CALIFORNIA, USA

Drone: DJI Phantom 4 Pro
Camera: Integrated
Lens: 24mm (35mm format equivalent), Vivid ND4 filter
Aperture: f/2.8
Shutter speed: 1/15 sec.
ISO: 200

SOLAR PANELS
CRESCENT DUNES SOLAR ENERGY PROJECT,
NYE COUNTY, NEVADA, USA

Drone: DJI Phantom 4
Camera: Integrated
Lens: 20mm (35mm format equivalent), Vivid ND4 filter
Aperture: f/2.8
Shutter speed: 1/125 sec.
ISO: 100

MASTER OF MOTION
SEAN STALTERI

Sean Stalteri developed a love of photography when he was around 15 years old, and he has had a lifelong passion for the outdoors and exploration. A self-taught photographer with a keen eye for aesthetic beauty, Sean found his niche in both drone and traditional photography. He currently sells fine art prints of his work and also does commercial drone work.

Sean spends much of his time on snow-covered mountains or on the ocean, both of which offer excellent opportunities for capturing the motion that is such a distinctive characteristic of his drone photography. Water is a recurring motif, and the perfect vehicle for capturing vivid movement in all its different forms. Sean's philosophy is that, just as water gives us life, so it gives life to his photographs.

RACING HOME

This image was taken from my backyard—from the deck you can see this road. It had just snowed and the traffic was making lines in the snow. I sent the drone up in the hope of getting a shot like this with a snowplow, but I couldn't get a clear shot of one—they weren't driving straight enough and in order to get a shot like this the drone has to fly exactly in sync with the subject. So I settled on making the photograph with a bus. It came out better than I expected, with the light pouring out at the front, and the street lights at the left side. The light really makes the lines in the snow "pop," bringing all of the elements in the image together.

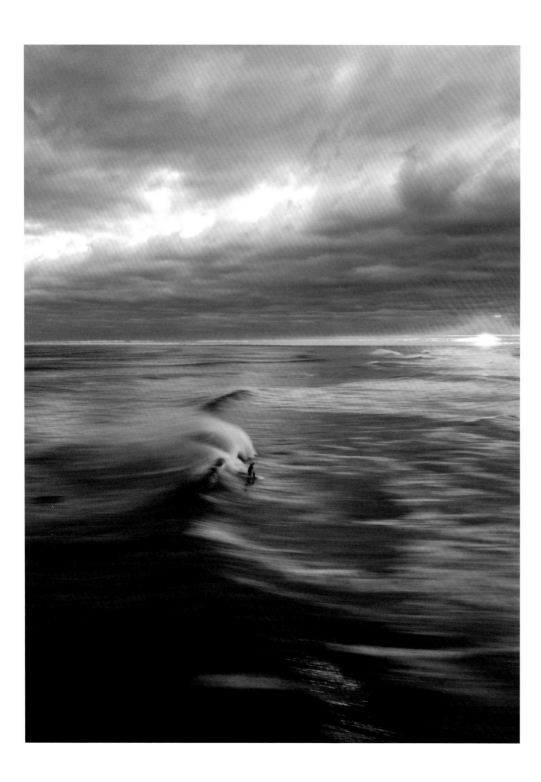

A SECOND OF SUNSHINE

This shot was over a year in the making. Waves don't come to New York very often, but when they do, they're great! The only problem is they normally come with storms, which means the conditions are cloudy and the light isn't optimal. This day was the same—cloudy all day. But for a brief couple of minutes, just as the sun was about to dip below the horizon, everything came together. I was able to take maybe 30 photographs in the short time, and a couple came out. All of my practice over the previous year, and thousands of terrible pictures, led to this photograph.

NEOPRENE NINJA

This was a lucky shot. In order to get these surf blurs, you have to fly in perfect sync with the surfer. But they are constantly turning in different directions, and making all sorts of movements. On top of that, when you hit the shutter, you lose your view for a split second, so you have to anticipate where the wave and surfer will be going in order to keep taking more shots. Everything somehow lined up for this one, and I was able to be right on top of the surfer—exactly what I wanted. There are lots of shots like this of surfers that have been taken in the water or from the land; but I wanted to be the first to do it from the air!

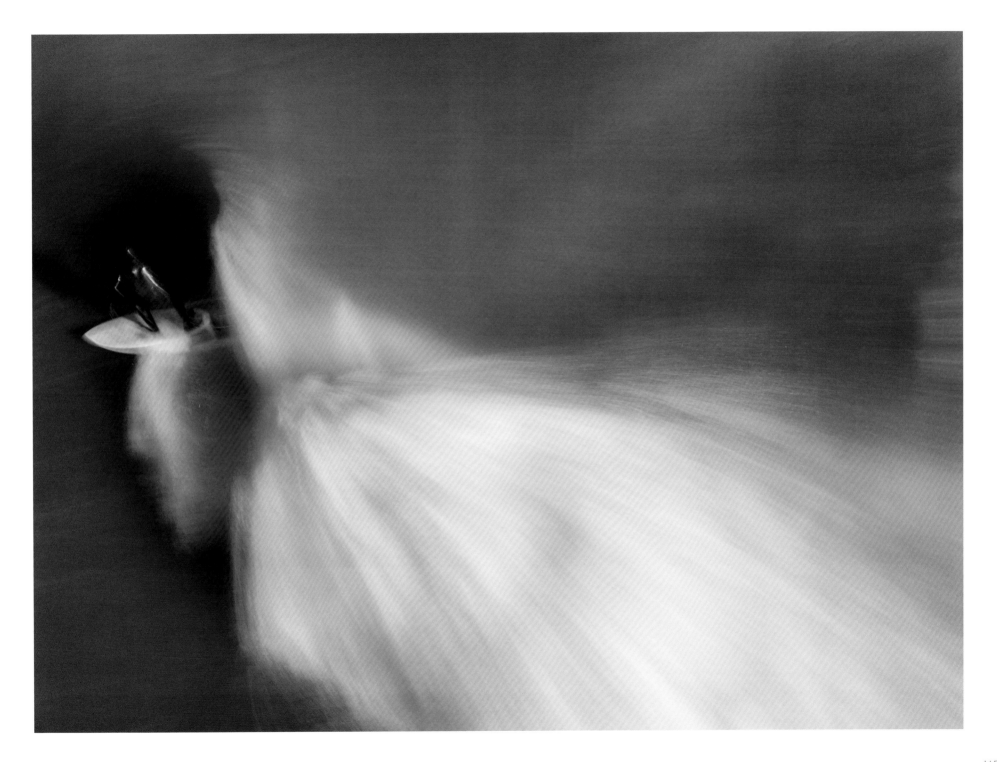

What do you look for when you set out to create a strong drone image?

When creating a composition, there are a few things I like to look for. For starters, I look for water in all its forms: the ocean, ice, clouds, anything with water! Water gives us life and it gives photographs life because it is constantly changing, providing a unique scene every time. I then try to provide some context and scale, so maybe I'll wait for a boat to drive by, or have somebody go for a swim in the frame. I like bright vibrant colors, but it can be tough at times to find something different—but after a lot of searching, you are bound to find a color that "pops" and stands out. All summer, here in the northeast, it is just green, green, green—but when fall strikes, you are given a brand new canvas of beautiful colors to work with.

How do you research a location before you visit?

The internet is a great tool for researching locations. When I'm bored or need some inspiration, I will hop on Google Maps and just move around the map in satellite view, looking for things that catch my eye. I can then just drop a pin, and have instant directions to the location—it is amazing. I also use Instagram a lot, because most people tag the location of their photos. By browsing through different locations, tags, and people's feeds, it's possible to discover new places that are worth of a visit. I like looking through a lot of different pictures of the same place, and then thinking about how I can go there and make a photograph that is going to stand out. It's extremely important to think outside the box and try to make something unique, especially now that everyone has the internet and a drone and can just fly up and take the same picture over and over again. Some photos might get you more Likes, but they are probably just the boring, generic shot of a place. Be different and bold so you can create something special.

How does composing a drone-shot landscape image differ from creating a ground-shot image?

I think it's important to treat a drone landscape image the same as a ground-based image. The rules of photography still apply and they should be followed and broken accordingly. Looking at the monitor of a drone is like looking through my camera's viewfinder—it's just much easier to get around. Whether on the ground with my camera or flying the drone, I'm just trying to create the most beautiful image possible. I want the photograph I create to be good enough to hang on a wall somewhere.

Do you have the image in your mind before you launch the drone?

I visualize a lot of my photographs quite some time before. You never know when you'll be sitting around the house and have an idea for a photograph. I'll then figure out how I can execute the shot. Sometimes, it's much harder to execute than I originally thought, but it is part of the work to figure it out. An amazing thing happens when you go out and try and execute a shot with the drone. You put it up in the air with the purpose of taking a photo of one thing, but then you are flying around and you see something that is even more interesting than the original target. Now, I might photograph both or just focus on the new find. You never know what kind of intriguing things you will find from up in the sky.

HYPER CORN

I was driving around the countryside for a few hours, looking for a solitary tree to photograph. The sun was starting to set and I hadn't found one I liked yet. I stopped next to this corn field and put the drone up—this beautiful, gnarly tree came into view. This shot shows that you don't have to fly high to unlock the creativity of drones. I threw my trusty 10-stop ND filter on the lens, and locked focus on the tree. I then began to fly backward very fast while shooting a few images. I kept repositioning, and doing it over and over, until I was happy with the feel of the photograph—part-running through a corn feel and part-flying right above the cobs!

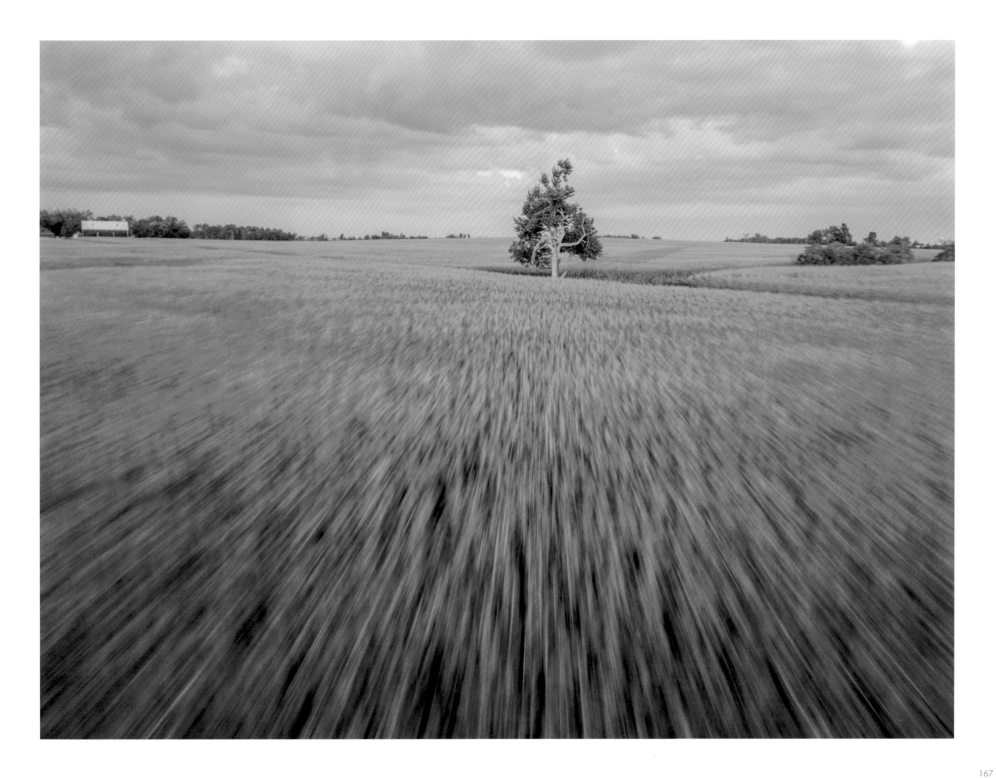

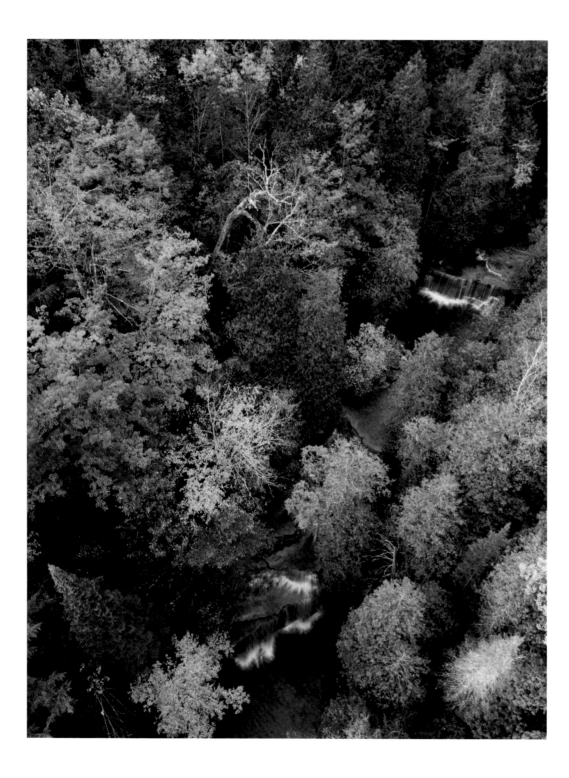

A RIVER FALLS THROUGH IT

Fall is a magical time of year. The constant green turns into vibrant orange, yellow, and red, transforming the landscape and giving you plenty of reasons to get outside and take photographs. Without a drone you would only be able to photograph one of these falls at a time. I decided to blur the water, because I think it just makes waterfalls look serene among the forest, but this was easier said than done! The difficulty with a shot like this is the wind, which constantly moves the drone and the trees. It can also be difficult to take off and land in a situation like this—drones don't like tree branches, so you need to keep practicing your flying to make sure you can cope with situations like this.

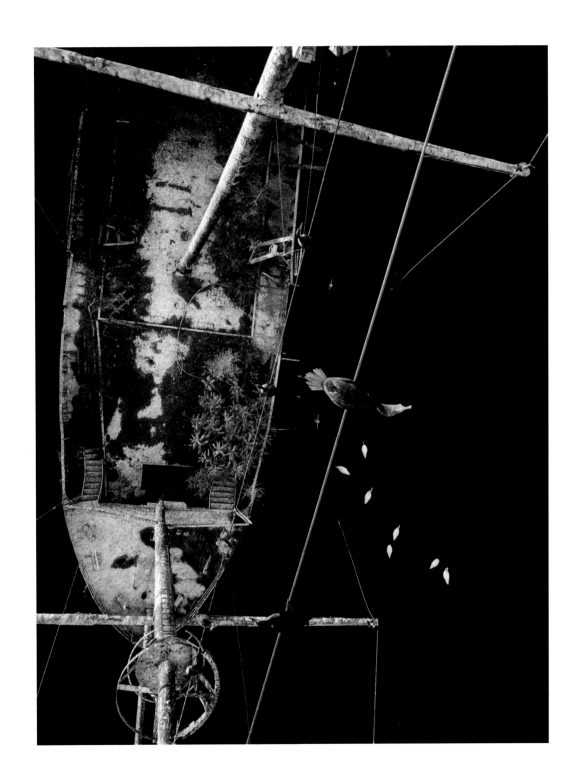

CAPTAIN CORMORANT

I've photographed this shipwreck before, and I anticipated getting a shot of the whole boat as usual. But there was a large flock of cormorants just hanging out on it. This guy didn't care about the drone, and kept watch over everything. It was sunset and the sun was striking his beautiful brown feathers perfectly. The white swans below him add a nice contrast, giving a sense that he is high above everything. I like making photographs with my drone that at first glance don't look like they are from a drone but would be impossible without one.

Q + A

What are the most important aspects of flying a drone to master?

Today's drones are incredibly easy to fly—they can almost fly themselves! However, you still need to be a skilled pilot, because you need to be comfortable flying it to truly unleash your creativity and get the best results. Read the manual, practice in a wide-open space (a lot!) and fly as much as you can. When you are comfortable flying the drone, and not worried about crashing potentially thousands of dollars of kit, you will get much better results. To me, the drone is just a camera in a different kind of support—yes, it's fun to fly, but that's not why I have it. It's a camera you can put wherever you want, and the more comfortable you are with it, the more it is an extension of you, and the better your photographs will be.

What particular challenges do you face as a drone landscape photographer?

You face some challenges that ground-based photographers don't have or can more easily overcome—the biggest being the weather. You can't fly when it's too windy or raining, but for a landscape photographer these can be some of the best times to shoot. With a DSLR a simple plastic bag can protect your gear, but there's no such easy fix with a drone and it can be very frustrating when you visualize a photograph you want to take, but the weather doesn't allow it. Hopefully, within the next few years, weather-proof drones will come down in price.

What role does social media play in your drone photography?

I spend too much time on Instagram and on other social media! Instagram is a good place to find new locations, and to connect with people, and get your work out there. It's also a great place for finding inspiring photographers and seeing the amazing work they are doing. It can also be incredibly frustrating. You spend so much time taking amazing photographs and then you put it in a little square, and people cannot see what you truly captured. A lot of the time, it favors the same old types of photos and they can become stale. It can be tough to see someone else's picture is blowing up, and the picture you worked so hard to create isn't going anywhere! But that's not the reason I'm out taking pictures. I love doing it, and I would be doing it if there weren't social media. It is something we have to use, but not as much as we do. Keep taking amazing pictures, no matter if you get one Like or a million.

What single piece of kit is most useful in your work?

The most important pieces of equipment I use are neutral density (ND) filters. The camera on my drone has a fixed aperture, so, in order to reduce my shutter speed and achieve motion in my photographs, I must use a strong ND filter. You don't need the fanciest equipment, you just need to use whatever you have to its full potential. A small piece of gear is all you need to make yourself stand out. Master what you have—if you can't take good photographs with a sub-par camera, a fancy one will not help you.

"It's a camera you can put wherever you want, and the more comfortable you are with it, the more it is an extension of you, and the better your photographs will be."

TECHNICAL INFORMATION

RACING HOME
ONTARIO, CANADA

Drone: DJI Mavic Pro
Camera: Integrated
Lens: 26mm (35mm format equivalent)
Aperture: f/2.2
Shutter speed: 0.4 sec.
ISO: 200

A SECOND OF SUNSHINE
LONG ISLAND, NEW YORK, USA

Drone: DJI Mavic Pro
Camera: Integrated
Lens: 26mm (35mm format equivalent), 10-stop ND filter
Aperture: f/2.2
Shutter speed: 1/4 sec.
ISO: 100

NEOPRENE NINJA
LONG ISLAND, NEW YORK, USA

Drone: DJI Mavic Pro
Camera: Integrated
Lens: 26mm (35mm format equivalent), 10-stop ND filter
Aperture: f/2.2
Shutter speed: 0.4 sec.
ISO: 200

HYPER CORN
ONTARIO, CANADA

Drone: DJI Mavic Pro
Camera: Integrated
Lens: 26mm (35mm format equivalent), 10-stop ND filter
Aperture: f/2.2
Shutter speed: 1/4 sec.
ISO: 100

A RIVER FALLS THROUGH IT
ONTARIO, CANADA

Drone: DJI Mavic Pro
Camera: Integrated
Lens: 26mm (35mm format equivalent), 10-stop ND filter
Aperture: f/2.2
Shutter speed: 0.8 sec.
ISO: 400

CAPTAIN CORMORANT
ONTARIO, CANADA

Drone: DJI Mavic Pro
Camera: Integrated
Lens: 26mm (35mm format equivalent)
Aperture: f/2.2
Shutter speed: 1/100 sec.
ISO: 100

JP & MIKE ANDREWS
MASTERS OF ABSTRACT

www.abstractaerialart.com

Brothers JP and Mike Andrews formed Abstract Aerial Art on a trip to Australia in 2016. They continue to travel the world looking for the best aerial shots, and their adventures can be followed on their blog. The aim with each image is not to work out what it is but to appreciate how weird and wonderful the world can look from above.

Instagram: @abstractaerialart
Blog: abstractaerialart.com/blog/
Facebook: abstractaerialart

FRANCESCO CATTUTO
MASTER OF MOOD

www.francescocattutophotographer.com

Francesco Cattuto is based in Emilia Romagna, Italy, but travels the globe for photography-related projects. He was the winner in the Travel category of the 2016 Dronestagram International Drone Photography Contest. Francesco's work has been featured in *Vanity Fair*, *Sunday Times* magazine, *SpazioItalia*, *Digital Photographer*, *RC Flight Camera Action*, and *RotorDrone* magazine. He has exhibited at Fotografia Europea 2016 and Assisi Drone Festival 2018.

Instagram: @fcattuto
Blog: francescocattutophotographer.com/blog/
Facebook: FrancescoCattuto.Photographer

AMOS CHAPPLE
MASTER OF LIGHT

www.amoschapplephoto.com

Amos Chapple is a Kiwi making news-flavored travel photography. His stories have regularly appeared on the front page of Reddit and other viral news platforms. In 2015, photos he shot with a modified drone were compiled into a photo gallery that received more than 6 million page views.

Instagram: @amos.chapple
Facebook: amoschapplephotography

TUGO CHENG
MASTER OF RHYTHM

www.tugocheng.com

Tugo Cheng is a Hong Kong-based fine art photographer whose awards include 2015 National Geographic International Photo Contest First Prize; 2016 International Photographer of the Year Grand Prize Winner; and 2018 Hasselblad Masters Landscape Finalist. His works have been exhibited in Asia and Europe, and featured by major media including CNN, *The Guardian*, and *National Geographic*.

Instagram: @tcycheng
Facebook: tugochengphotography

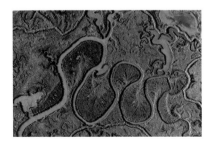

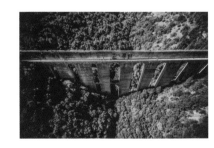

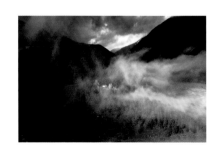

JEROME COURTIAL
MASTER OF LANDSCAPE

www.masterdronephotography.com

Jerome Courtial is a French photographer based in London. His work attracted international attention in 2016, when his work featured in the DJI anniversary book, *Above the World*, and two of his shots appeared in the '20 best drone images of 2016' by Dronestagram. In 2017, he won best drone image in the Nature category, which was subsequently published in *National Geographic*. Jerome runs Master Drone Photography, a website dedicated to helping photographers take and edit better drone photography.

Instagram: @jcourtial

STACY GARLINGTON
MASTER OF OCEANS

www.djiphotoacademy.com

Stacy Garlington is co-owner and instructor at the DJI Aerial Photography Academy, which offers intensive one-day classes designed to give valuable insight to attendees wanting to create top-quality, compelling, marketable aerial drone photography. Her drone images have been published in *Forbes*, *Time*, and *GQ* magazines.

Instagram: @dronediva
Facebook: Stacy Weskerna Garlington

TOBIAS HÄGG
MASTER OF COLOR

www.airpixelsmedia.com

Tobias Hägg is a photographer and filmmaker based in Eskilstuna, Sweden. His work has been published all around the globe in publications including *National Geographic*, *The Telegraph* and the *Daily Mail*, and has featured in exhibitions at the Swedish Museum of Photography at Fotografiska. He is an official ambassador for the outdoor brand Fjällräven and is passionate about photographing nature.

Instagram: @airpixels
Facebook: airpixelsmedia

DAVID HOPLEY
MASTER OF COMPOSITION

www.drawswithlight.co.uk

Based in York, England, David Hopley is regarded as one of the UK's most pioneering and inspirational fine art drone photographers. He has received Highly Commended and Commended awards in the Landscape Photographer of the Year competitions 2016 and 2017, and was a finalist in the Outdoor Photographer of the Year competitions 2016 and 2017. His work has featured in publications including the *Sunday Times Magazine*, *Outdoor Photography*, *Photography Week*, *Amateur Photographer Magazine* and *PhotoPlus Magazine*.

Instagram: @drawswithlight
Blog: drawswithlight.co.uk/blog/

 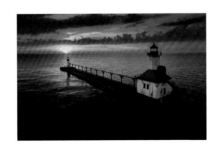 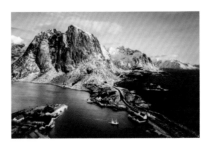 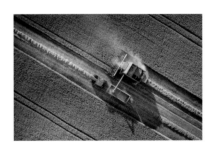

KARIM ILIYA
MASTER OF TRAVEL

www.karimphotography.com

Karim Iliya is a professional aerial cinematographer (drone pilot), underwater photographer, filmmaker, and whale-swimming guide based on the island of Maui, Hawaii. His photography has featured in *National Geographic* and *National Geographic Traveler* magazines. Karim's humpback whale photography won the 2018 Hasselblad Masters, Wildlife category.

Instagram: @karimiliya
Whale trips and photo workshops:
www.dancewithwhales.com

FERGUS KENNEDY
MASTER OF PANORAMA

www.ferguskennedy.com

Fergus Kennedy is a commercial drone operator, diver and marine biologist. His photography has been highly commended in the Wildlife Photographer of the Year competition, and he is a regular contributor to *Outdoor Photography* magazine. His company, Skylark Aerial Imaging, provides high-quality aerial video, photography and 3D imaging for clients including the BBC, ABC Television, Canon Europe and WWF.

www.skylarkaerialimaging.com
Instagram: @fergus_kennedy_photography
Publications:
Drone Photography and Video Masterclass, 2017

PETRA LEARY
MASTER OF GEOMETRY

www.petraleary.com

Petra Leary has featured in several group and solo exhibitions in Auckland, New Zealand, most recently in Post Graffiti Pacific Third Edition at The Pah Homestead, Wallace Arts Centre, in 2018. She also won first place in the 2017 DJI Skypixel Aerial Photography Contest in the Portrait Category. Petra is currently working on a project on Instagram: @skateparksofnewzealand. This is an ongoing project with the goal of mapping the many skate parks across New Zealand.

Instagram: @petraleary

ANDY LECLERC
MASTER OF LOW LIGHT

www.andy-leclerc.pixels.com

Andy Leclerc is a drone photographer based in Connecticut, USA. He began creating aerial photography in 2015, and his work has gained popularity through Instagram, Skypixel website, and on exhibition with DJI photography.

Instagram: @aleclercphotography
Print store: andy-leclerc.pixels.com
Facebook: andy leclerc

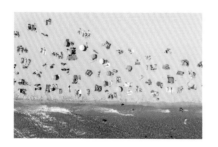

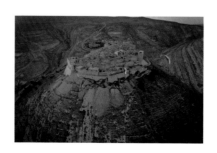

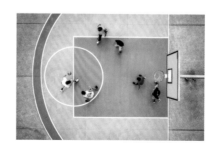

FLORIAN LEDOUX
MASTER OF THE ARCTIC

www.florian-ledoux.com

Florian Ledoux has won photography awards for his work including Skypixel/ DJI Grand Prix Drone Photography of the Year, 2017; First Prize, Drone Video Animals, 2017; Third Prize, Drone Photography, National Geographic/ Dronestagram, 2017; and Third Prize, Wildlife, in the Nature Conservancy Photo Contest 2018. He works in conservation in conjunction with a number of organizations.

Instagram: @florian_ledoux_photographer
Photography tours: nordboundtravel.com

BACHIR MOUKARZEL
MASTER OF ARCHITECTURE

www.bachirmoukarzel.me

Based in Dubai, Bachir Moukarzel is an aerial photographer whose images record the urbanization of his city. He is a certified commercial drone pilot and PolarPro brand ambassador. His image "Concrete Jungle" won First Place in the Urban category in the 2017 Dronestagram competition.

Instagram: @bachirphotophactory
Facebook: BachirPhotoPhotography

KARA MURPHY
MASTER OF COASTS

www.karaemurphy.co

Based in Michigan, USA, Kara Murphy has been a drone photographer since 2014. She operates as a Part 107-certified commercial remote pilot, writer, photographer, and consultant. Her work has been published in magazines including *Drone360*, and used by major brands such as Intel.

Instagram: @karaemurphy
Print store: aerialprintshop.com

SEAN STALTERI
MASTER OF MOTION

www.plotography.org

Sean Stalteri's photography has been featured online and in many publications, including in *Surfline Local Pro*, *Whalebone* magazine, *The Surfers Journal*, *On The Water* magazine, and *National Geographic Your Shot*. Sean was short-listed for the 2017 Outdoor Photographer of the Year contest's View from Above category.

instagram: @plotography

Publications:
A Flight Around Town, 2017

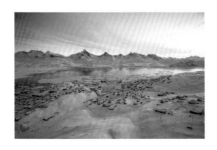

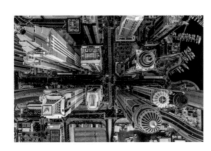

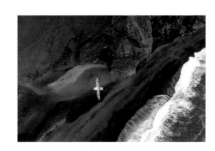

ACKNOWLEDGMENTS

The publishers and editors would like to thank the photographers for all their hard work and assistance, and for their kind permission to reproduce the images in this book:

Cover image copyright © Jerome Courtial
Title page image copyright © Tugo Cheng
p.8–11 images copyright © Fergus Kennedy
p.12–21 images copyright © JP and Mike Andrews
p.22–31 images copyright © Francesco Cattuto
p.32–41 images copyright © Amos Chapple
p.42–51 images copyright © Tugo Cheng
p.52–61 images copyright © Jerome Courtial
p.62–71 images copyright © Stacy Garlington
p.72–81 images copyright © Tobias Hägg
p.82–91 images copyright © David Hopley
p.92–101 images copyright © Karim Iliya
p.102–111 images copyright © Fergus Kennedy
p.112–121 images copyright © Petra Leary
p.122–131 images copyright © Andy Leclerc
p.132–141 images copyright © Florian Ledoux
p.142–151 images copyright © Bachir Moukarzel
p.152–161 images copyright © Kara Murphy
p.162–171 images copyright © Sean Stalteri
p.172–175 images copyright © individual photographers, as above

AMMONITE
PRESS

www.ammonitepress.com